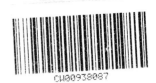

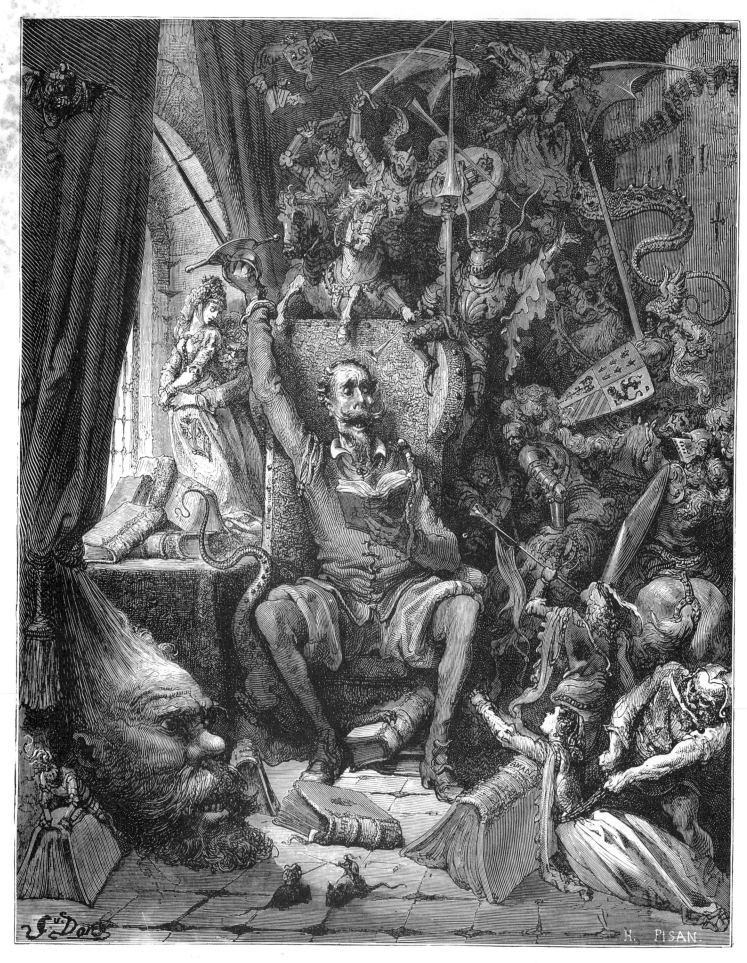

Don Quixote's imagination is inflamed by romances of chivalry (I, 1).

DORÉ'S ILLUSTRATIONS for "DON QUIXOTE"

A Selection of 190 Illustrations by
Gustave Doré

DOVER PUBLICATIONS, INC.
New York

Published in Canada by General Publishing Company, Ltd., 30 Lesmill Road, Don Mills, Toronto, Ontario.
Published in the United Kingdom by Constable and Company, Ltd., 10 Orange Street, London WC2H 7EG.

Doré's Illustrations for "Don Quixote": A Selection of 190 Illustrations, first published by Dover Publications, Inc., in 1982, is a new selection of illustrations from *L'ingénieux hidalgo Don Quichotte de la Manche par Miguel de Cervantès Saavedra / Traduction de Louis Viardot avec 370 compositions de Gustave Doré gravées sur bois par H. Pisan*, as published in two volumes by L. Hachette et Cie, Paris, 1869 (original printing, 1863). The selection, publisher's note and captions were done specially for the present edition.

DOVER *Pictorial Archive* SERIES

Manufactured in the United States of America
Dover Publications, Inc.
31 East 2nd Street
Mineola, N.Y. 11501

Library of Congress Cataloging in Publication Data

Doré, Gustave, 1832–1883.
Doré's illustrations for "Don Quixote."

Selected illustrations from l'Ingénieux hidalgo Don Quichotte de la Manche.
1. Doré, Gustave, 1832–1883. 2. Cervantes Saavedra, Miguel de, 1547–1616—Illustrations. I. Title.
NC980.5.D67A4 1982 769.92′4 81-19411
ISBN 0-486-24300-1 (pbk.) AACR2

PUBLISHER'S NOTE

Don Quixote, the supreme masterpiece of Spanish author Miguel de Cervantes (1547–1616), has intrigued illustrators practically from the moment of its first appearance at the beginning of the seventeenth century. This tale of Don Quixote—a courageous, highminded and well-educated country squire whose one besetting fault is his literal belief that the days of chivalry are not over—and Sancho Panza—his peasant squire who combines ignorance and gullibility with common sense and a healthy instinct for self-preservation—is a quick succession of graphically described humorous incidents that cry out for visual representation. The original edition (First Part, 1605; Second Part, 1615) included only a few stock woodcuts, but from 1618 on, Don Quixote, which was quickly translated into several other European languages, could boast of editions with original title-page illustrations and increasingly large numbers of plates. Among the outstanding eighteenth-century illustrators of Don Quixote were the French artist Antoine Coypel and the German Daniel Chodowiecki. In the first half of the nineteenth century, the Englishman Thomas Stothard and the Frenchman Eugène Lami were perhaps the most successful illustrators of the work. But all of these contributions are nearly forgotten today, whereas Doré's pictures for Cervantes' novel immediately come to mind.

Gustave Doré (1832–1883) was only thirty-one when his version of Don Quixote was published, but he had already been working for some ten years at his mammoth program of illustrating the great world classics. His Don Quixote illustrations, based to a great extent on his own travels in Spain, were done for the Parisian firm L. Hachette et Cie, which originally published them in 1863 within the framework of a complete annotated French translation of Cervantes' novel by Louis Viardot. The two folio volumes contained 120 full-page plates in addition to 259 smaller wood engravings: one headpiece (horizontal, full text width) and one tailpiece (a small vignette) for each of the 126 chapters, plus 7 front-matter illustrations. The wood engravings were prepared from Doré's drawings by H. Pisan, a long-time associate of the artist.

The present volume includes all 120 full-page plates and a selection of the 70 most lively and inventive headpieces and tailpieces. The art is reproduced directly from a fine copy of the 1869 printing of the Hachette edition. Whereas the captions in the original French edition consisted of brief and detached direct quotations from the text, the English captions specially prepared for this Dover edition summarize the action indicated in the illustrations, with a view to carrying the story line along. Except for the name of Don Quixote (used in that form rather than "Quijote") and one or two other historical names for which the usual English form is retained, the characters' names are based on the original Spanish text. At the end of each caption is the number of the chapter in which the illustrated incident occurs (in the form "I, 1," meaning "First Part, Chapter 1"; "II, 2," "Second part, Chapter 2"; etc.).

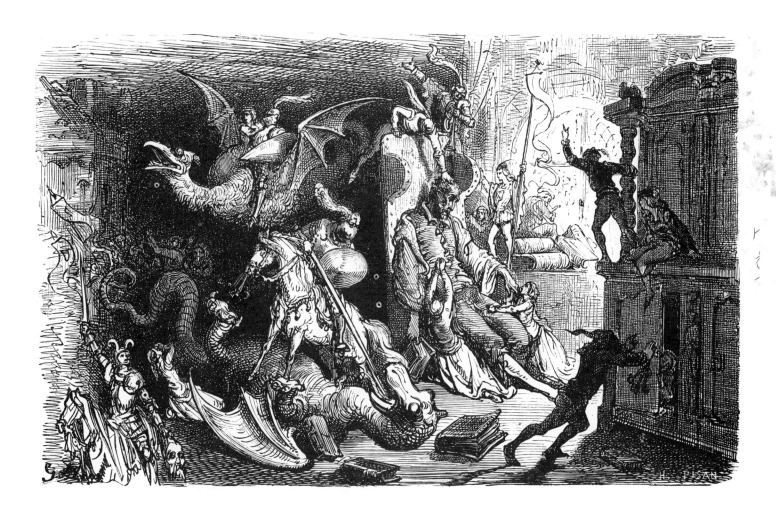

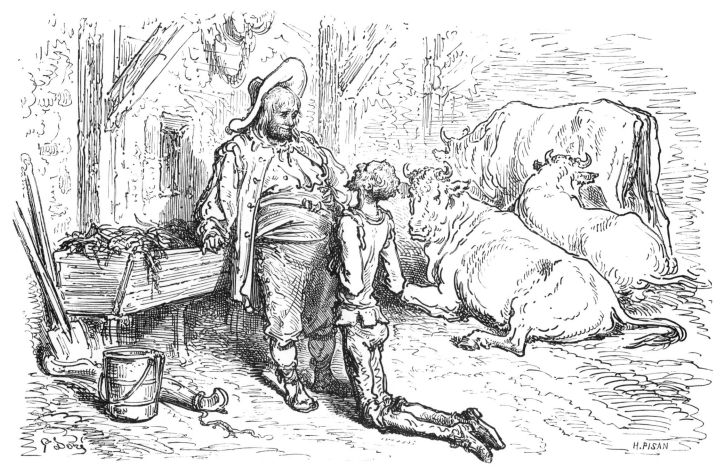

ABOVE: Don Quixote neglects his estate and thinks of nothing but knightly deeds (I, 1). BELOW: The Don pleads with the innkeeper to dub him a knight the next day (I, 3).

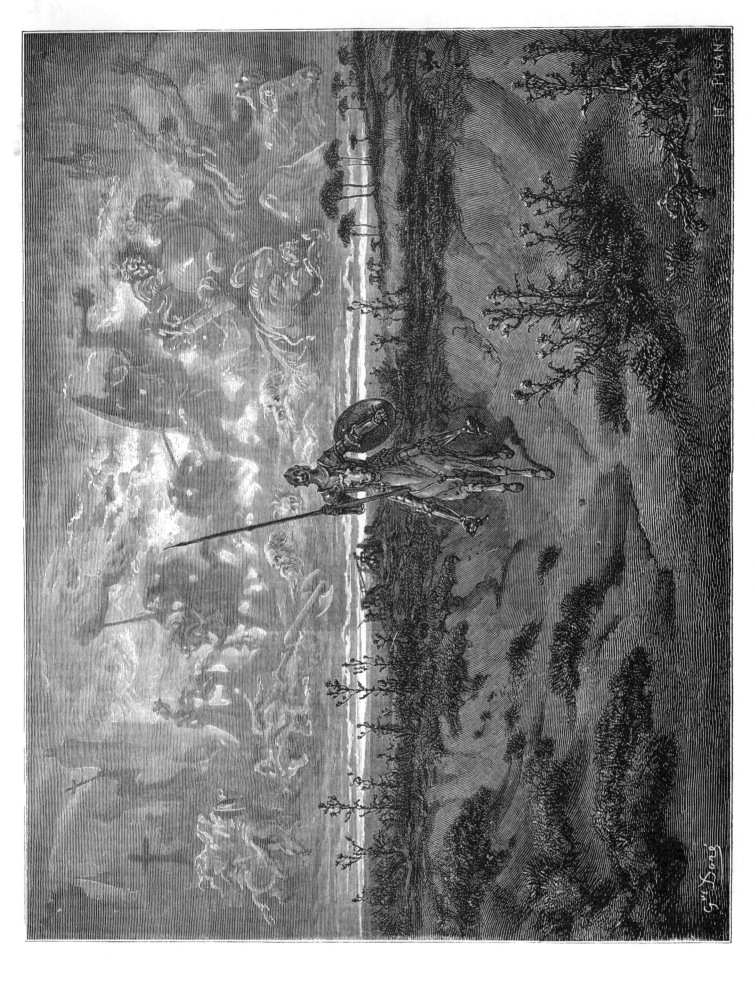

The Don on his first sally forth (I, 2).

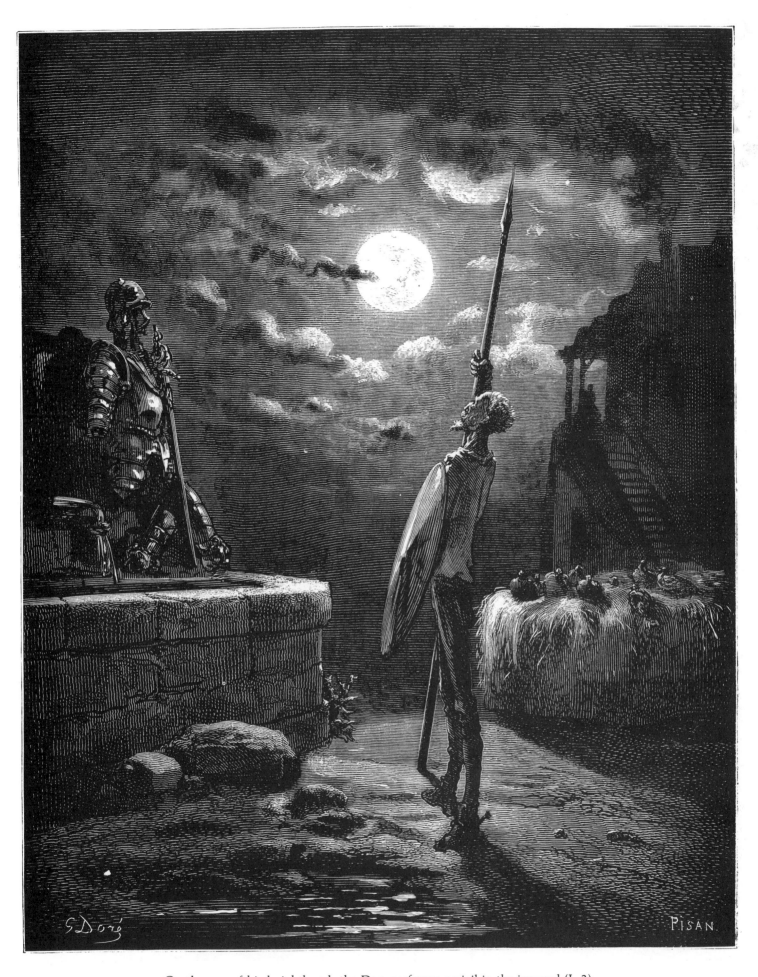

On the eve of his knighthood, the Don performs a vigil in the innyard (I, 3).

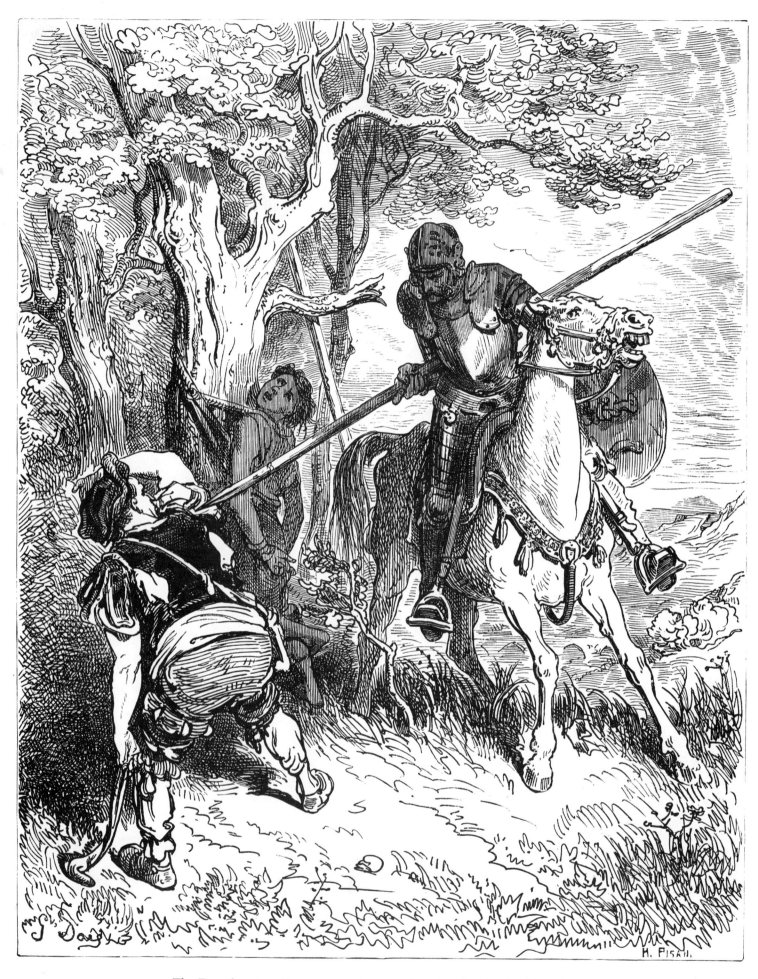

The Don threatens the peasant who was whipping the shepherd boy (I, 4).

The merchants of Toledo look on as one of their mule drivers beats Don Quixote (I, 4).

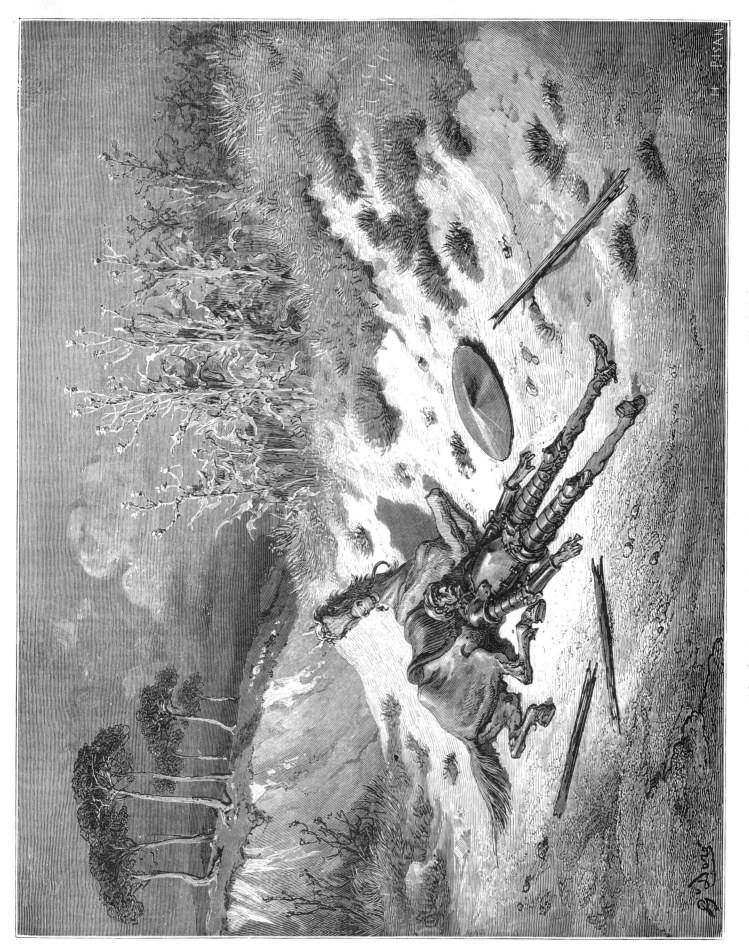

After his beating, the Don calls for his ideal lady, Dulcinea del Toboso (I, 5).

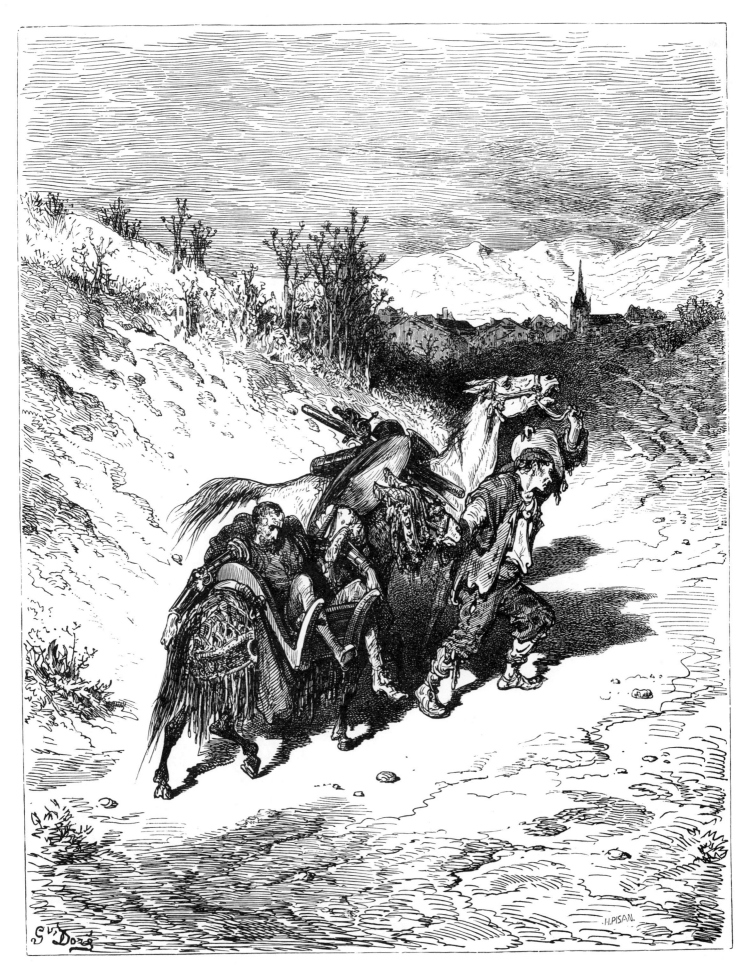

A plowman from his own village brings him home (I, 5).

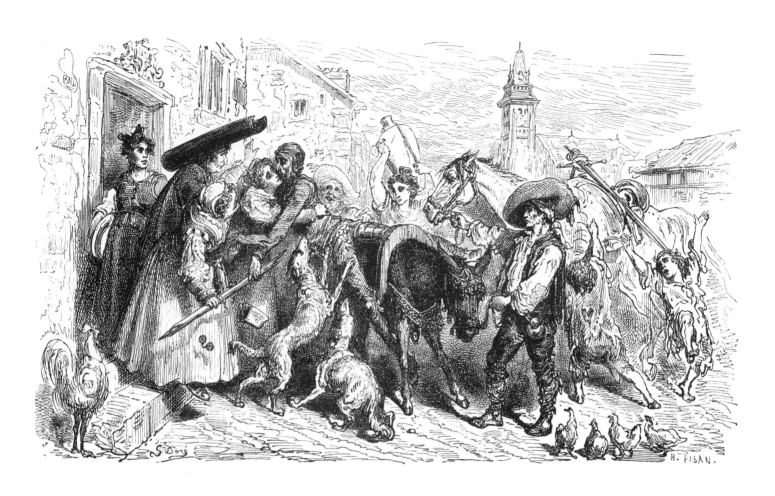

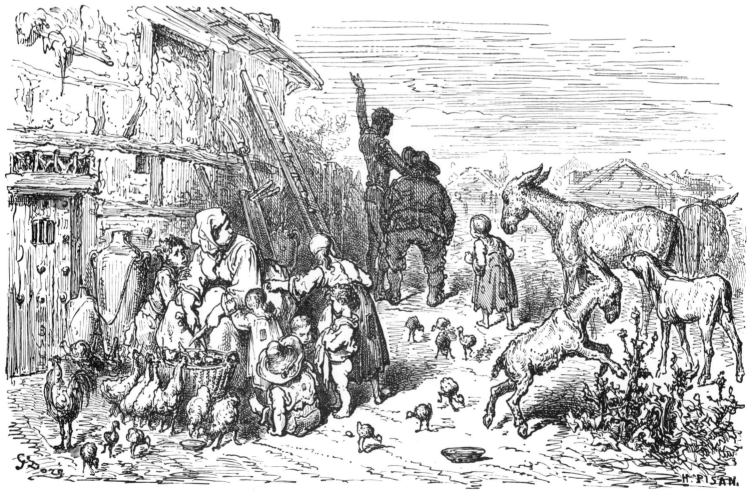

ABOVE: The battered Don arrives home (I, 5). BELOW: Don Quixote persuades
Sancho Panza to become his squire (I, 7).

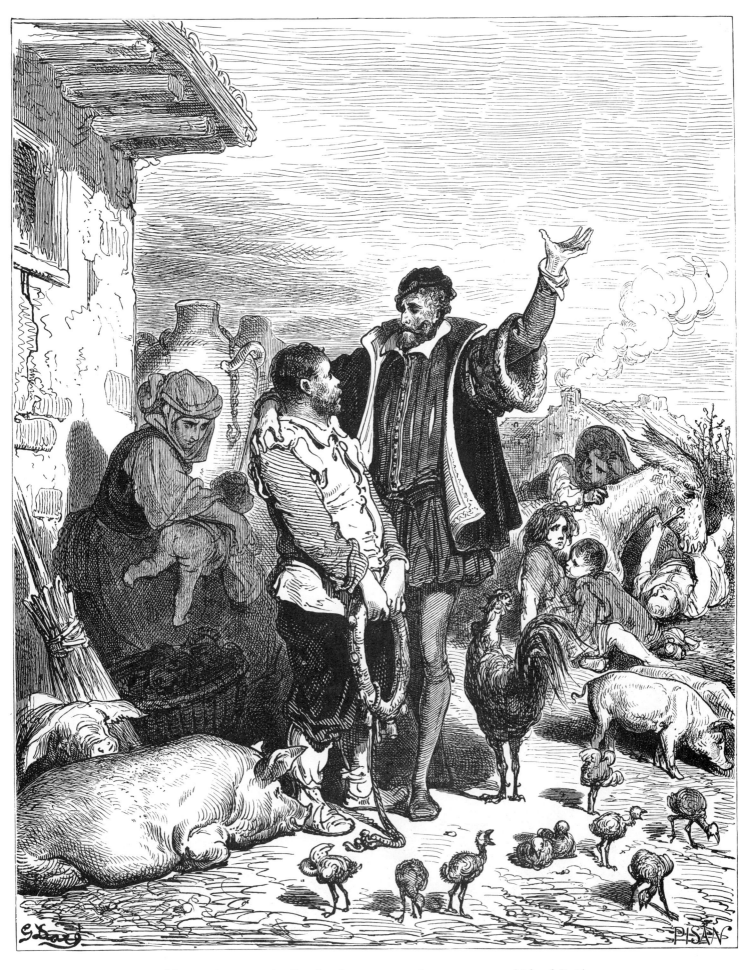

He promises to make Sancho the governor of some conquered island (I, 7).

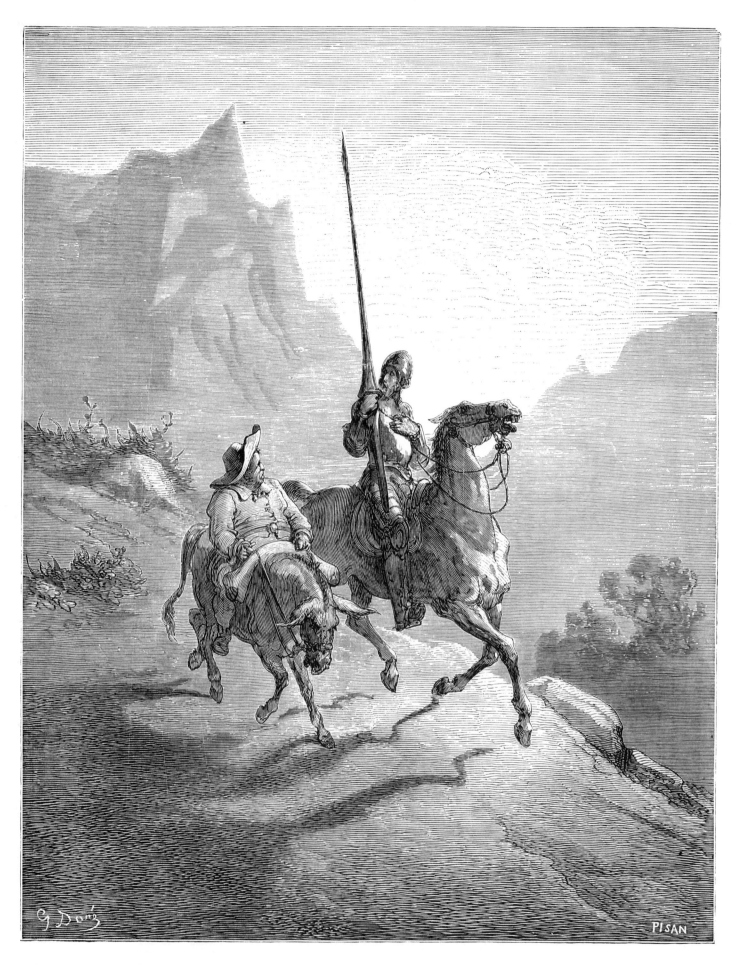

Sancho and the Don set out on their joint adventures (I, 7).

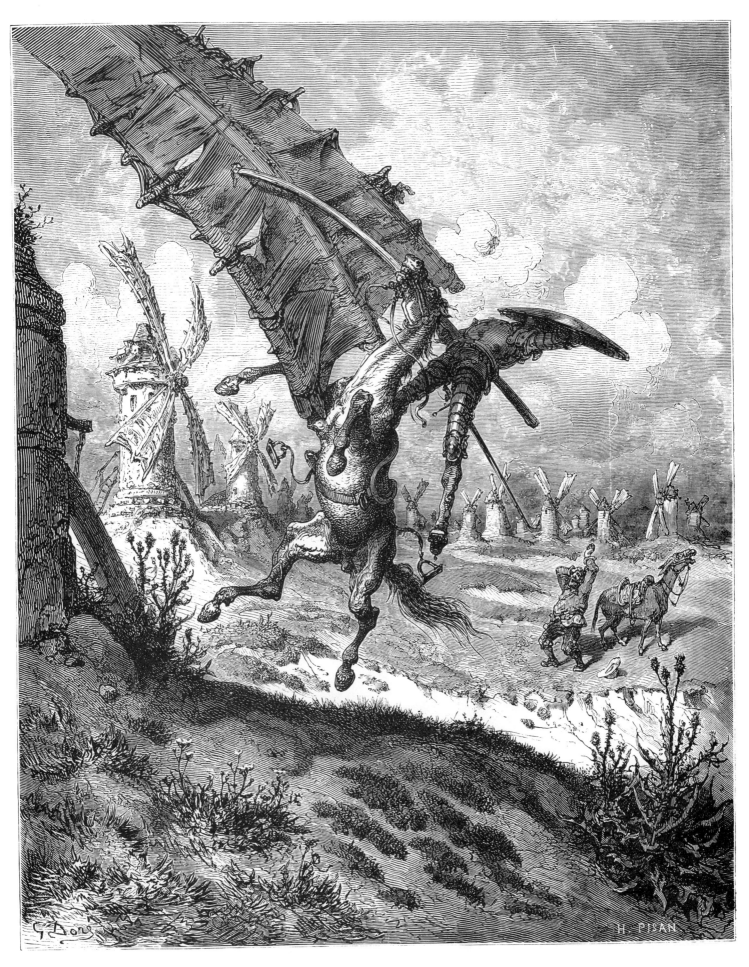

The attack on the windmill (I, 8).

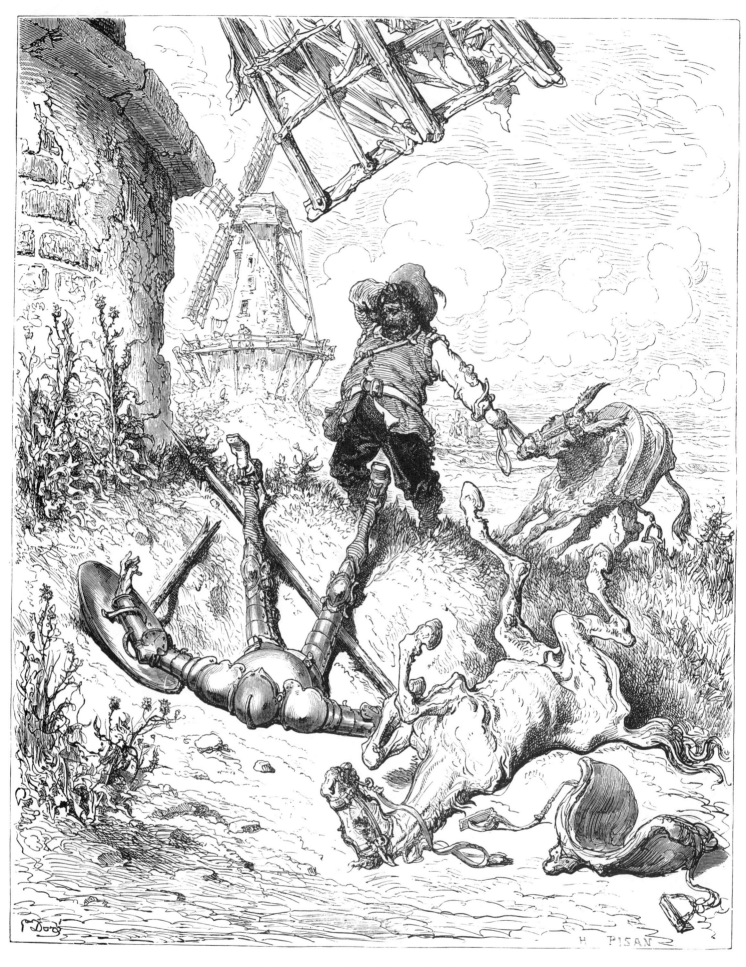

Sancho comes to Don Quixote's aid (I, 8).

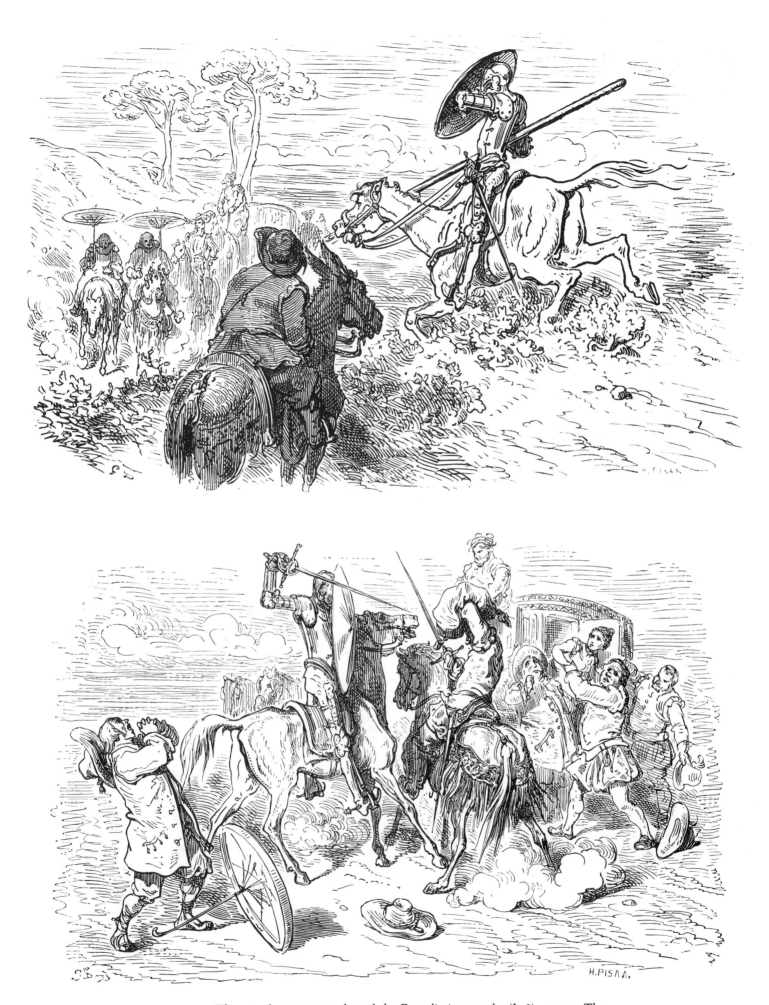

ABOVE: The attack on the coach and the Benedictine monks (I, 8). BELOW: The battle at the coach between the Don and the Biscayan (I, 9).

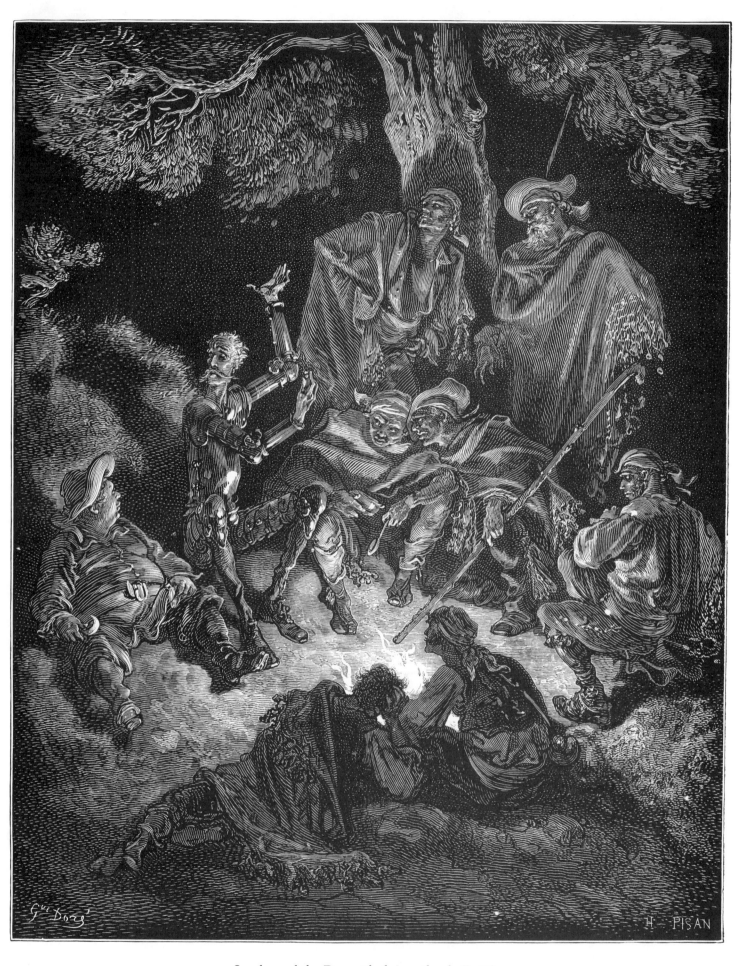

Sancho and the Don with the goatherds (I, 11).

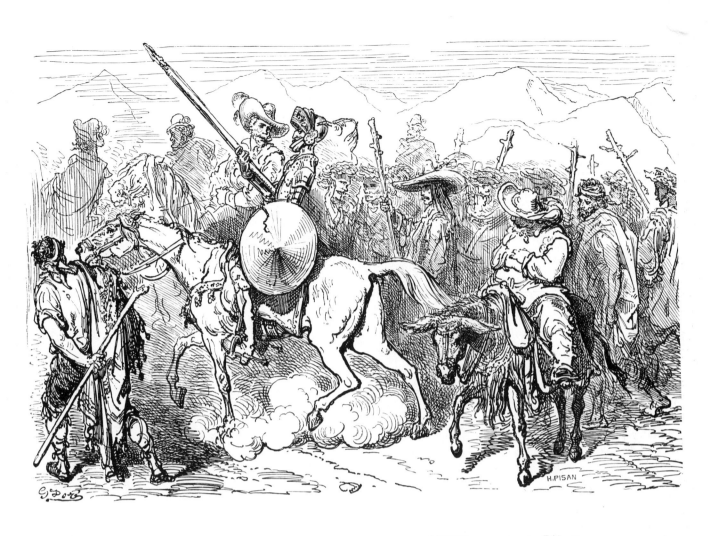

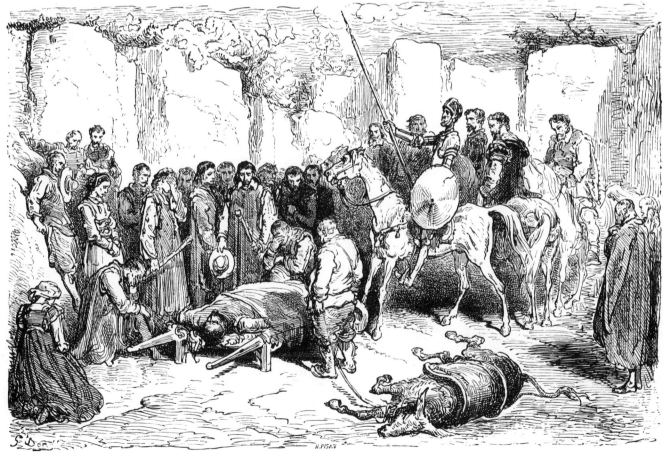

ABOVE: The Don rides off with the goatherds and others to the funeral of the spurned lover Gristóstomo (I, 13). BELOW: At the funeral (I, 14).

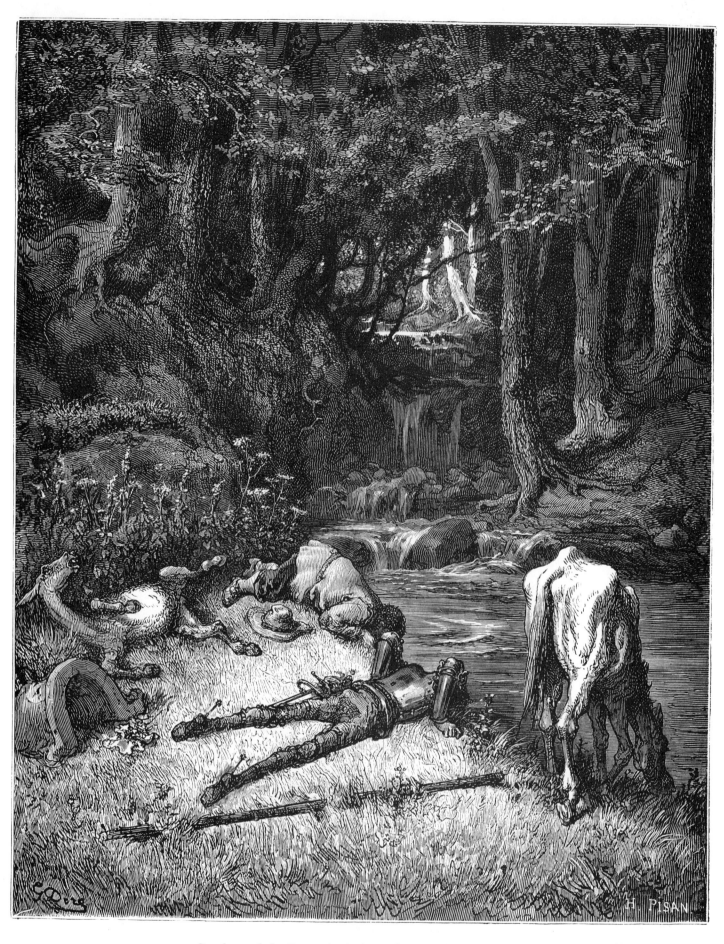

Sancho and the Don refresh themselves at a brook (I, 15).

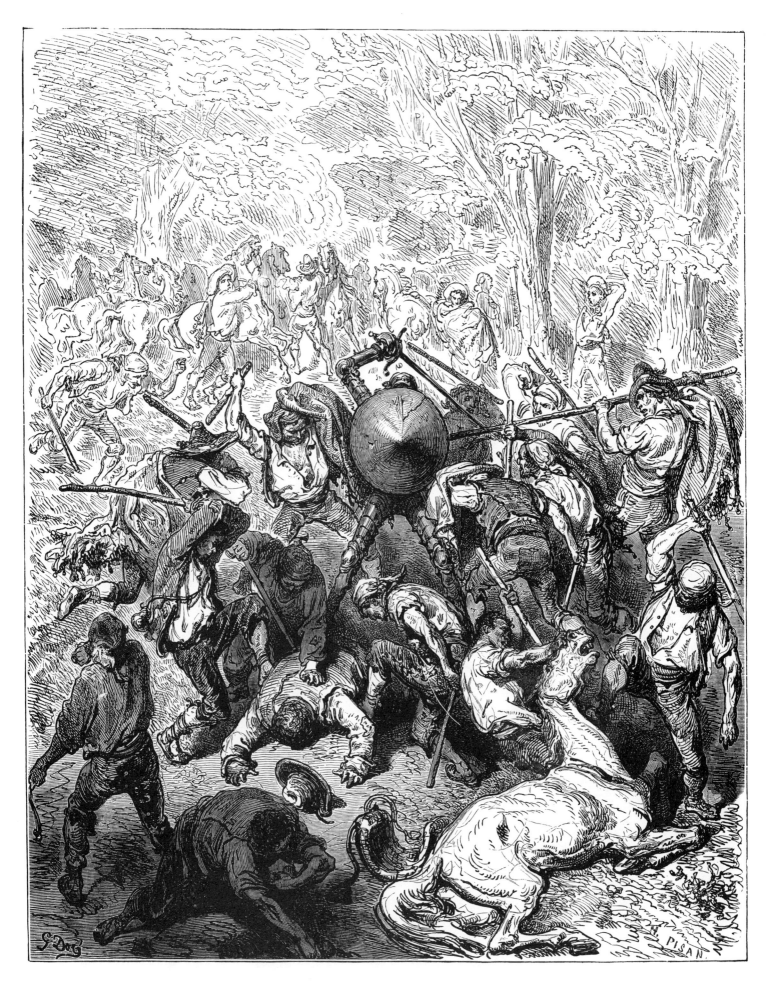

The fight against the muleteers from Yanguas (I, 15).

Sancho drags his master and their mounts back to the main road (I, 15).

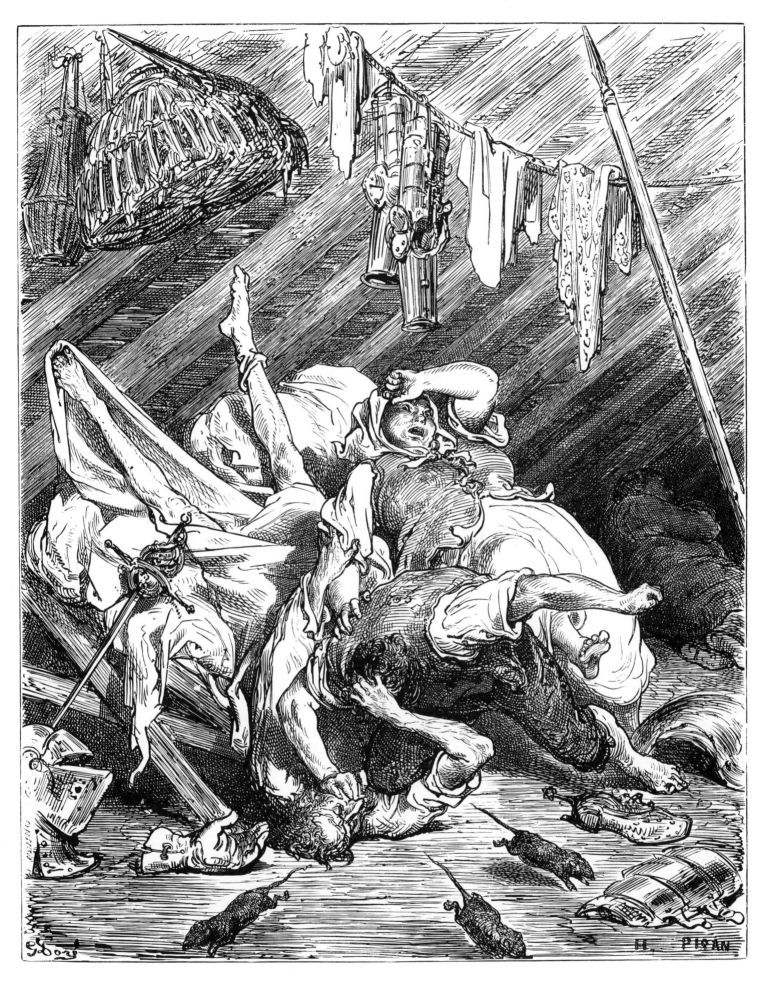

Maritornes is the innocent cause of a fight between the Don and her muleteer
lover (I, 16).

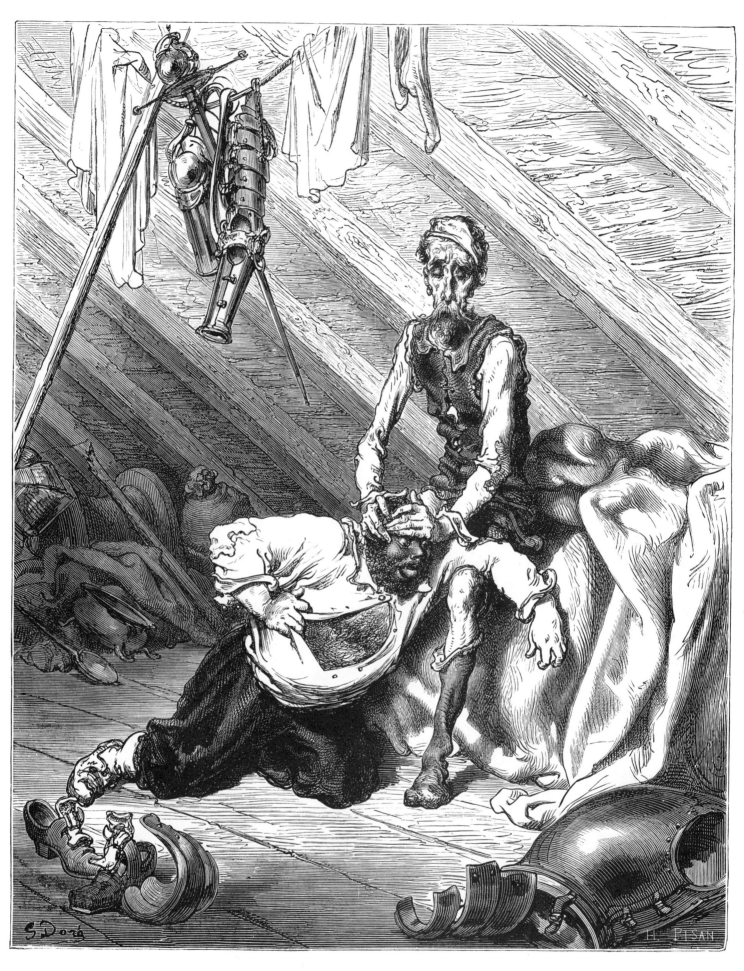

Bad effects of the medicine that was to heal Sancho's bruises (I, 17).

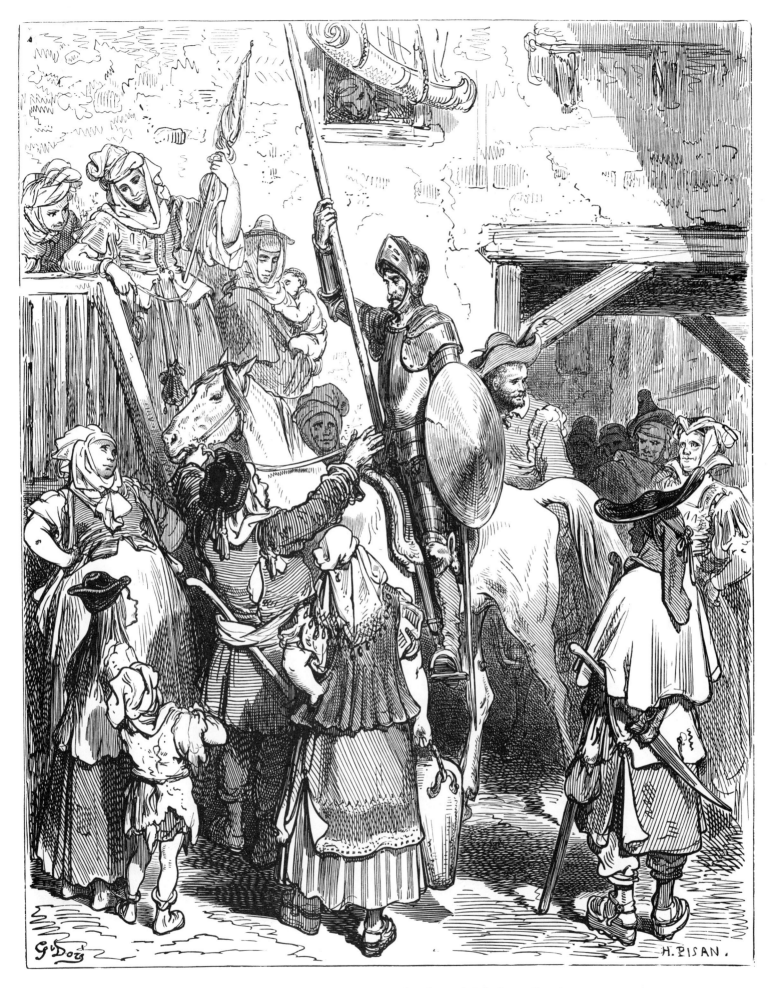

The innkeeper requests payment for the night's lodging (I, 17).

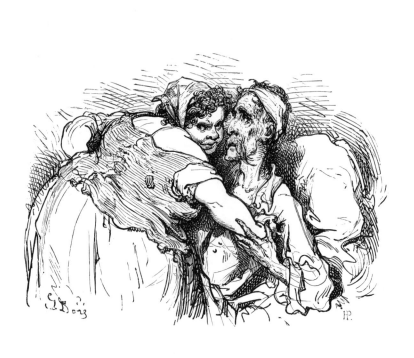

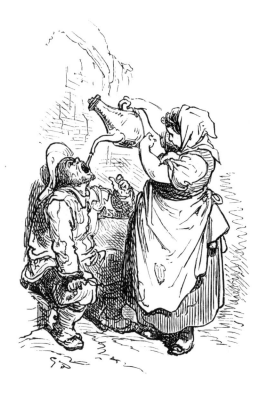

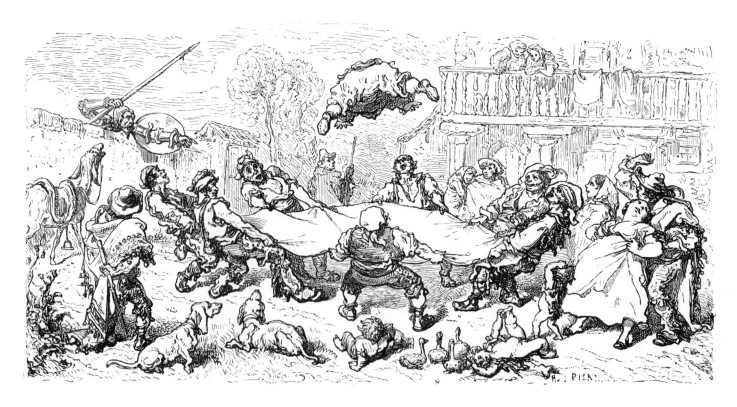

ABOVE LEFT: Maritornes and the Don (I, 16). ABOVE RIGHT: Maritornes gives
Sancho water (I, 17). BELOW: Sancho tossed in a blanket (I, 17).

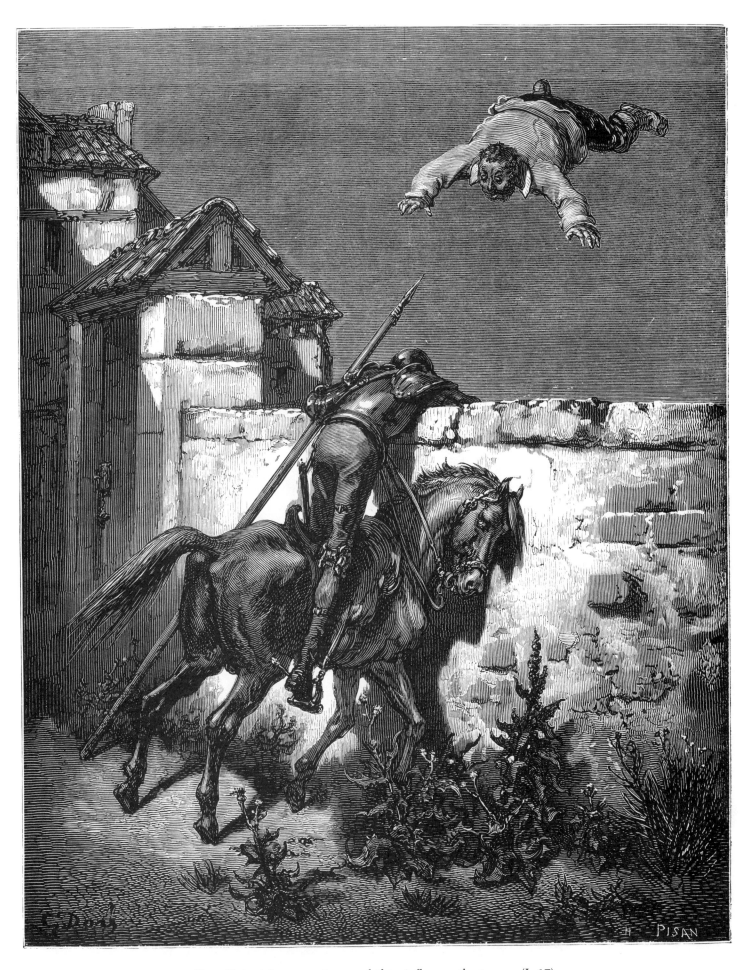

Don Quixote's remonstrances fail to influence the tossers (I, 17).

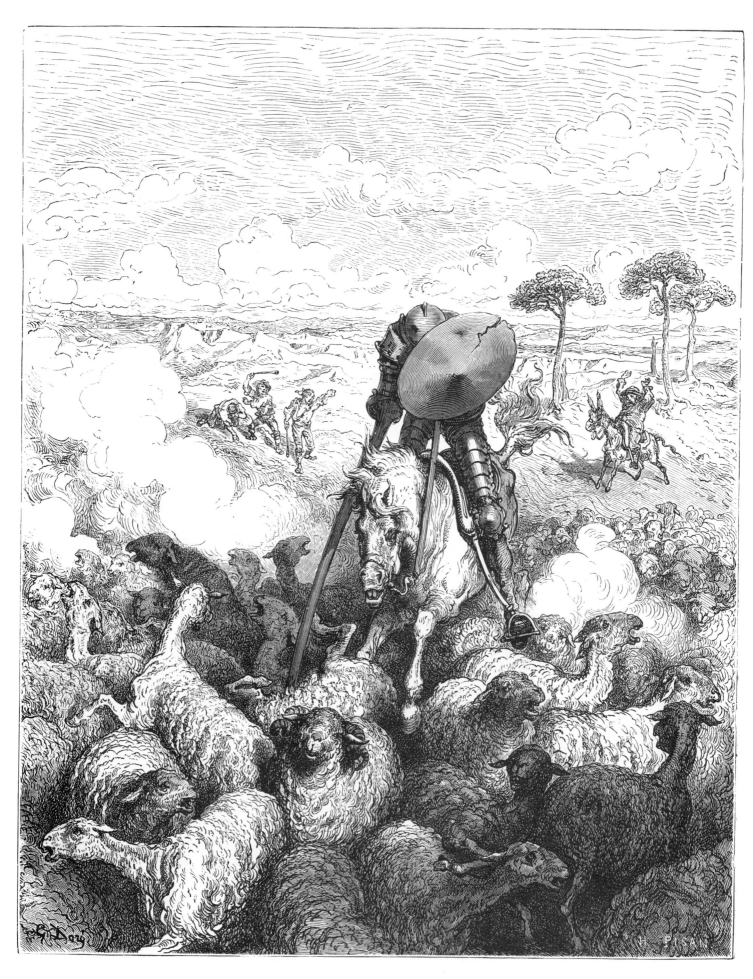

The Don attacks the flock of sheep (I, 18).

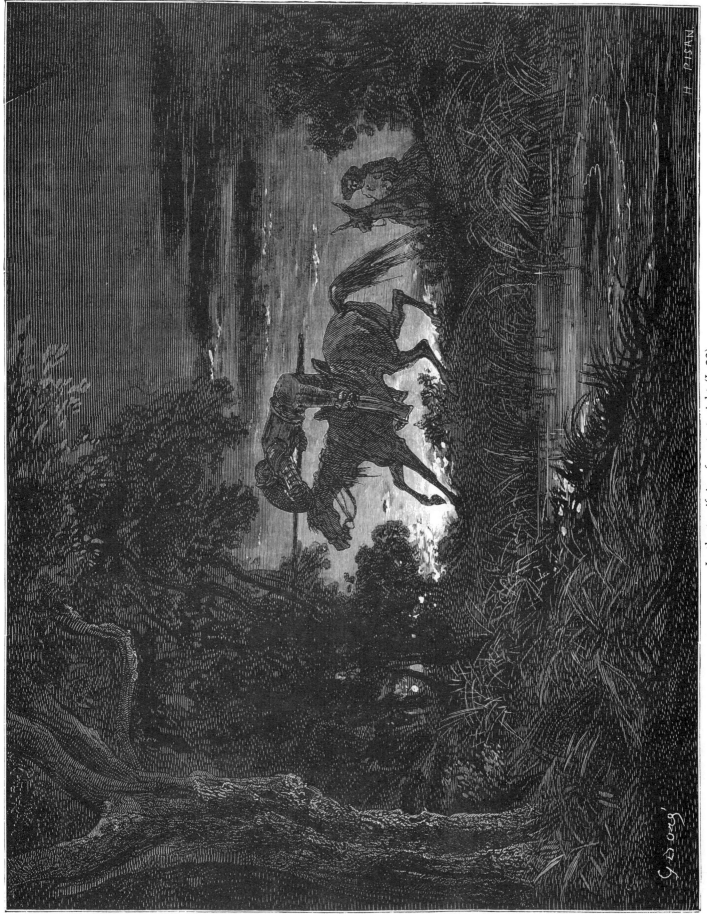

In the terrifying forest at night (I, 20).

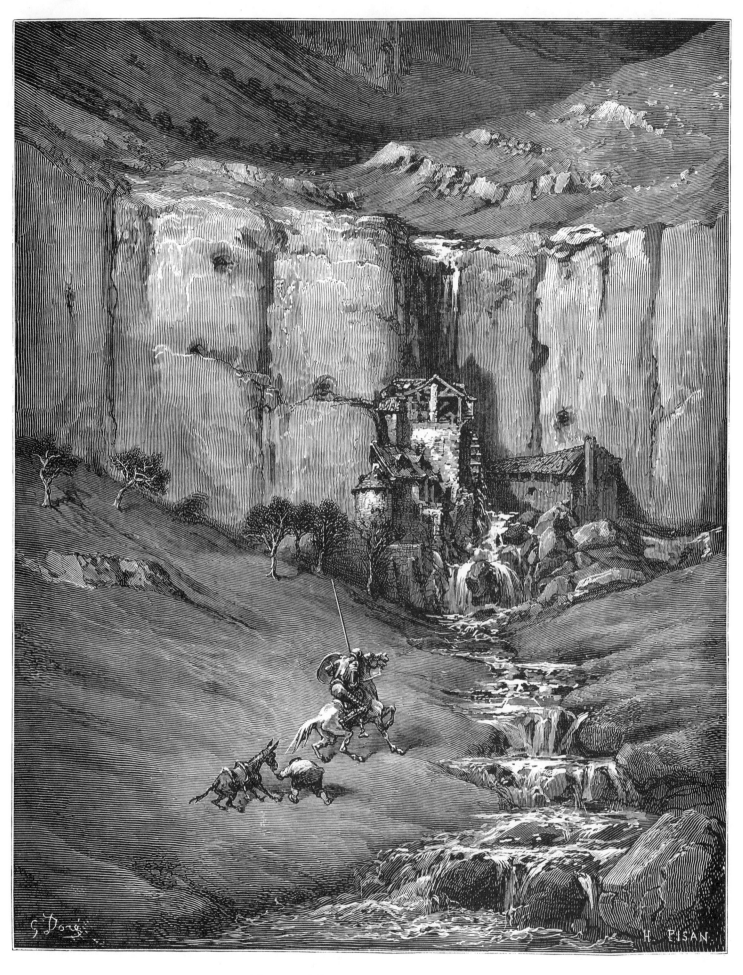

The waterfall and the noisy hovels (I, 20).

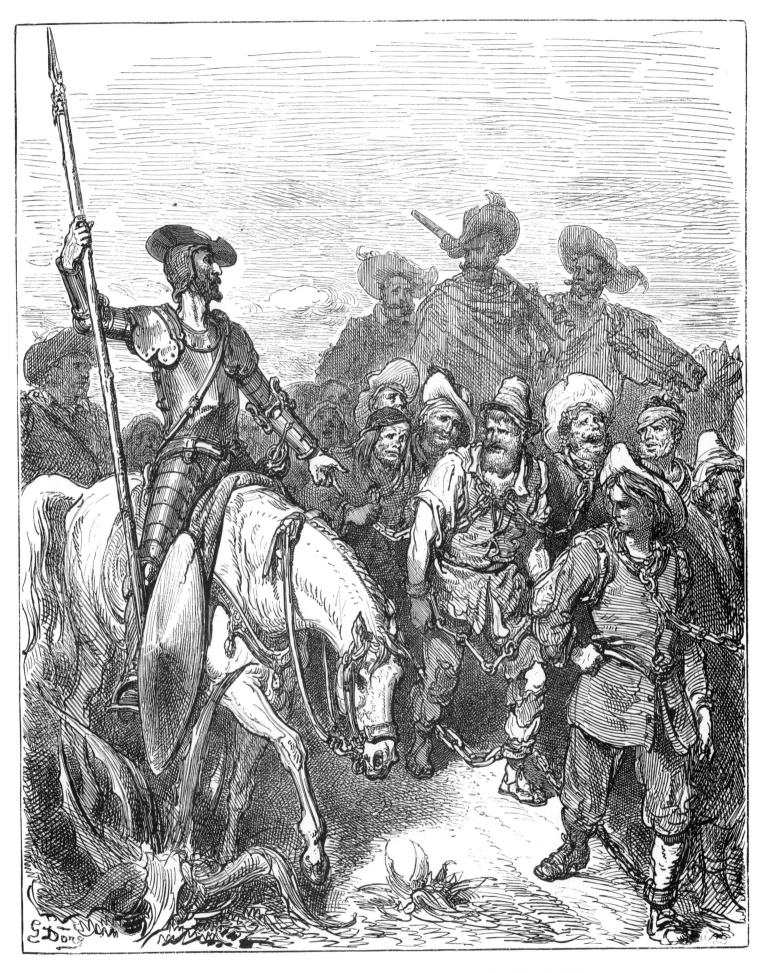

Don Quixote interrogates the criminals being led to the galleys (I, 22).

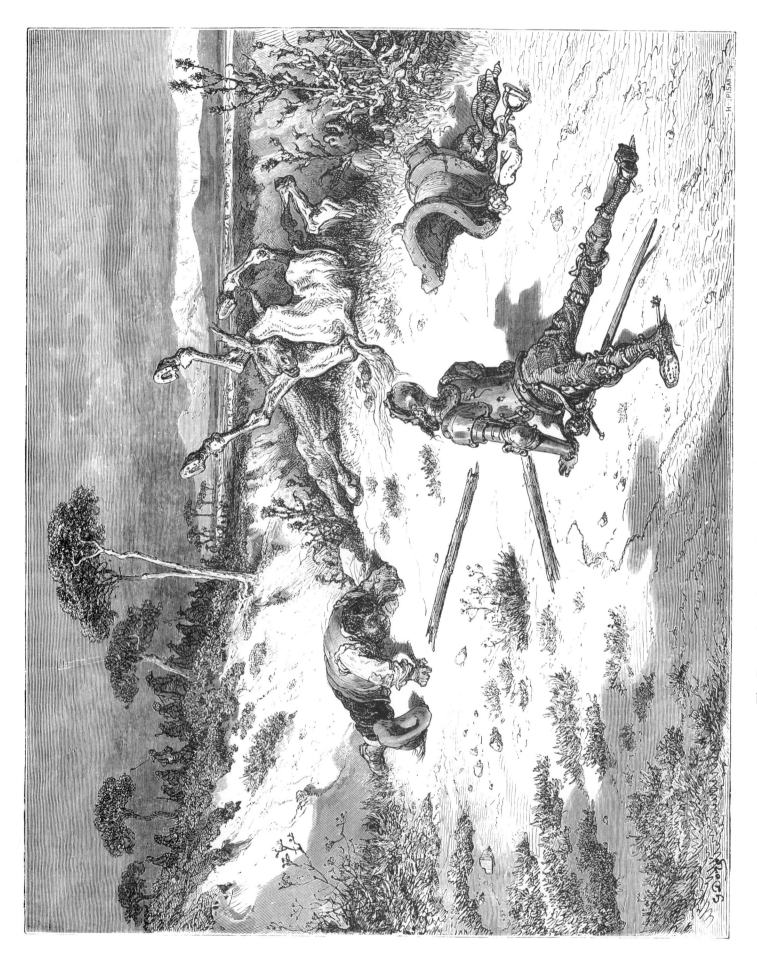

The Don and Sancho after the brawl with the guards and criminals (I, 22).

The Don and Sancho approach the Sierra Morena (I, 23).

29

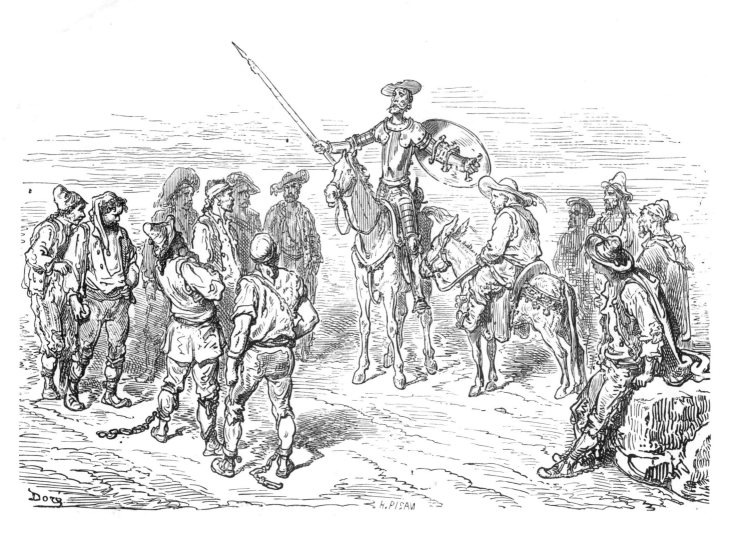

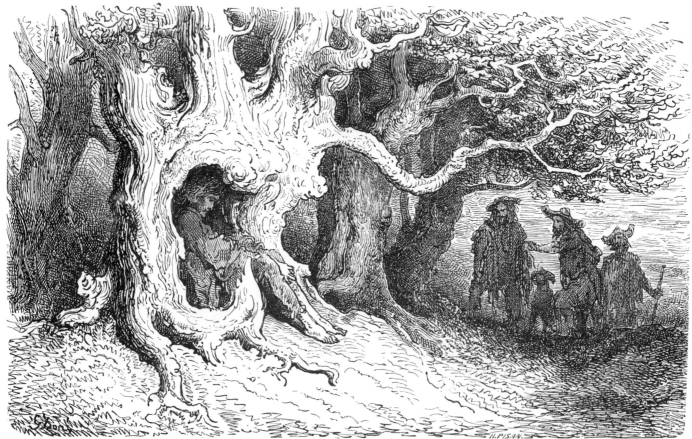

ABOVE: Don Quixote and the freed criminals (I, 22). BELOW: The goatherds find
the strange young man housed in a hollow tree (I, 23).

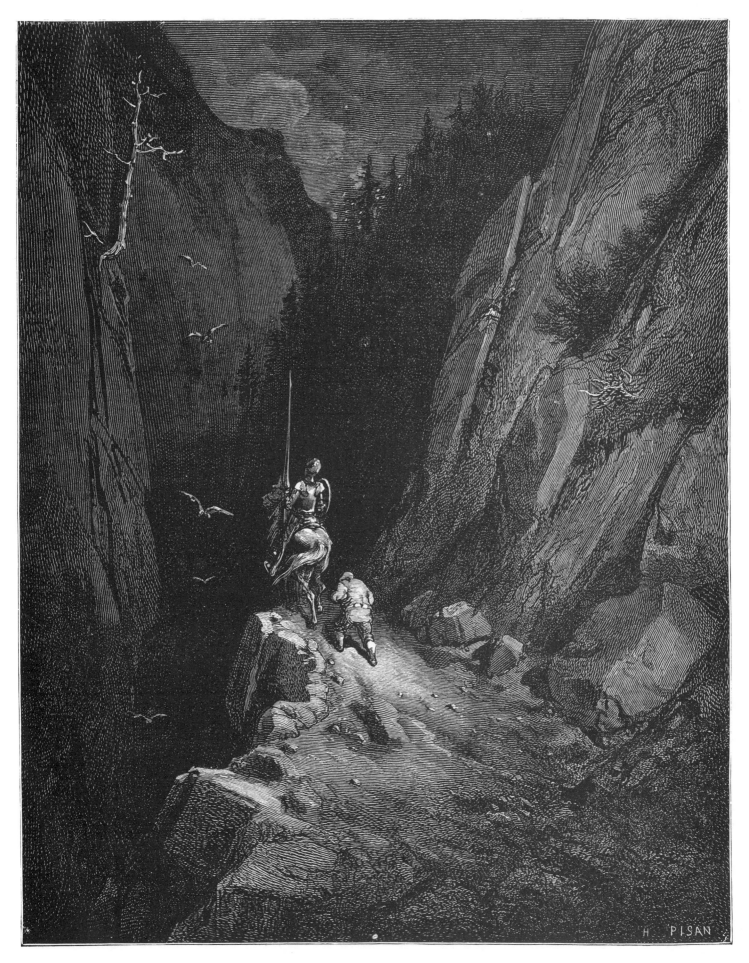

In the heart of the Sierra Morena (I, 23).

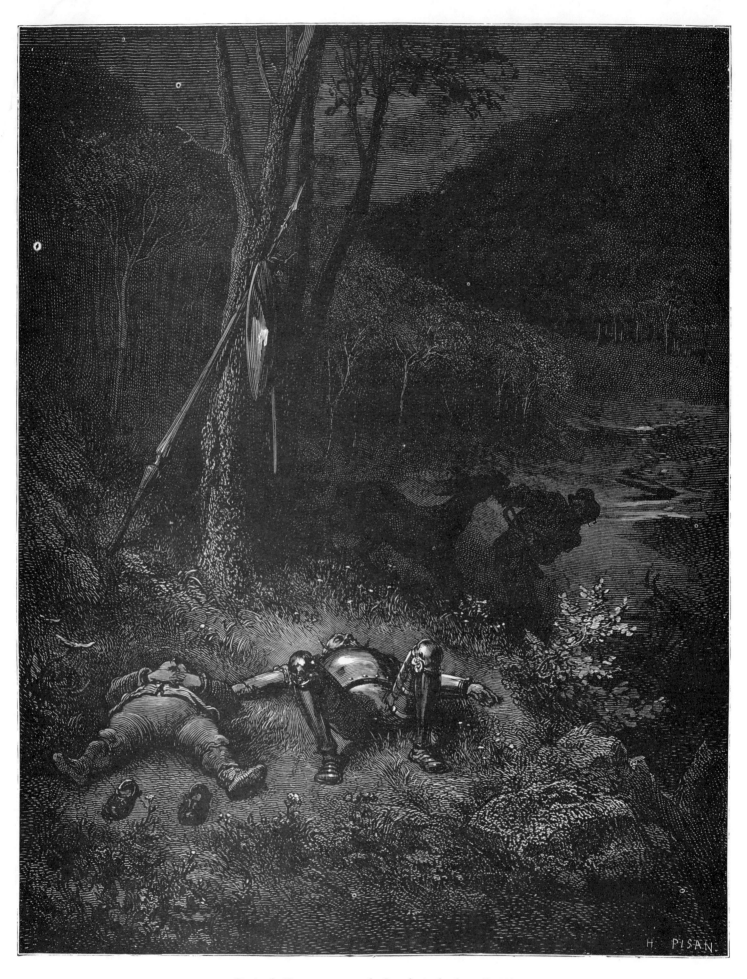

Ginés de Pasamonte steals Sancho's donkey (I, 23).

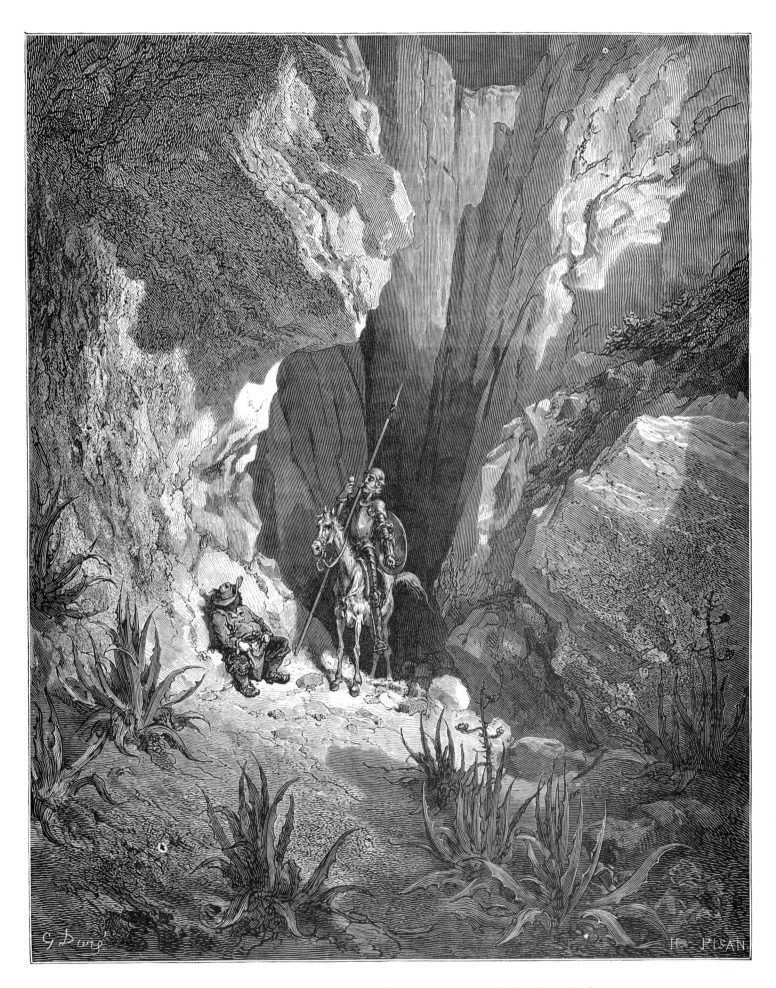

Don Quixote reads a sonnet from the little book found in the abandoned valise
(I, 23).

The travelers see a ragged man leaping among the rocks (I, 23).

Soon afterward they find the cadaver of a mule (I, 23).

ABOVE: Don Quixote visits Cardenio, the ragged young man (I, 24). BELOW:
Don Quixote sends Sancho off with a love letter for Dulcinea and a letter
requesting his niece to give Sancho some donkeys (I, 25).

Sancho complains about their journey through rugged terrain (I, 25).

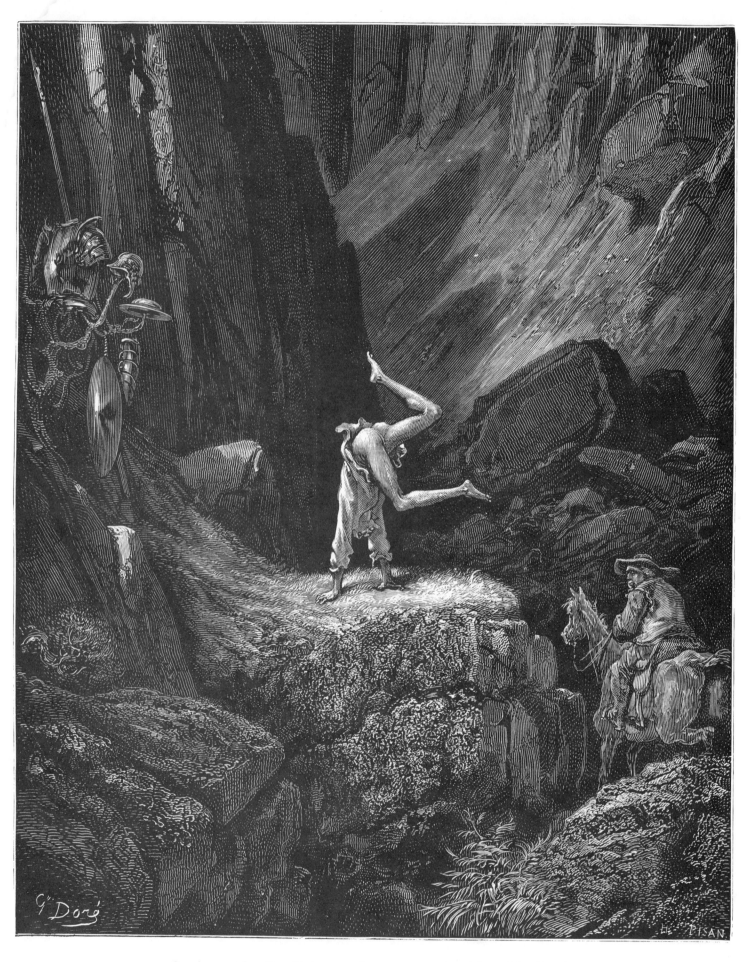

Sancho watches Don Quixote perform some penitential tumbles (I, 25).

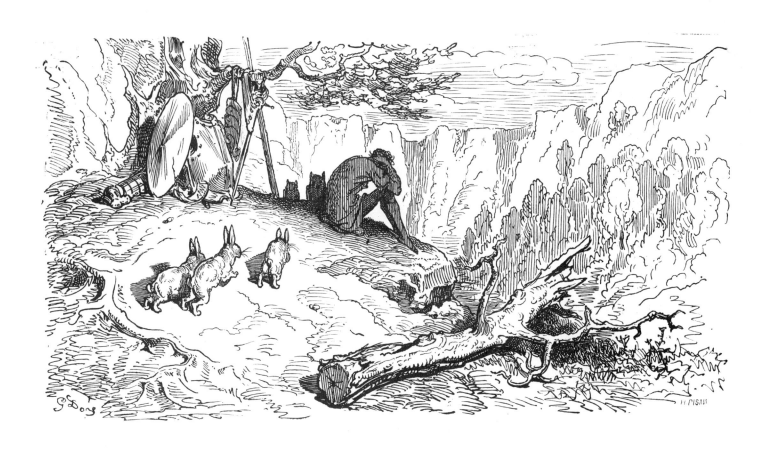

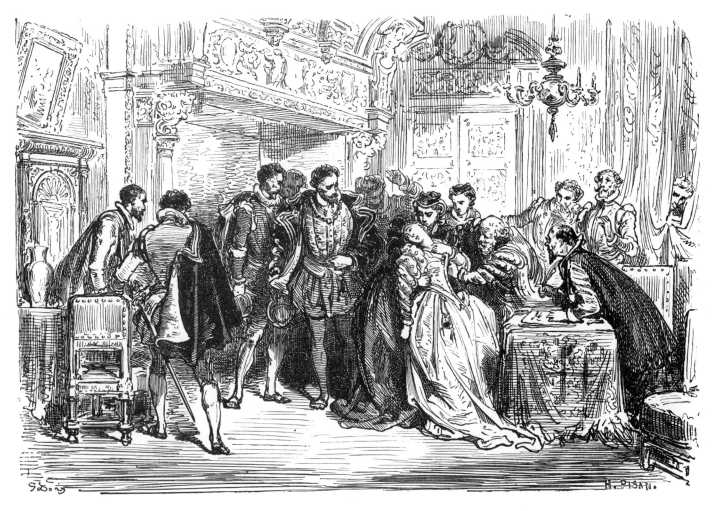

ABOVE: Don Quixote doing chivalric penance in the mountains (I, 26). BELOW:
In Cardenio's story, Luscinda faints on her wedding day (I, 27).

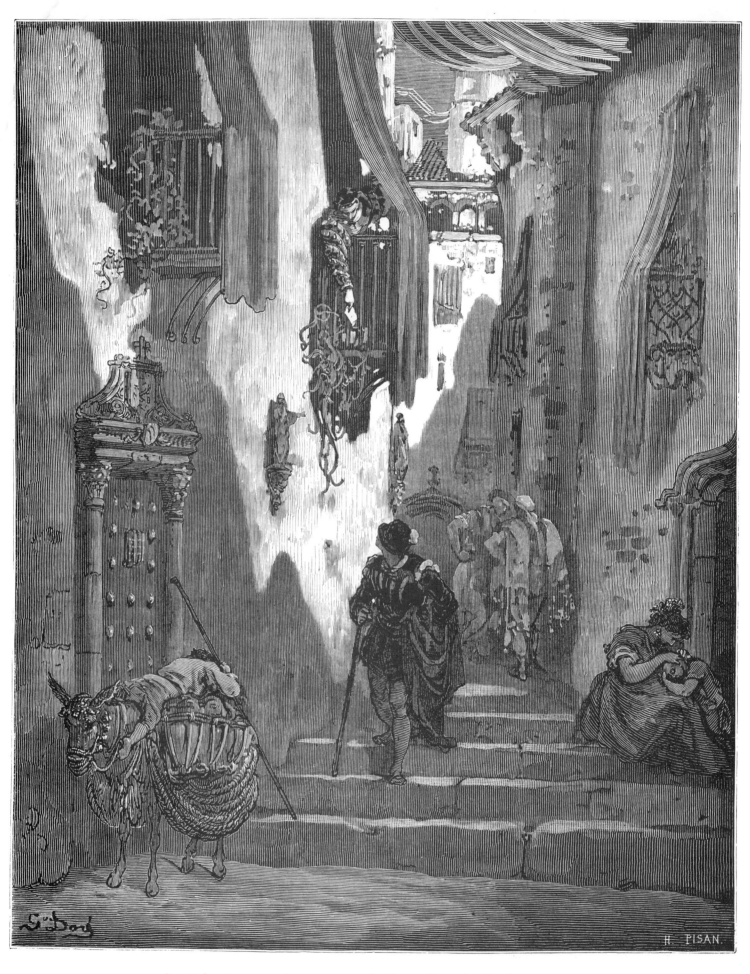

Luscinda gives a passing stranger a clandestine letter for Cardenio (I, 27).

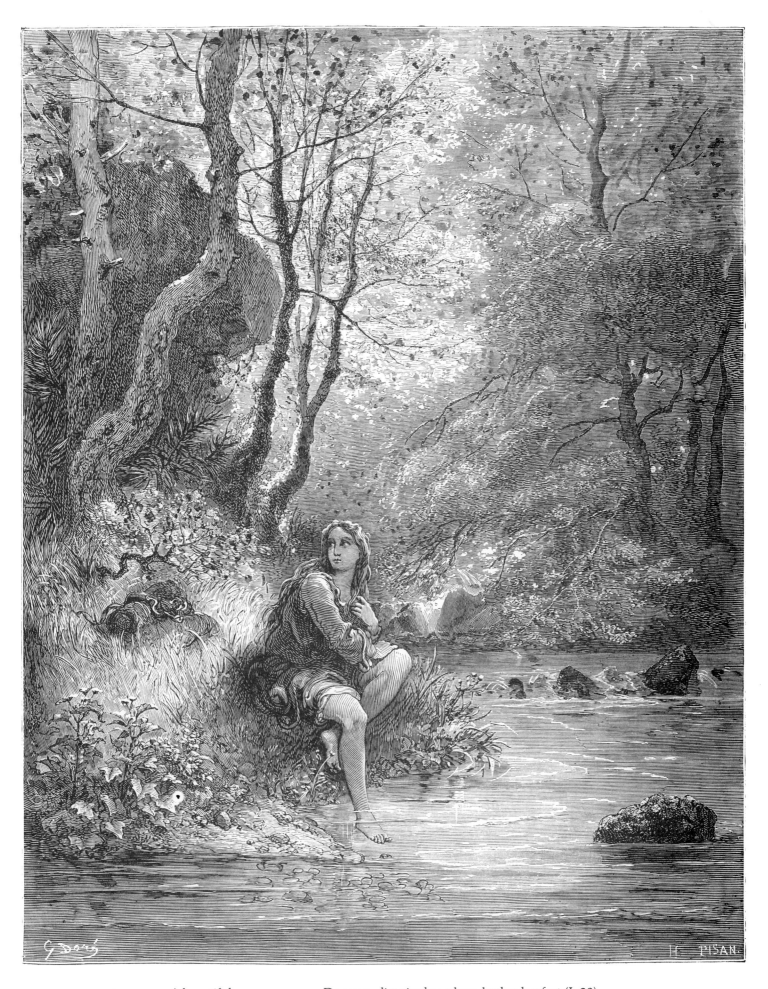

A beautiful young woman, Dorotea, disguised as a boy, bathes her feet (I, 28).

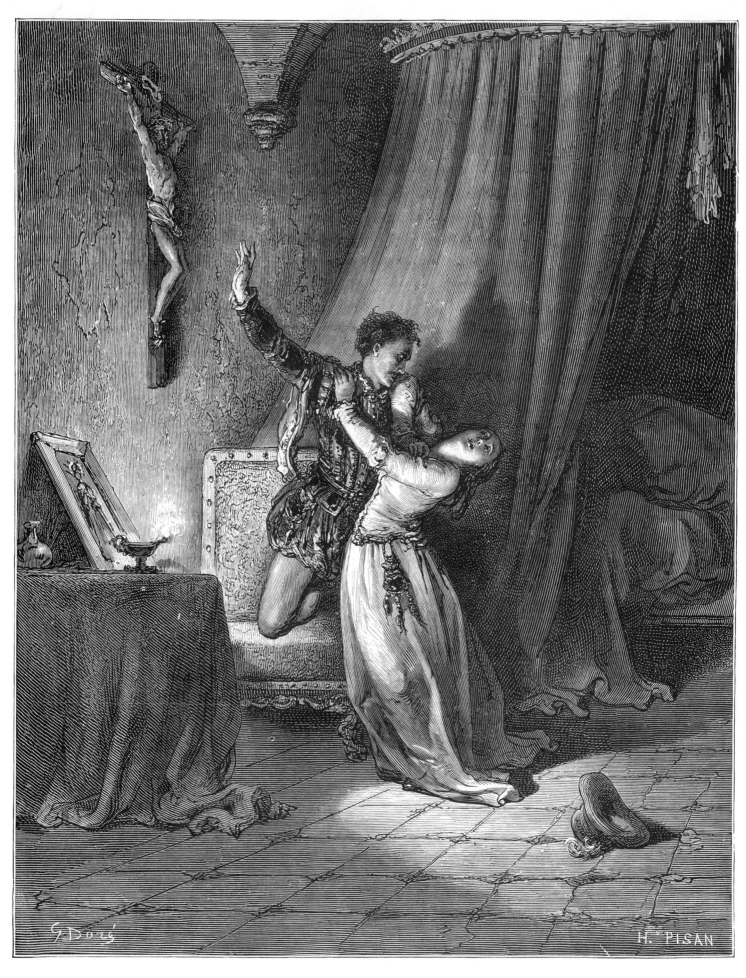

Dorotea recounts her secret engagement to Don Fernando, Luscinda's
treacherous bridegroom (I, 28).

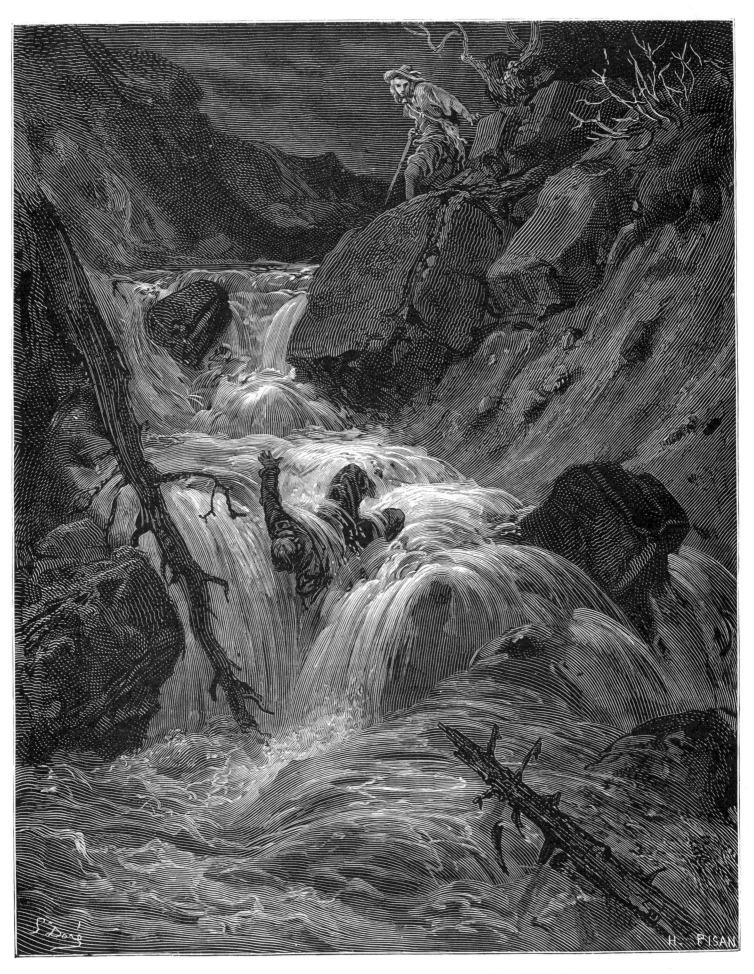

Dorotea pushes her unfaithful and lecherous servant off a cliff (I, 28).

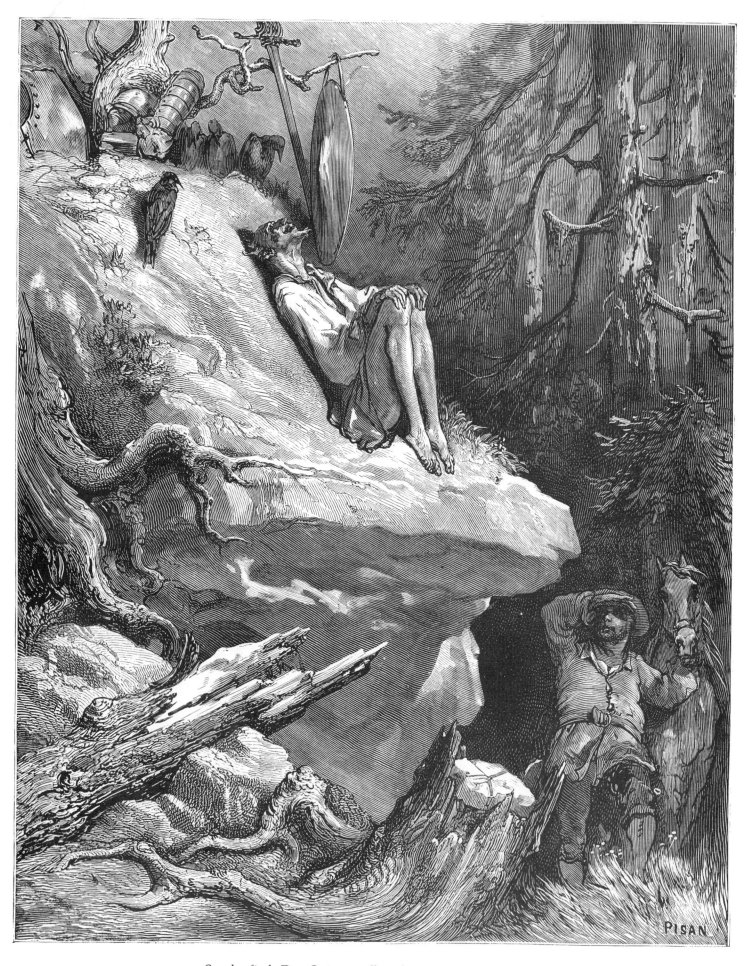

Sancho finds Don Quixote still performing penance (I, 29).

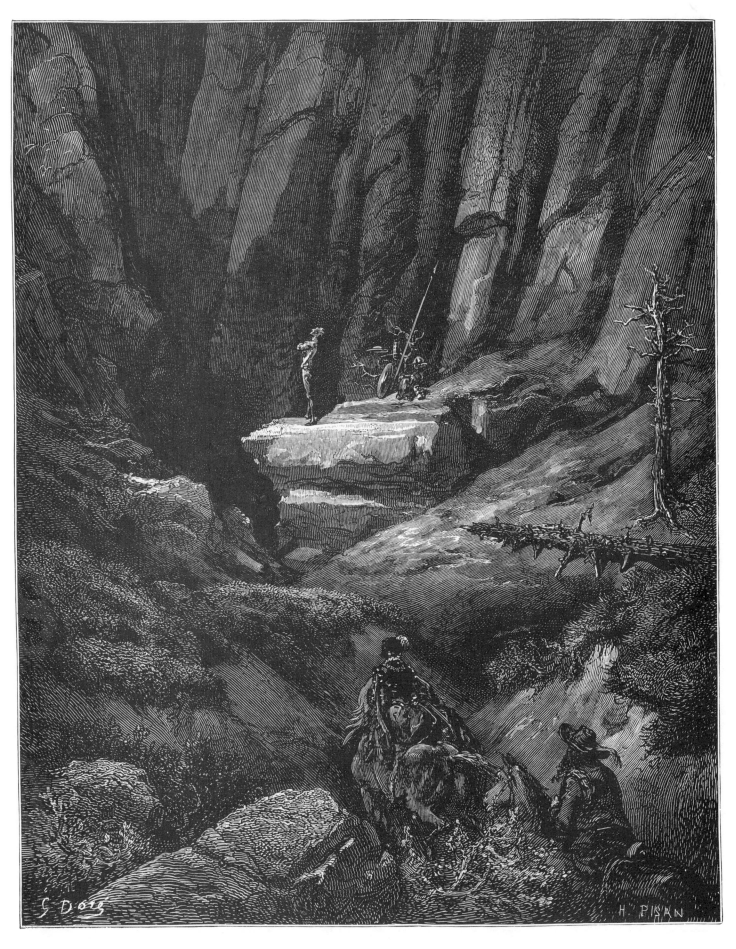

Dorotea and the disguised barber approach the Don (I, 29).

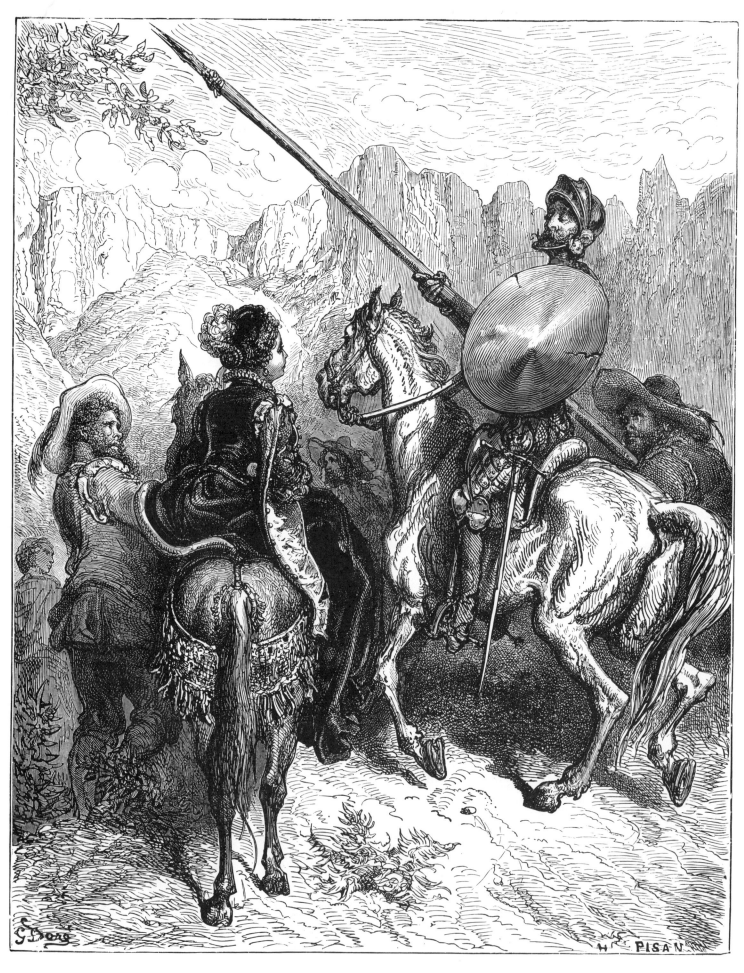

Don Quixote agrees to slay a giant for Dorotea (I, 29).

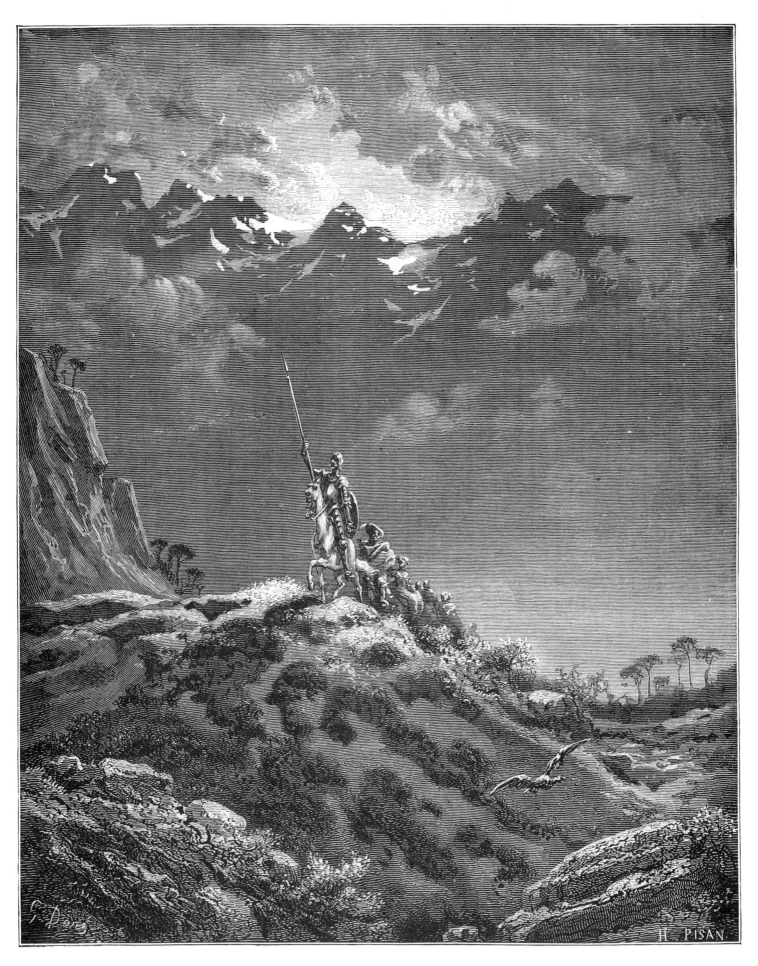

The group sets out in the direction of Don Quixote's home (I, 29).

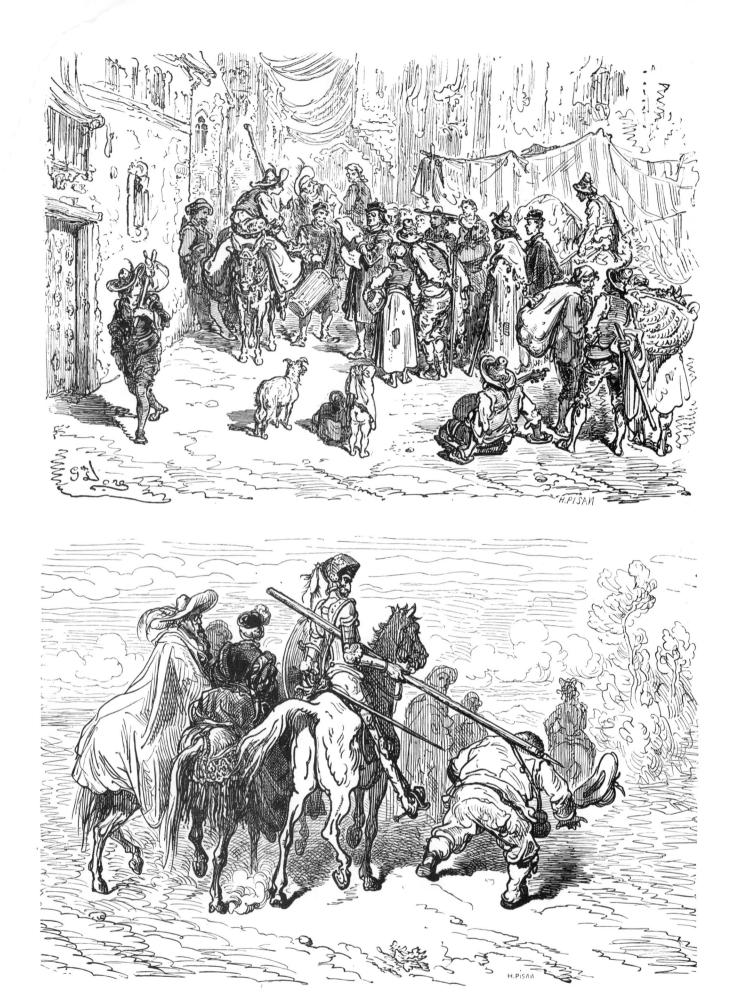

ABOVE: The town crier announces a reward for finding Dorotea (I, 28). BELOW: Don Quixote chastises Sancho for belittling Dulcinea (I, 30).

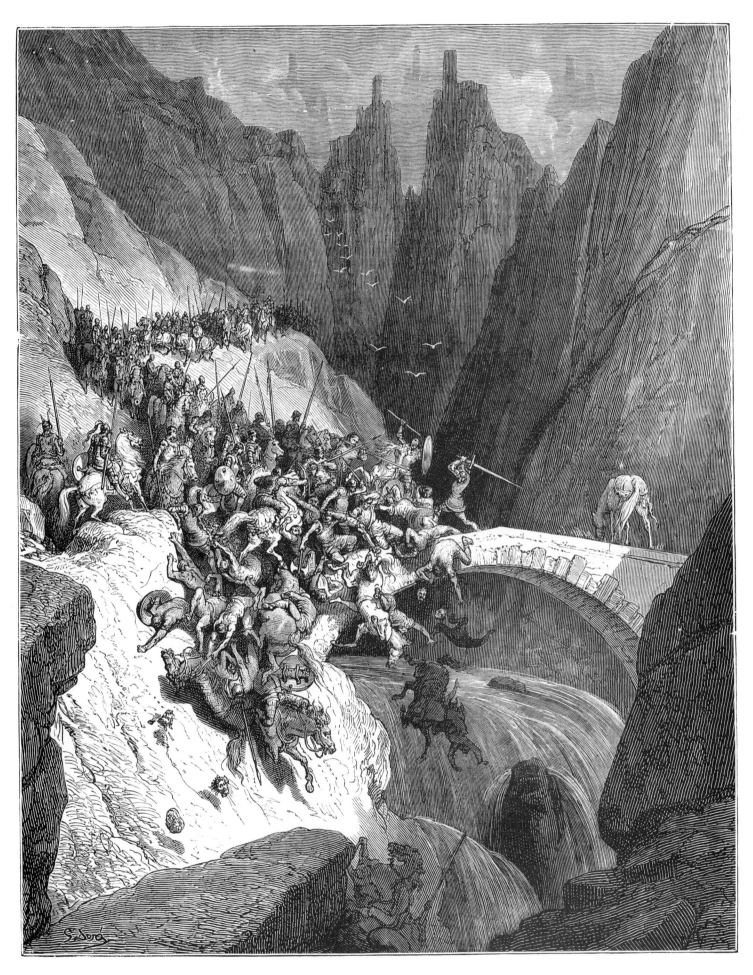

An exploit of Diego García de Paredes: singlehandedly holding a bridge
against an entire army (I, 32).

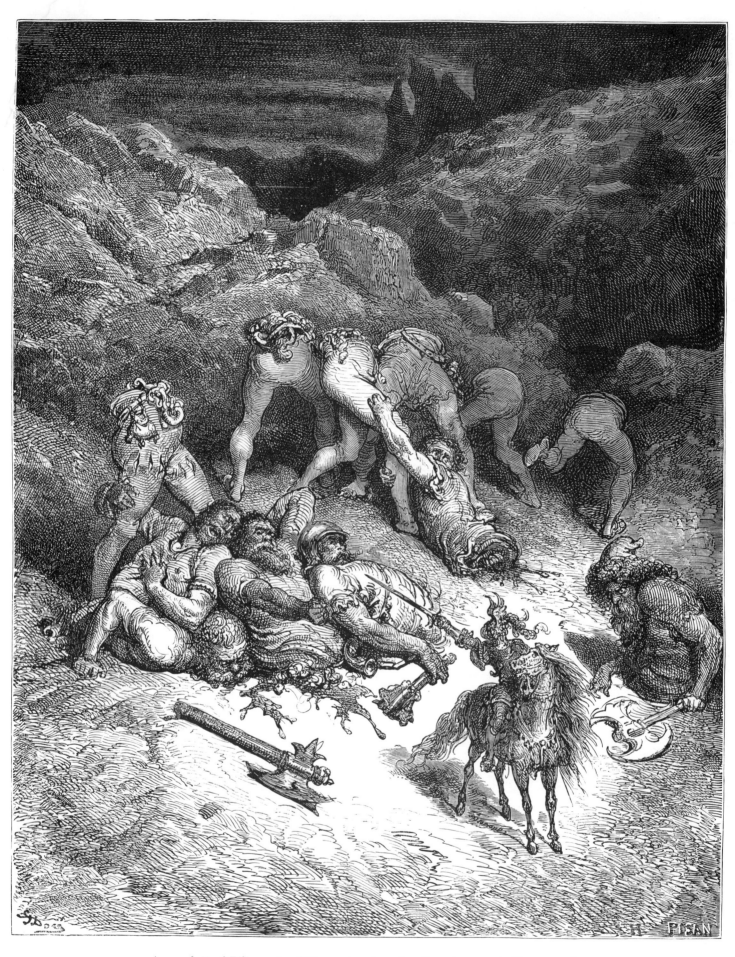

An exploit of Félixmarte of Hyrcania: chopping five giants in half at a single
stroke (I, 32).

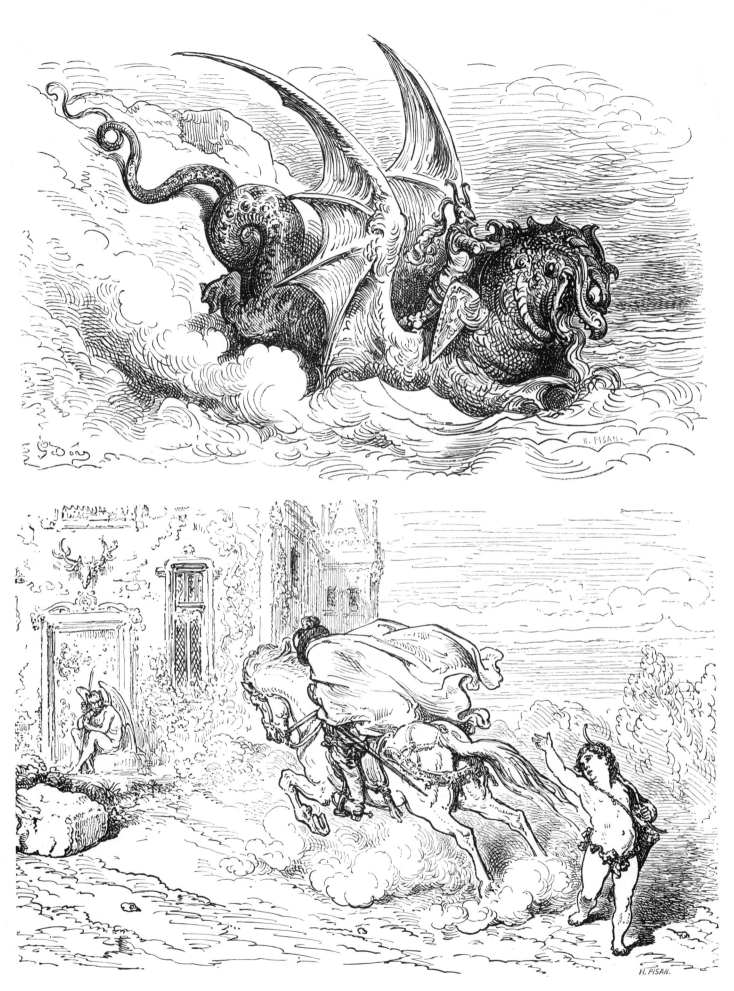

ABOVE: An exploit of Don Cirongilio of Thrace: riding a dragon (I, 32). BELOW:
In the story of the imprudently inquisitive man, Anselmo is tortured by doubts
concerning his wife's fidelity (I, 34).

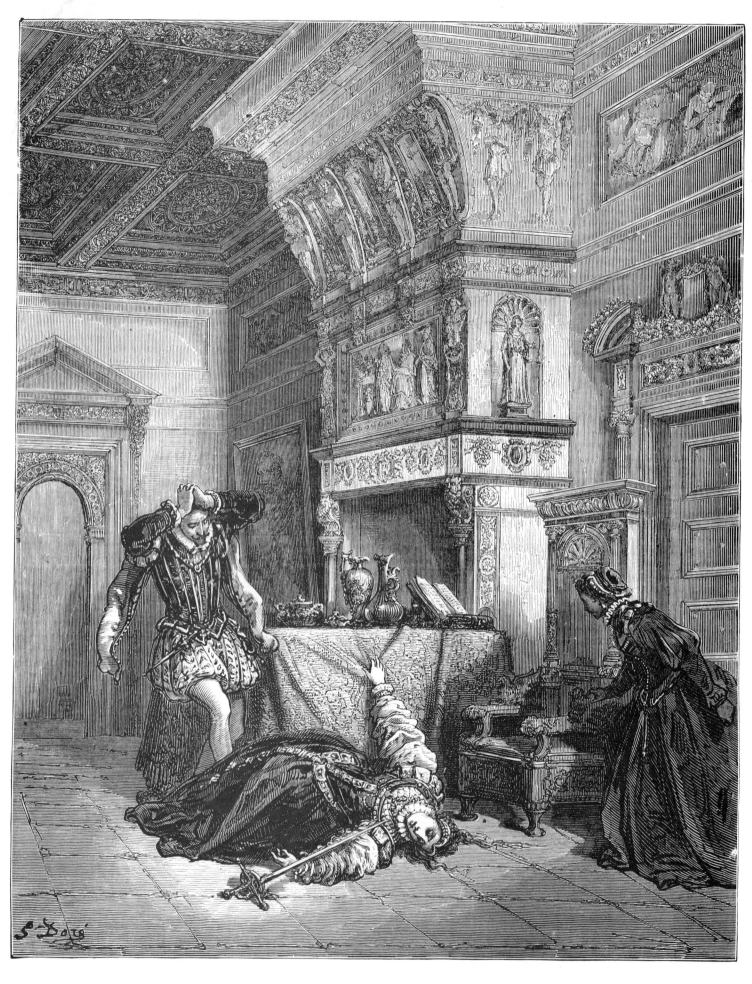

The unfaithful Camila, playing the role of a virtuous Lucretia, stabs herself
slightly and pretends to faint (I, 34).

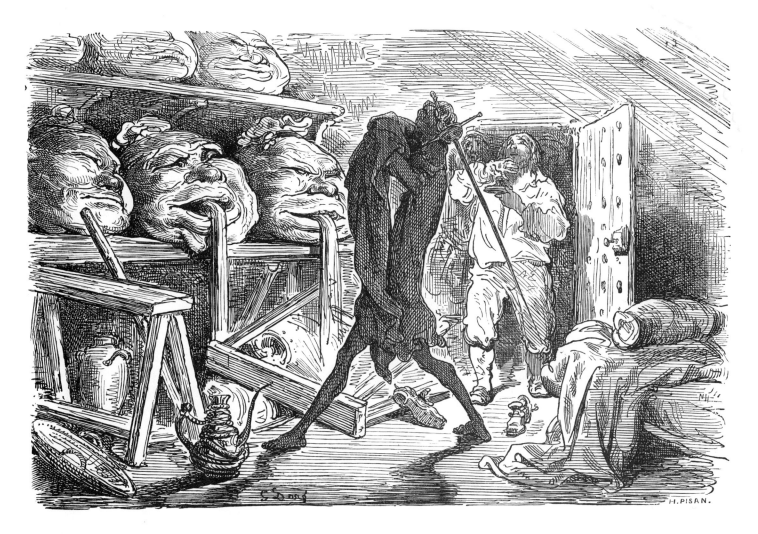

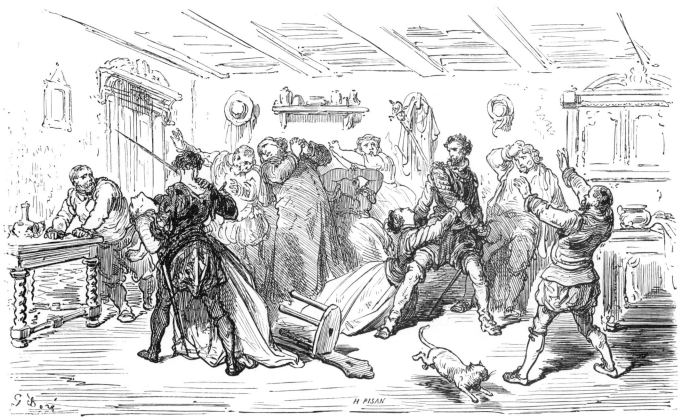

ABOVE: Don Quixote's assault on the wineskins in his sleep (I, 35). BELOW: the reunion of Dorotea, Luscinda, Cardenio and Fernando in the inn (I, 36).

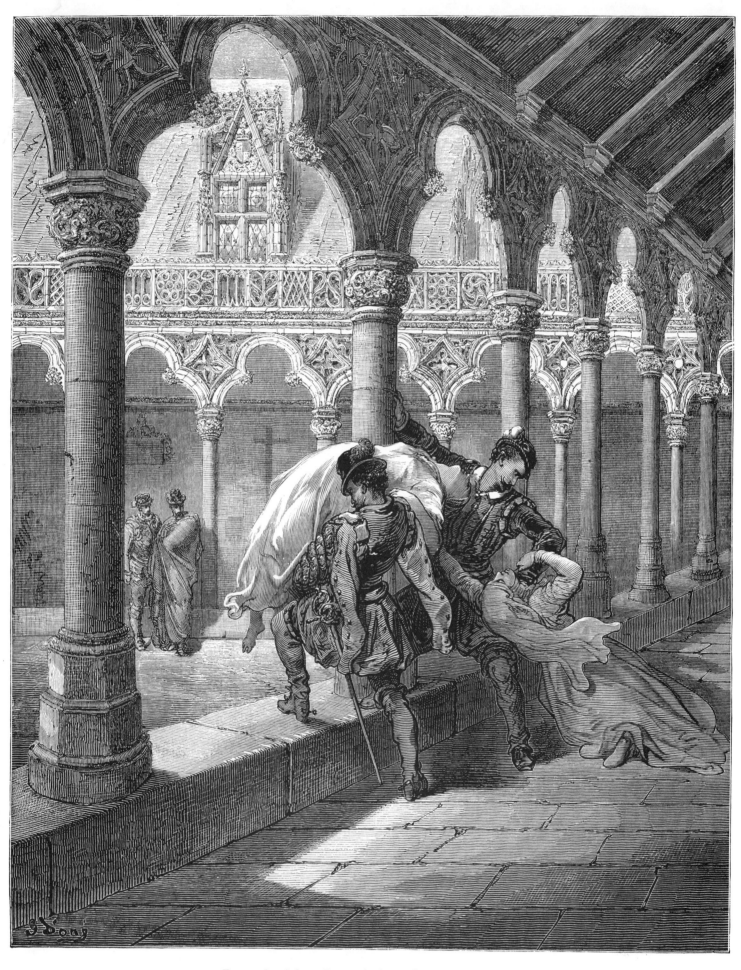

Fernando abducts Luscinda from the convent (I, 36).

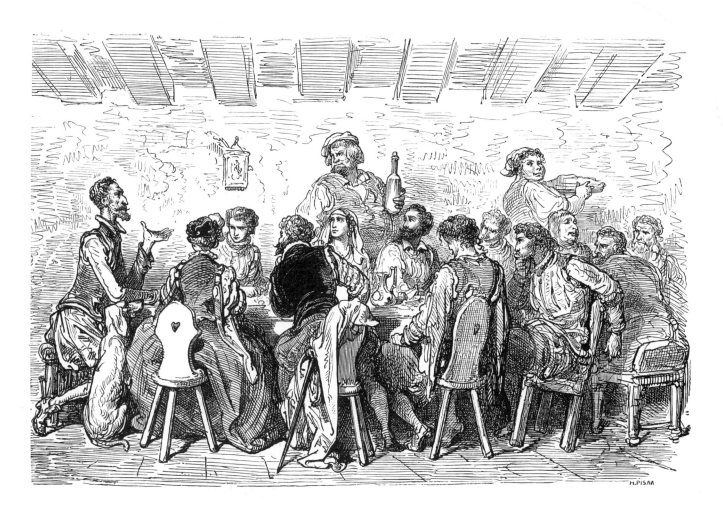

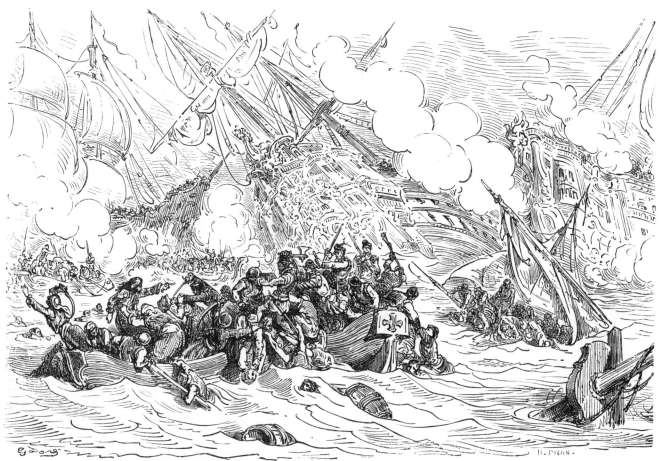

ABOVE: Don Quixote regales the party at the inn with theoretical reflections (I, 38). BELOW: In the captive's story, he recounts the great naval battle of Lepanto (I, 39).

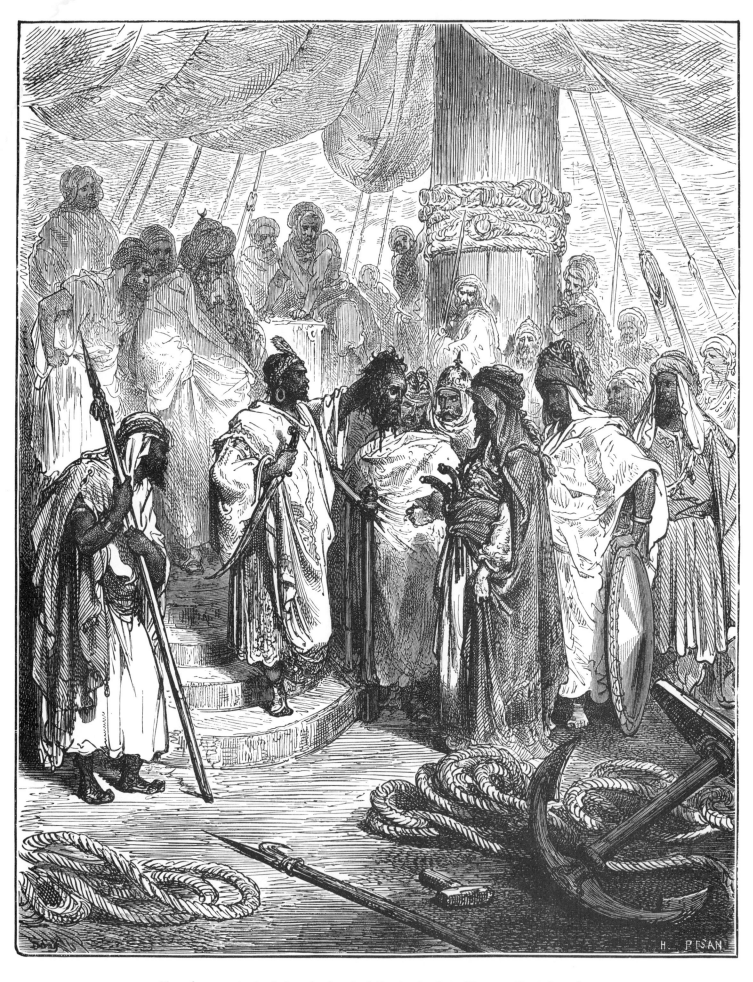

Treacherous Arabs bring the head of Pagán de Oria [Pagano Doria] to the
Turkish general (I, 39).

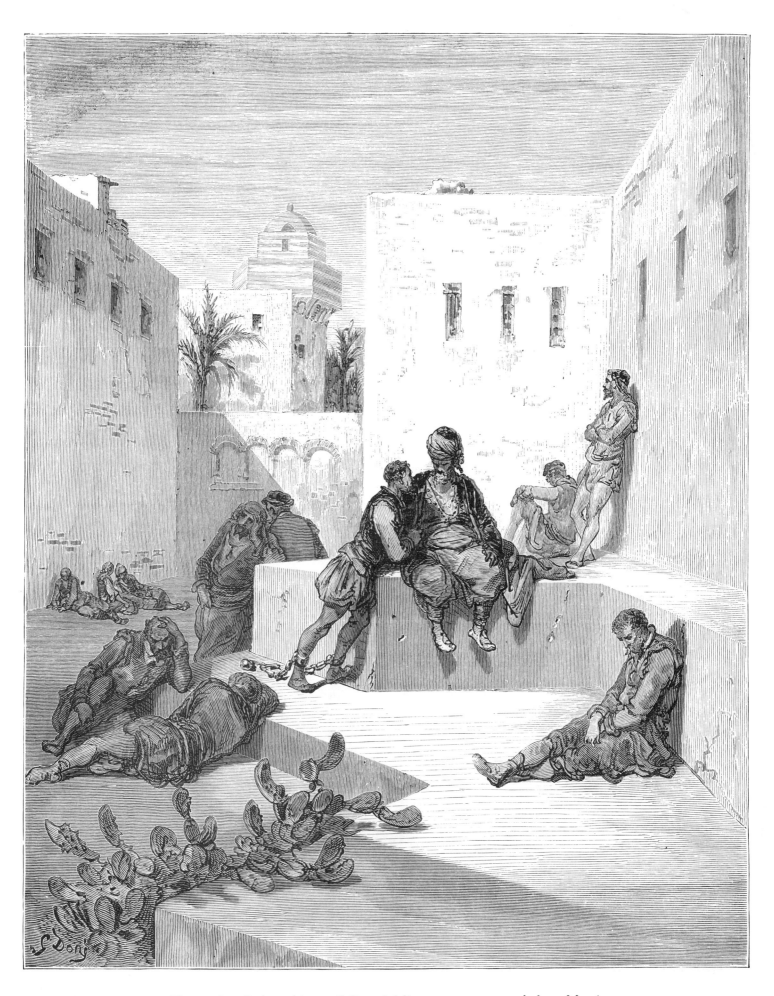

The captive discloses his possibility of deliverance to a renegade from Murcia
(I, 40).

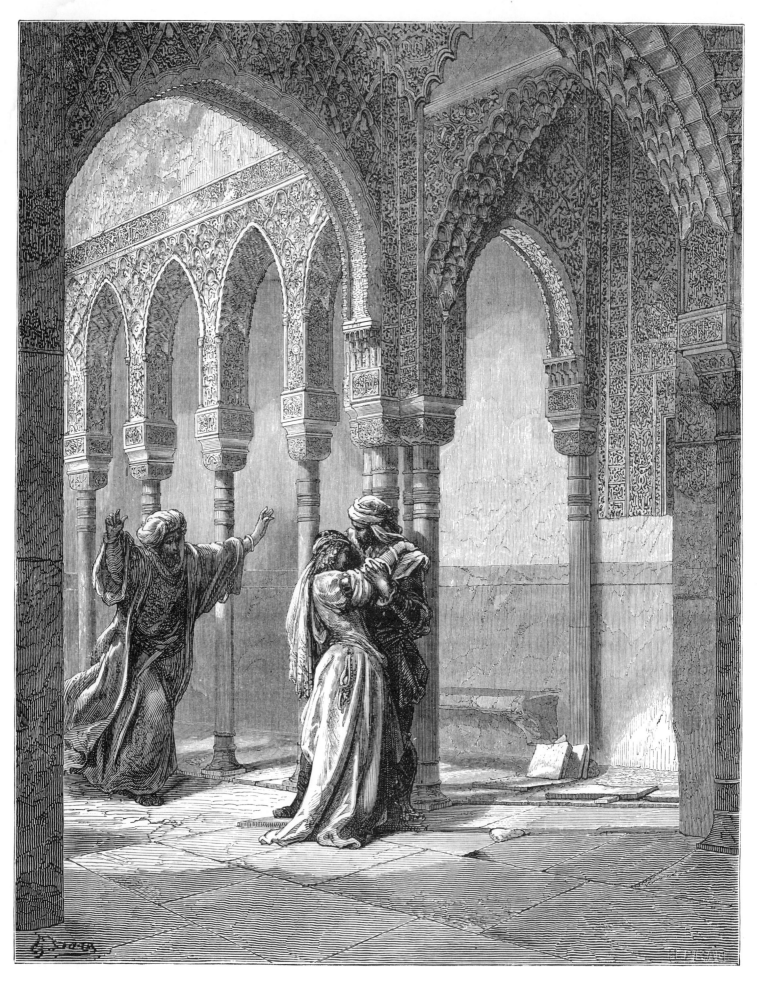

The father of Zoraida finds her in the captive's embrace (I, 40).

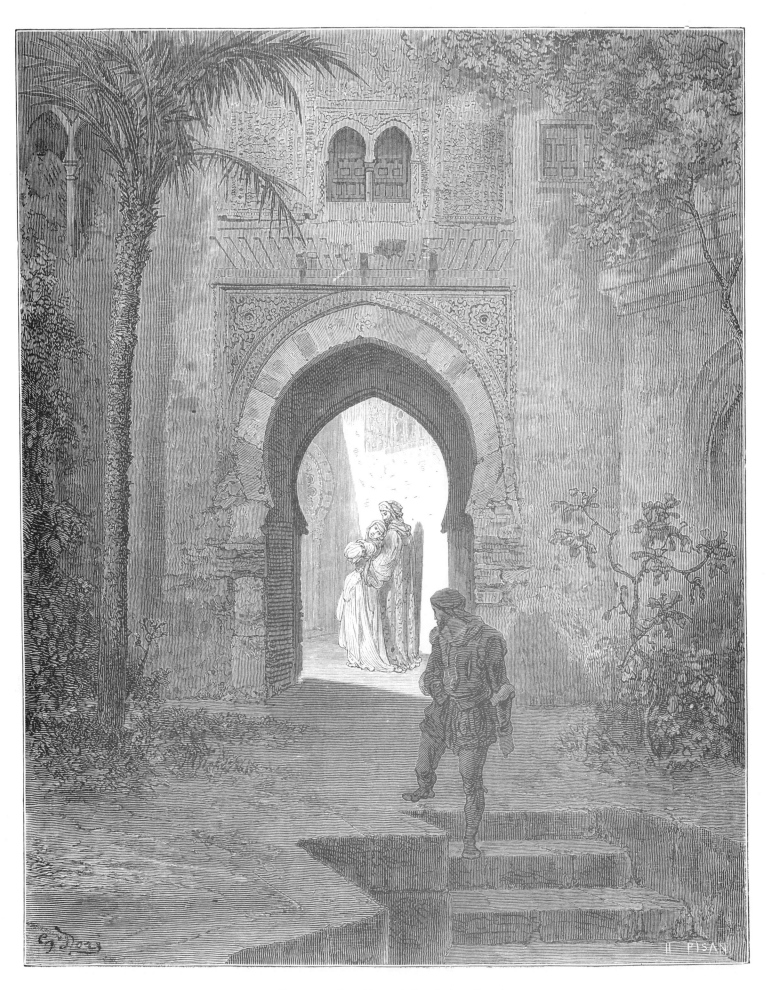

She goes off sadly with her father (I, 40).

Zoraida and the captive in the escape boat (I, 40).

Zoraida's father, put ashore, calls after her to rejoin him (I, 40).

61

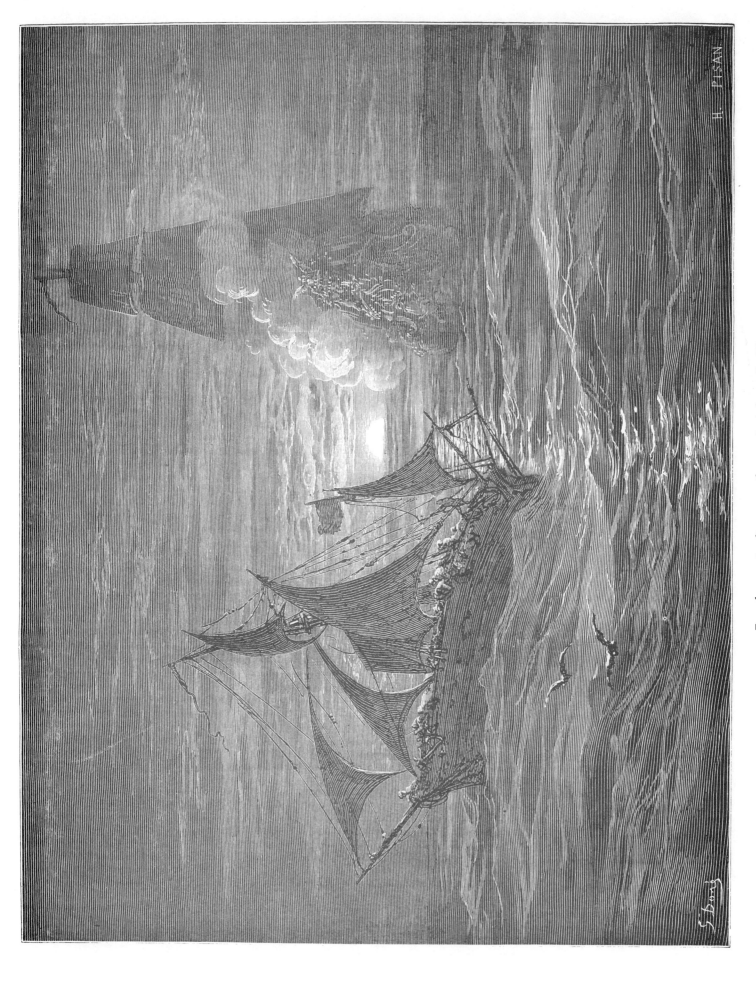

French corsairs fire upon the captive's boat (I, 40).

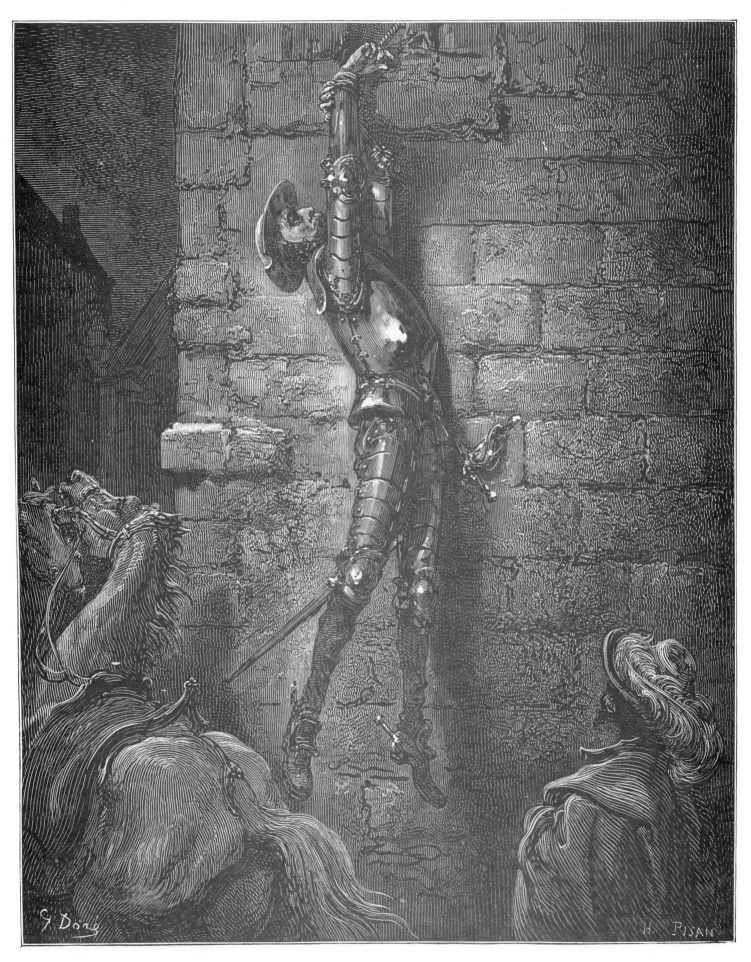

Maritornes leaves Don Quixote hanging from the window (I, 43).

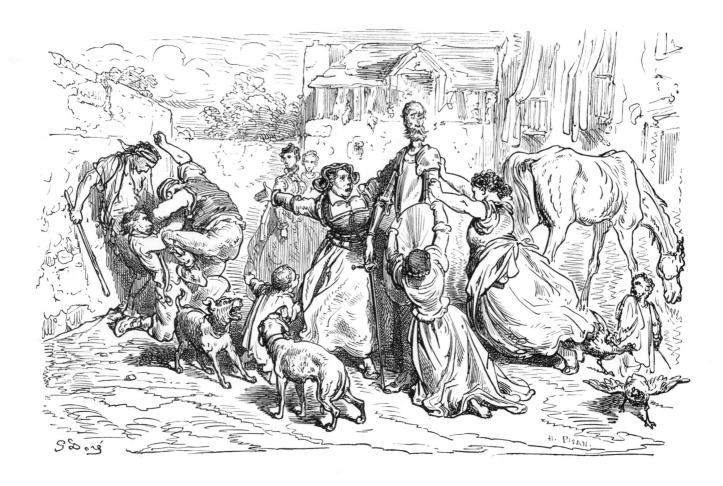

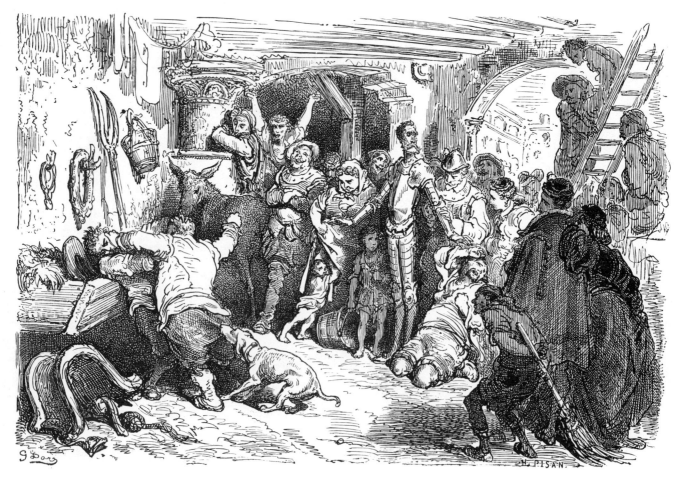

ABOVE: Don Quixote refuses to fight the common people belaboring the innkeeper (I, 44). BELOW: Sancho and the barber fight over the packsaddle (I, 45).

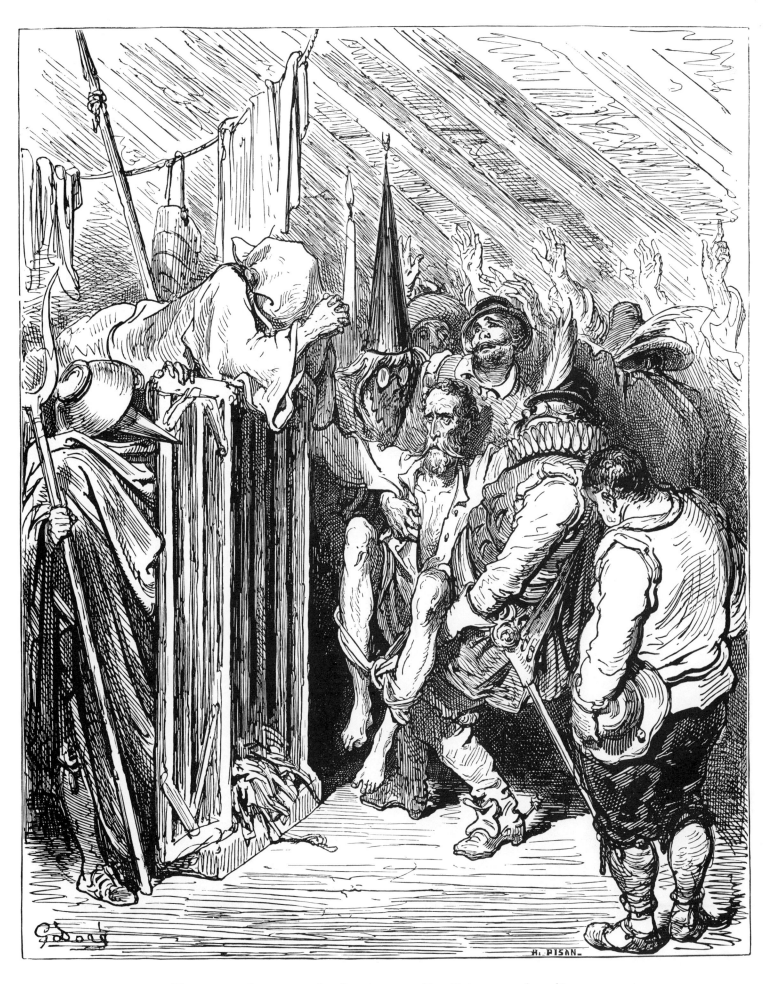

The party at the inn, wearing disguises, start Don Quixote on a forced journey
home (I, 46).

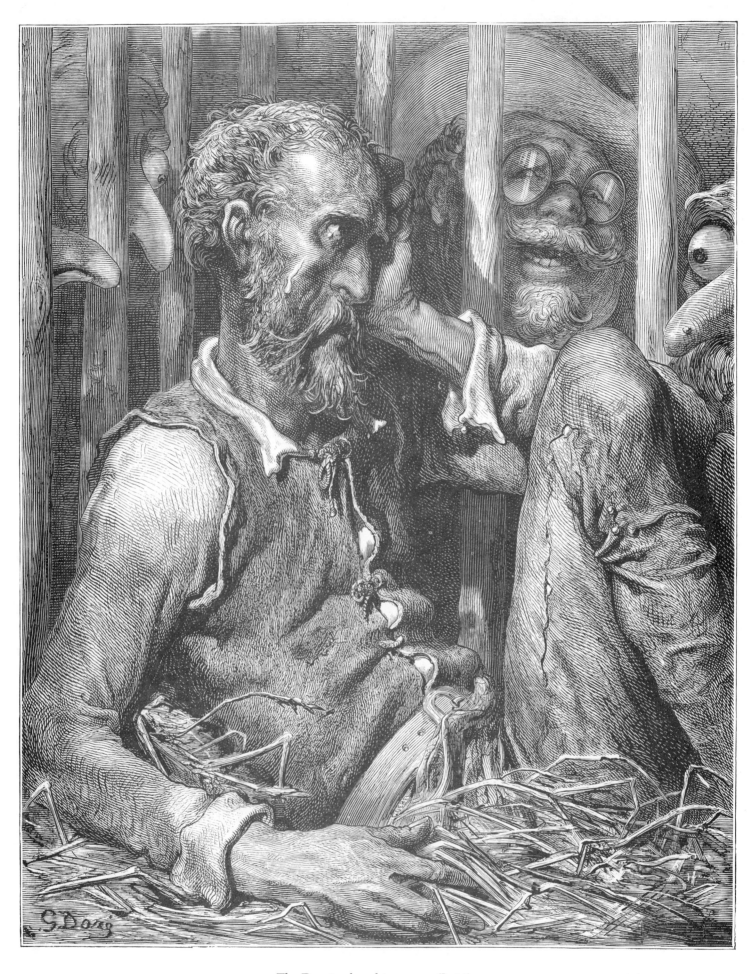

The Don is placed in a cage (I, 46).

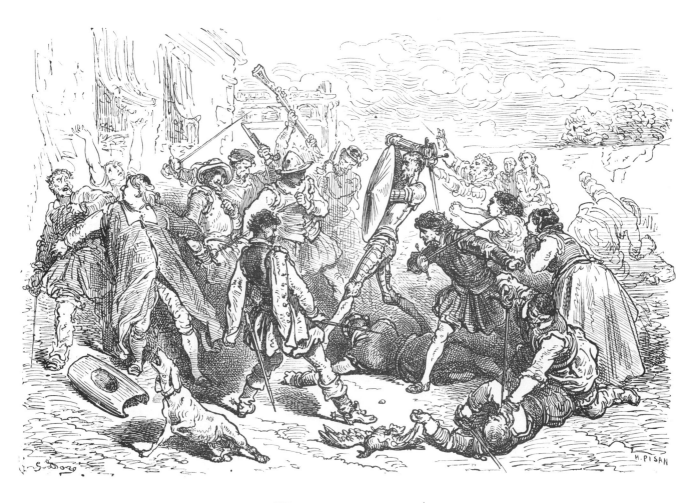

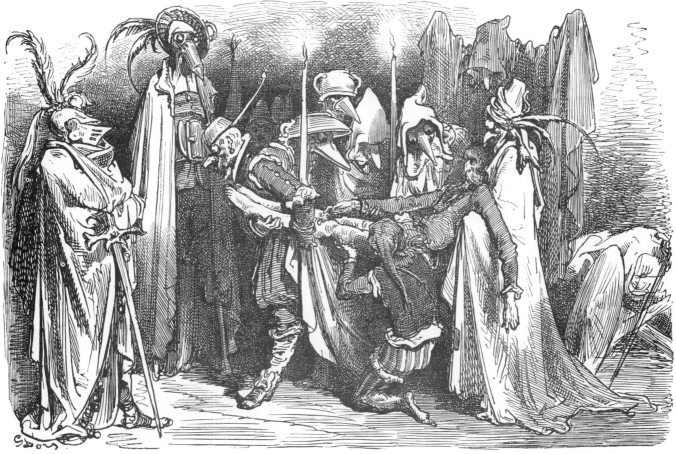

ABOVE: The brawling at the inn (I, 46). BELOW: The Don carried to his cage (I, 46).

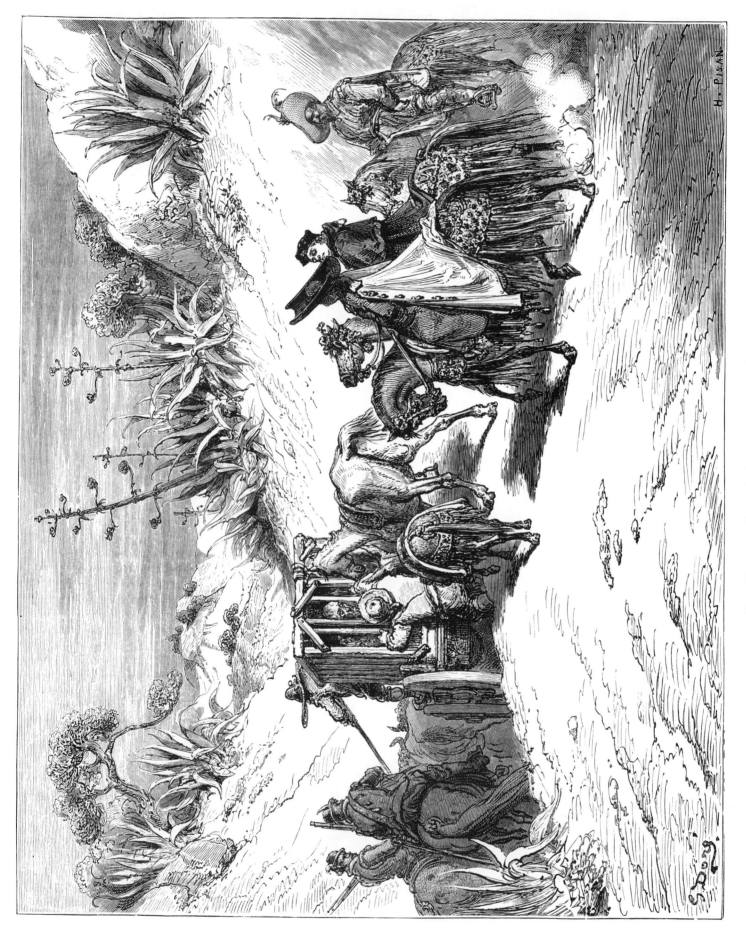

Don Quixote is brought home in a wagon (I, 47).

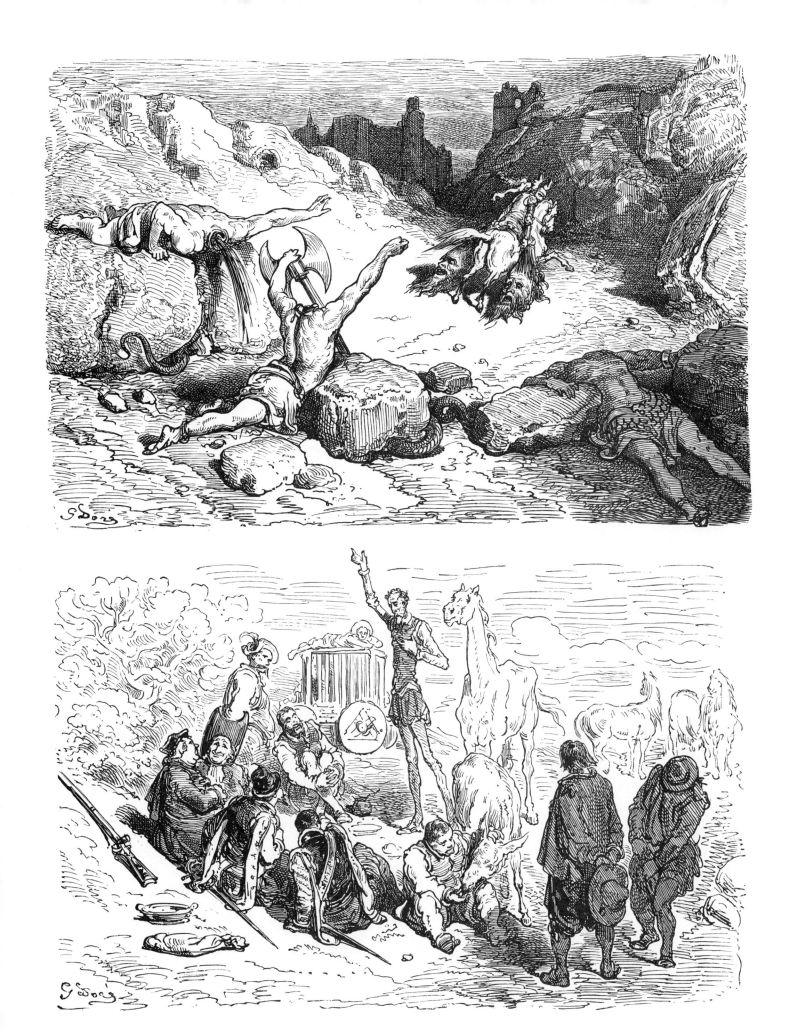

ABOVE: Don Quixote insists on the truthfulness of the knightly romances
(I, 49). BELOW: A defense of the books of chivalry (1, 50).

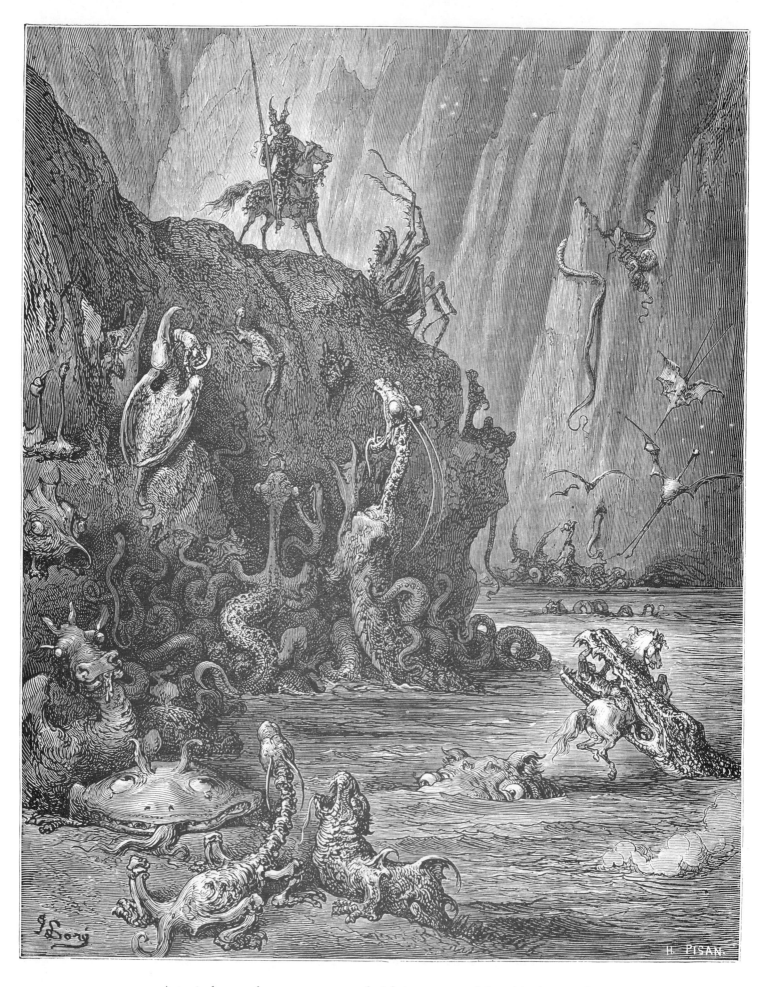

A typical scene from a romance: a knight comes to a lake of boiling pitch
inhabited by gruesome monsters (I, 50).

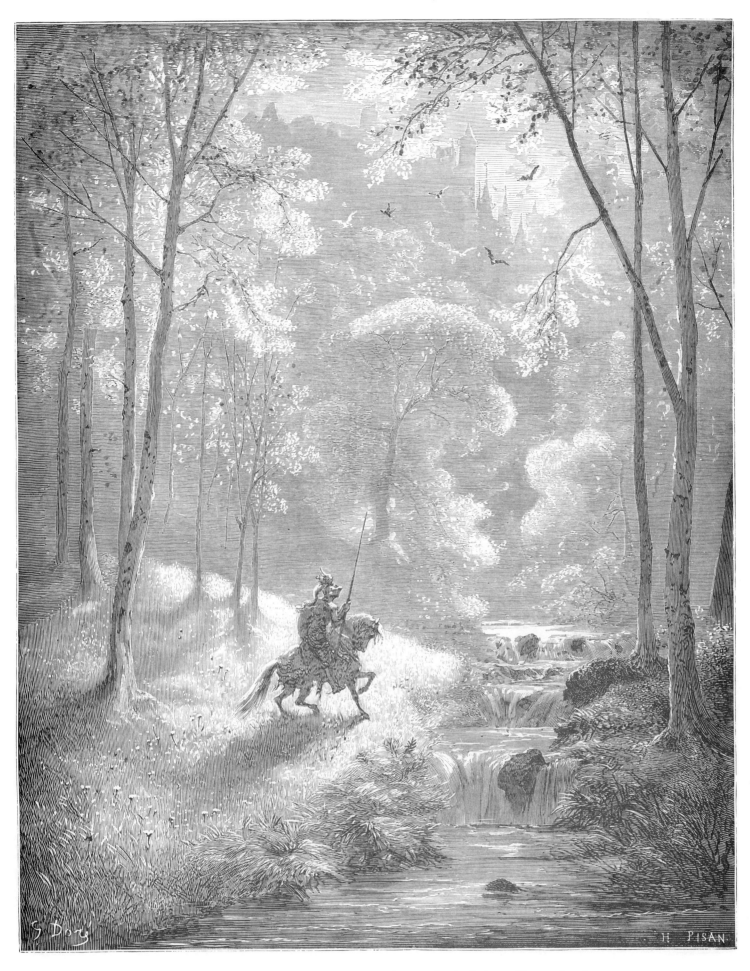

After plunging into the boiling lake, the knight finds himself in a lovely
countryside (I, 50).

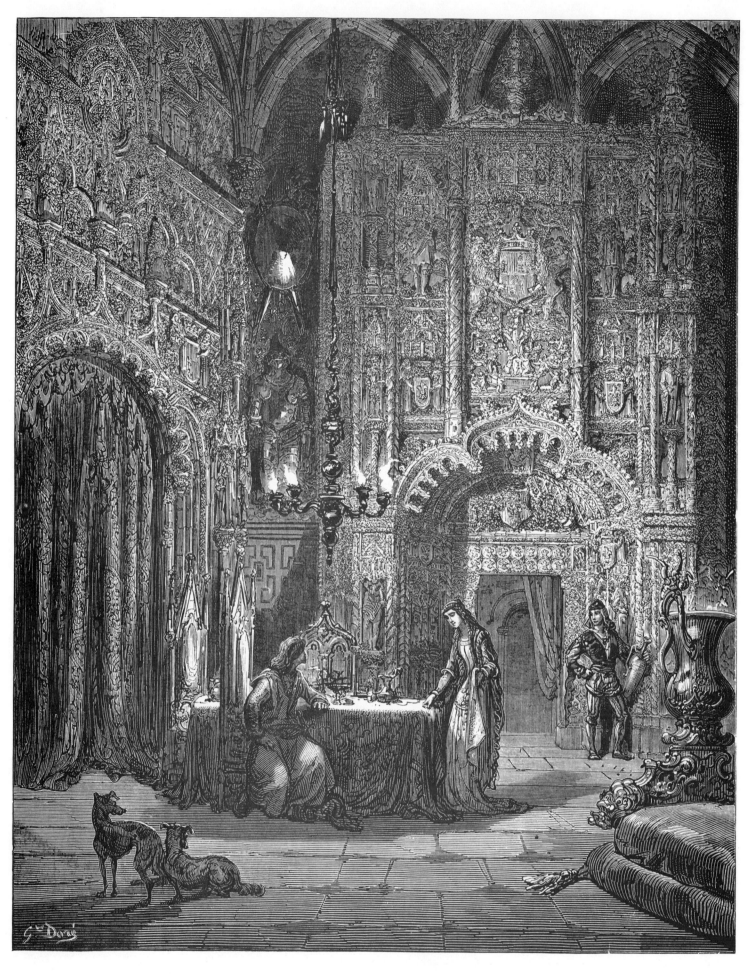

The knight arrives at a castle and hears the story of its enchantment (I, 50).

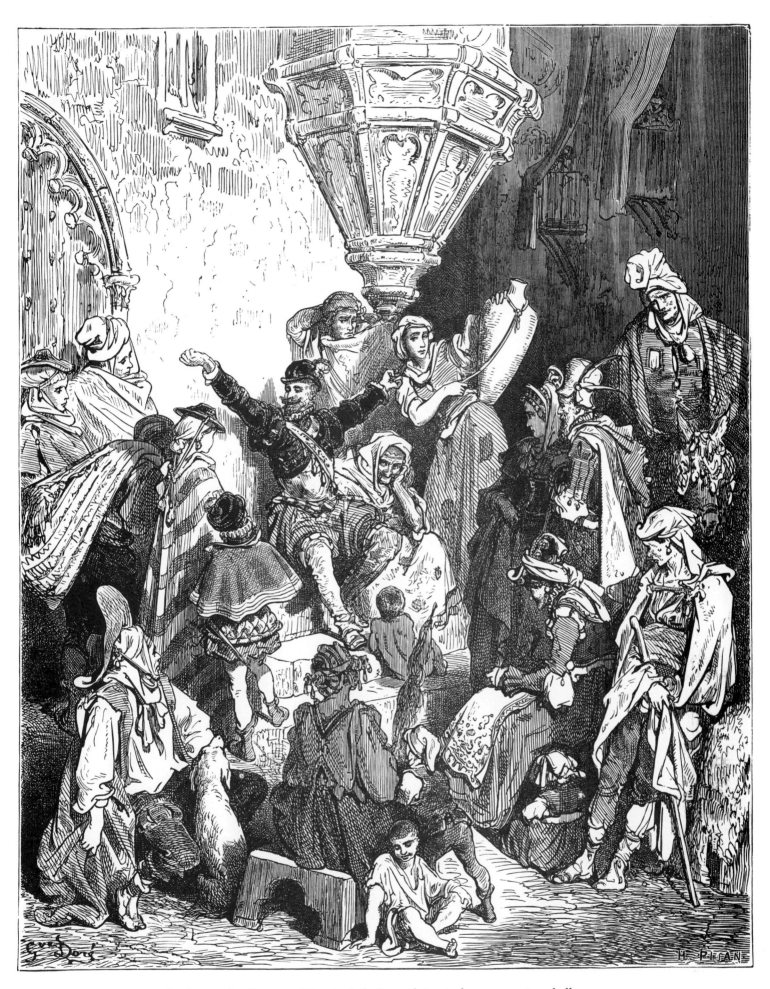

In the goatherd's story, Vicente de la Roca claims to have campaigned all over
the world (I, 51).

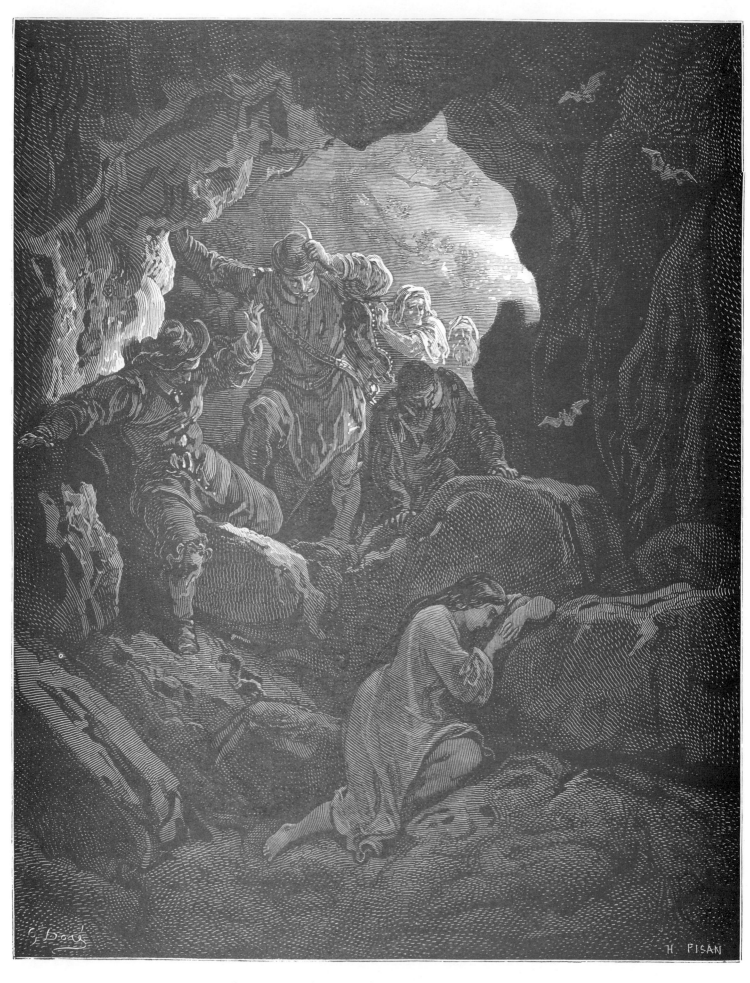

The runaway Leandra is discovered in a cave (I, 51).

Only Sancho is alarmed when the goatherd pummels Don Quixote (I, 52).

Don Quixote comes off badly in his attack on the white penitents (I, 52).

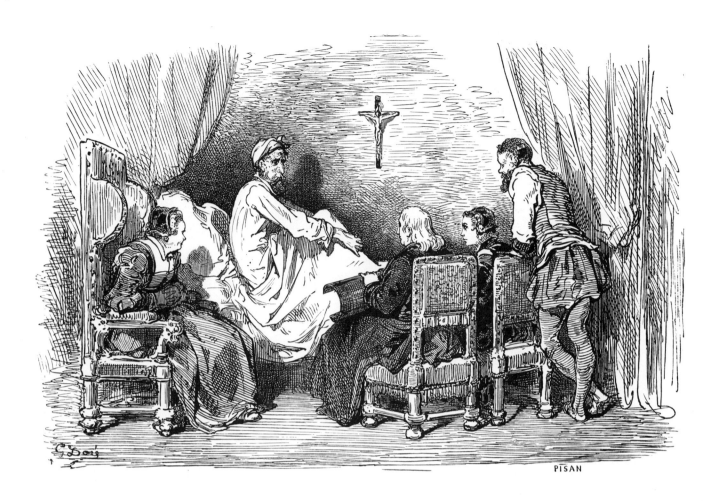

PISAN

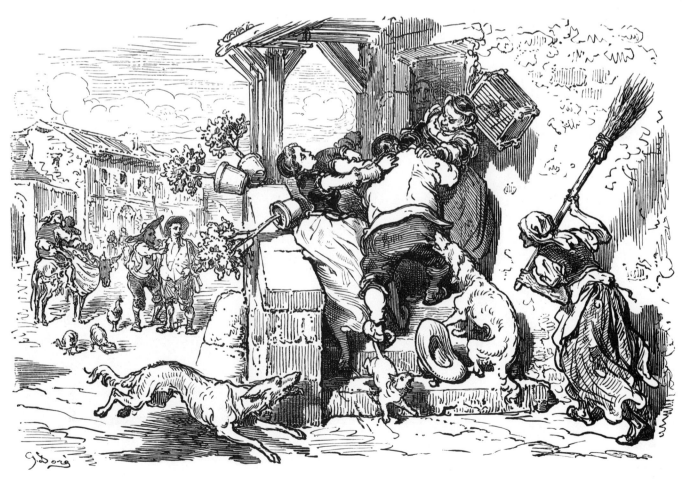

ABOVE: Back home, Don Quixote talks sensibly with his family and friends (II, 1). BELOW: The Don's niece and housekeeper prevent Sancho from entering (II, 2).

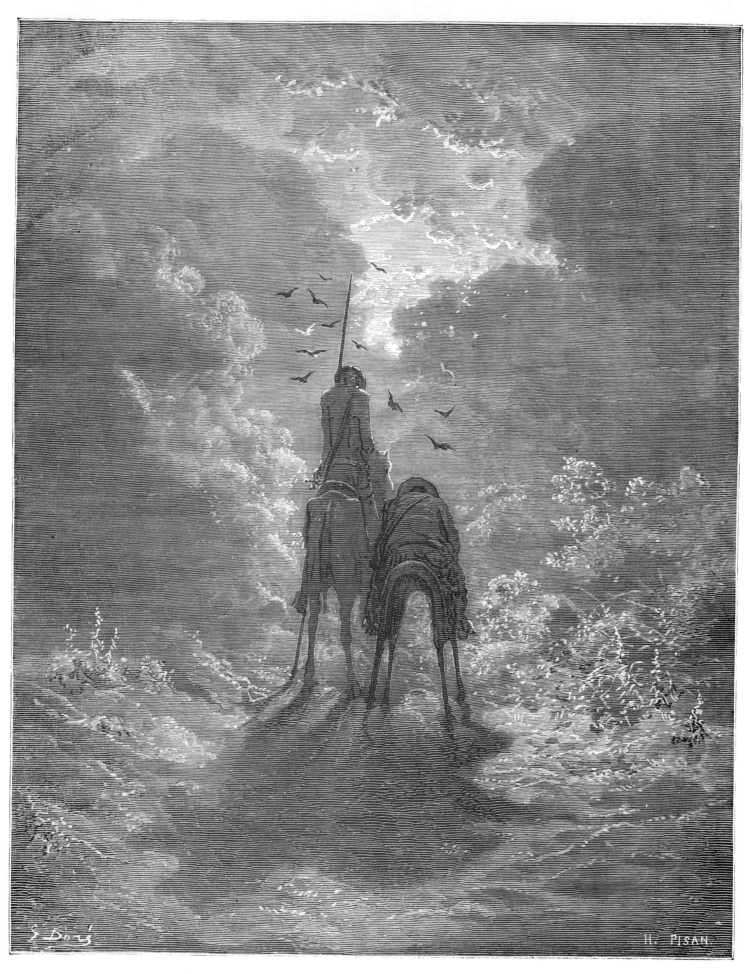

Sancho tells how his donkey was stolen from under him in the Sierra Morena
(II, 4).

The knight and his squire on the road again (II, 8).

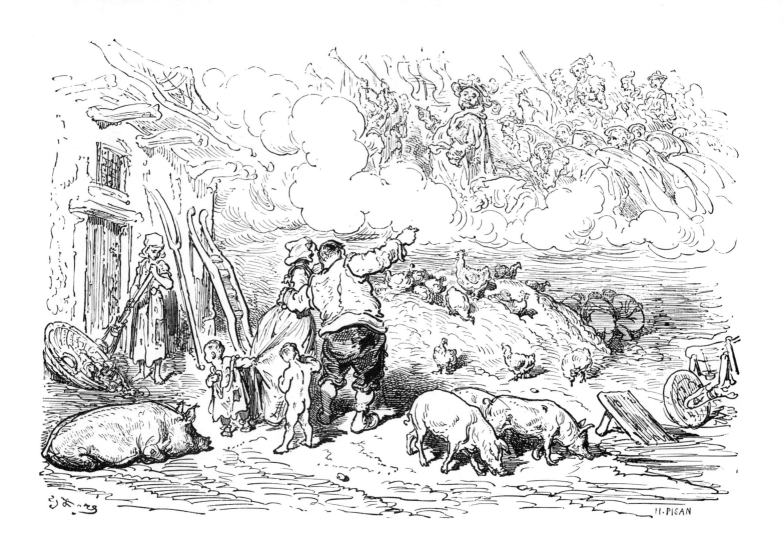

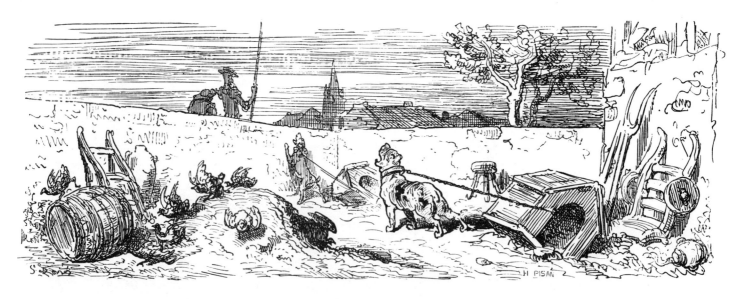

ABOVE: Sancho persuades his wife that glory awaits him with Don Quixote (II, 5). BELOW: The Don and Sancho enter the village of Toboso (II, 9).

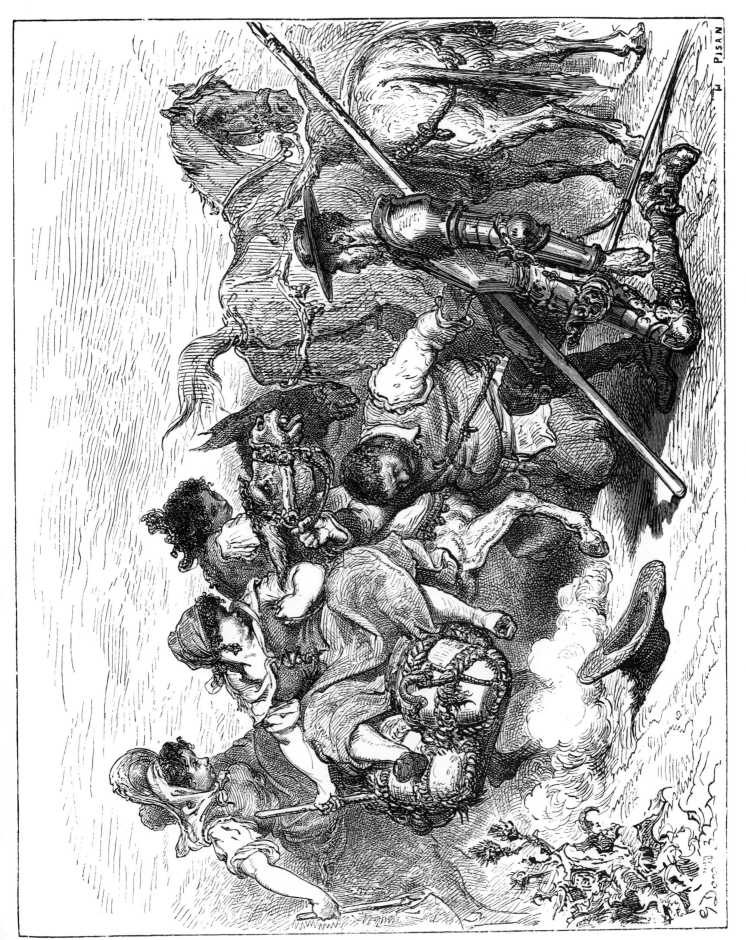

Sancho convinces Don Quixote that the three peasant women are Dulcinea and two of her attendants in a state of enchantment (II, 10).

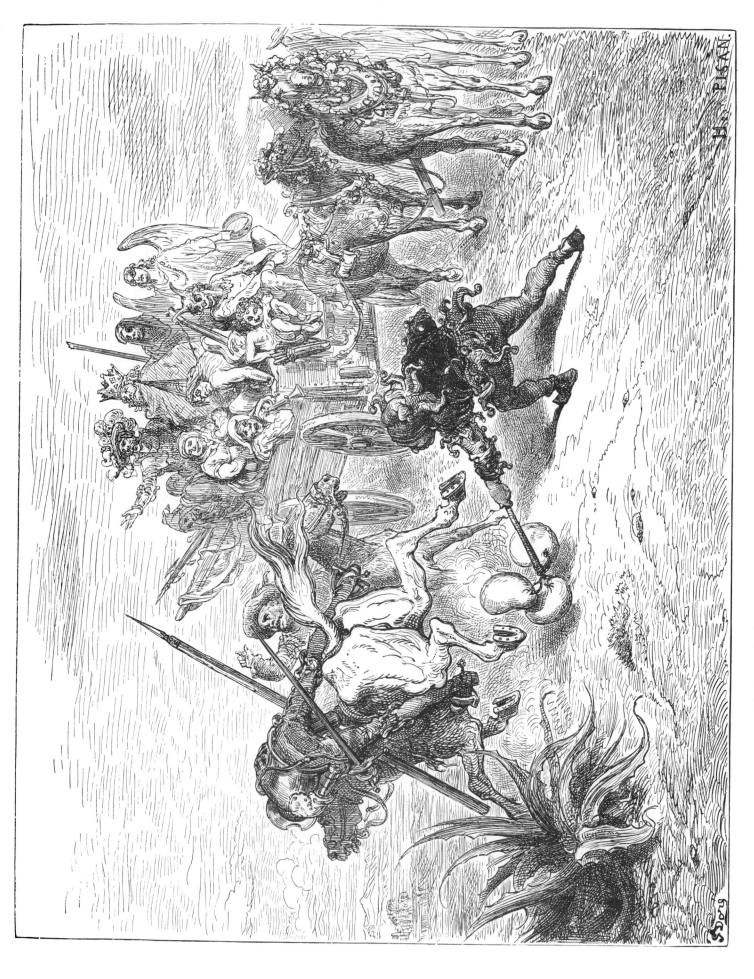

The jester frightens Don Quixote's steed Rocinante with his bladders (II, 11).

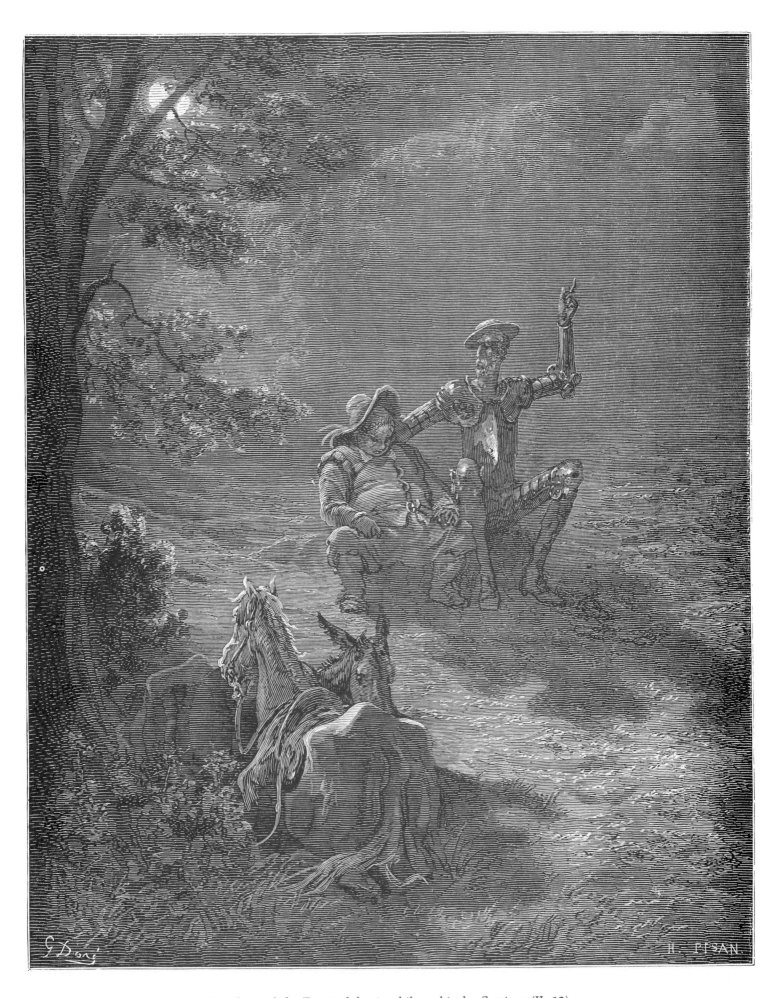

Sancho and the Don indulge in philosophical reflections (II, 12).

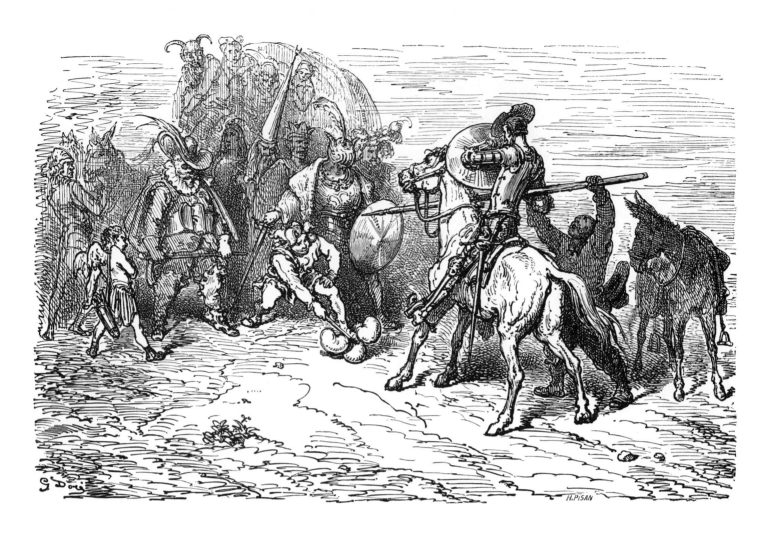

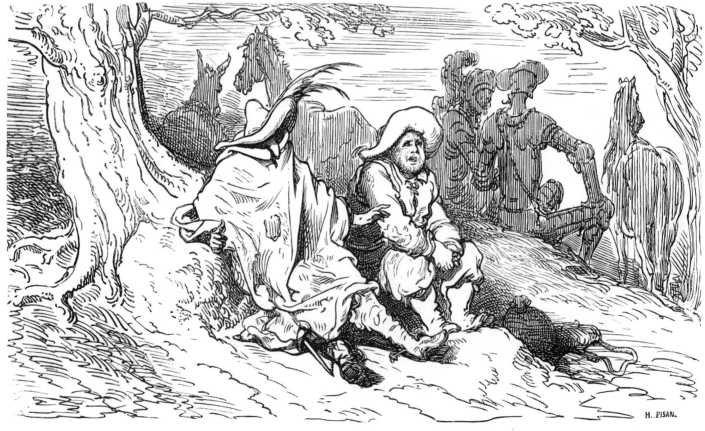

ABOVE: Don Quixote meets the costumed village actors (II, 11). BELOW: Don Quixote converses with the Knight of the Woods (or of the Mirrors) while their two squires chat (II, 13).

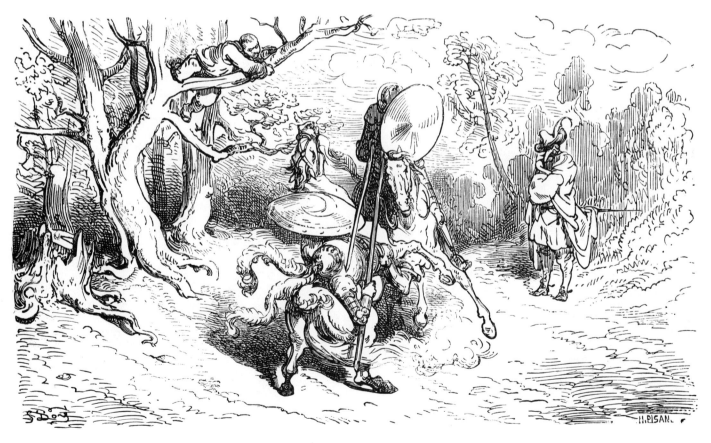

ABOVE: The ugly squire of the Knight of the Woods (II, 14). BELOW: The battle betweeen that knight and the Don (II, 14).

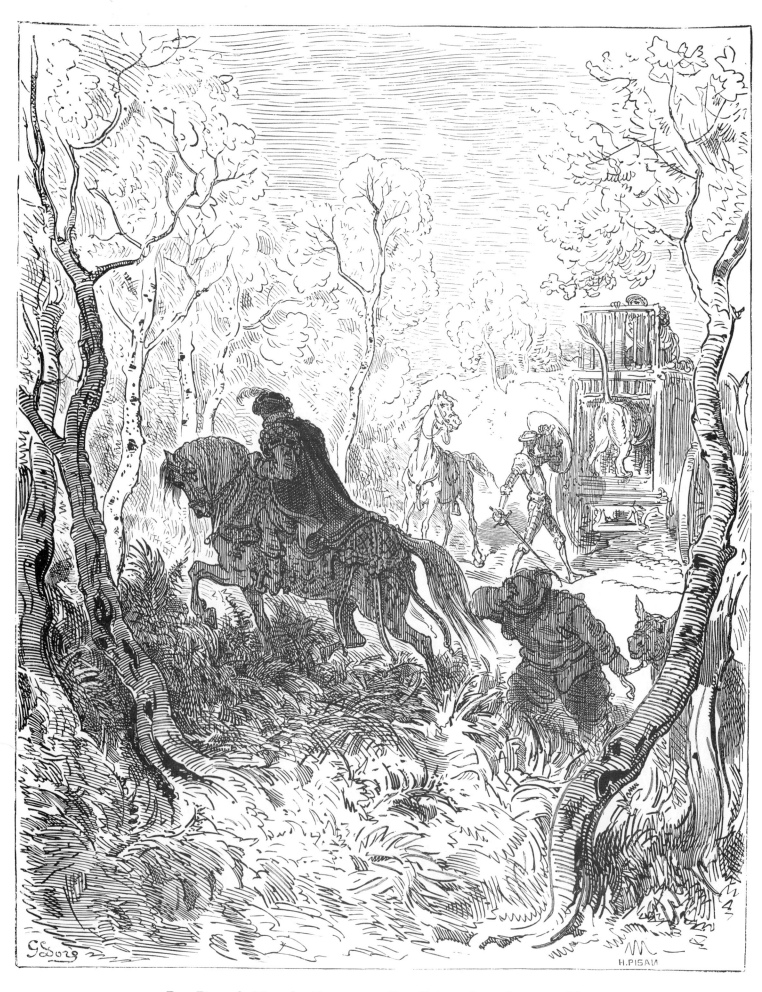

Don Diego de Miranda rides away as Don Quixote faces the uncaged lion
(II, 17).

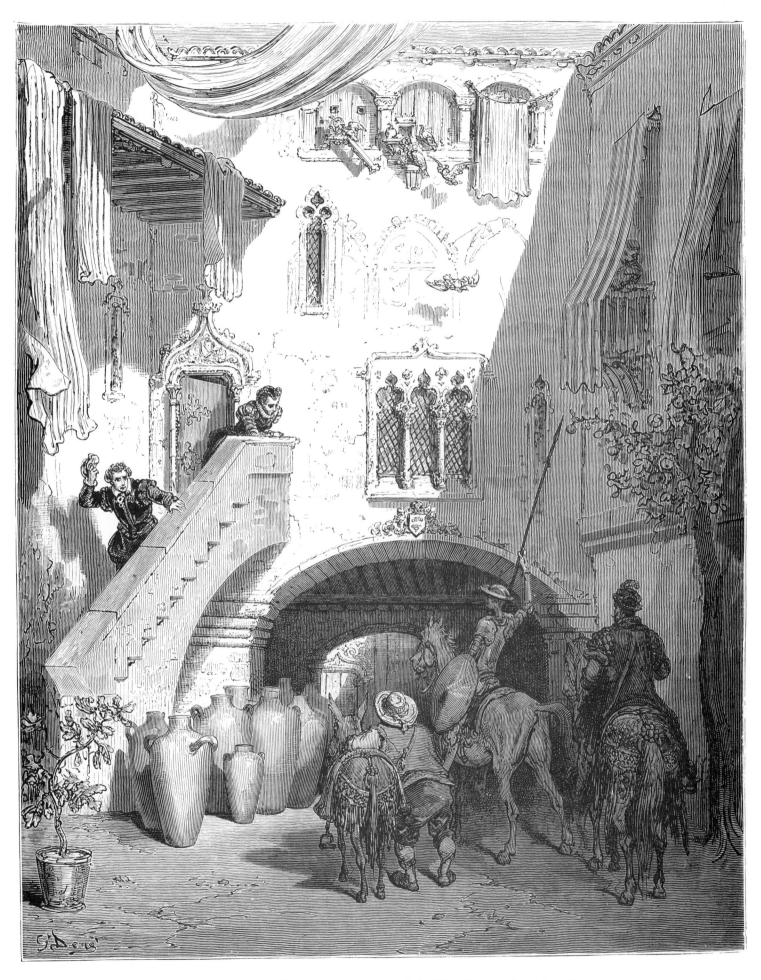

Visiting Don Diego, Don Quixote is reminded of Dulcinea at the sight of jars
made in Toboso (II, 18).

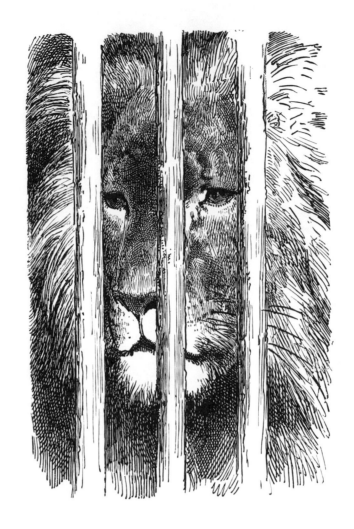

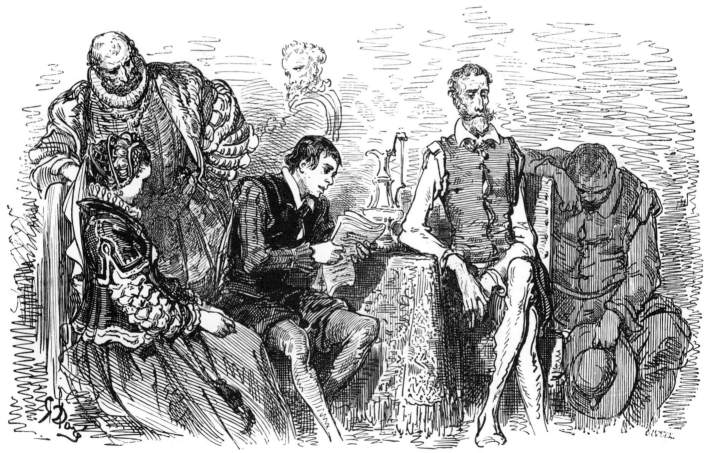

ABOVE: The lion (II, 17). BELOW: Don Diego's student son reads his poetry
(II, 18).

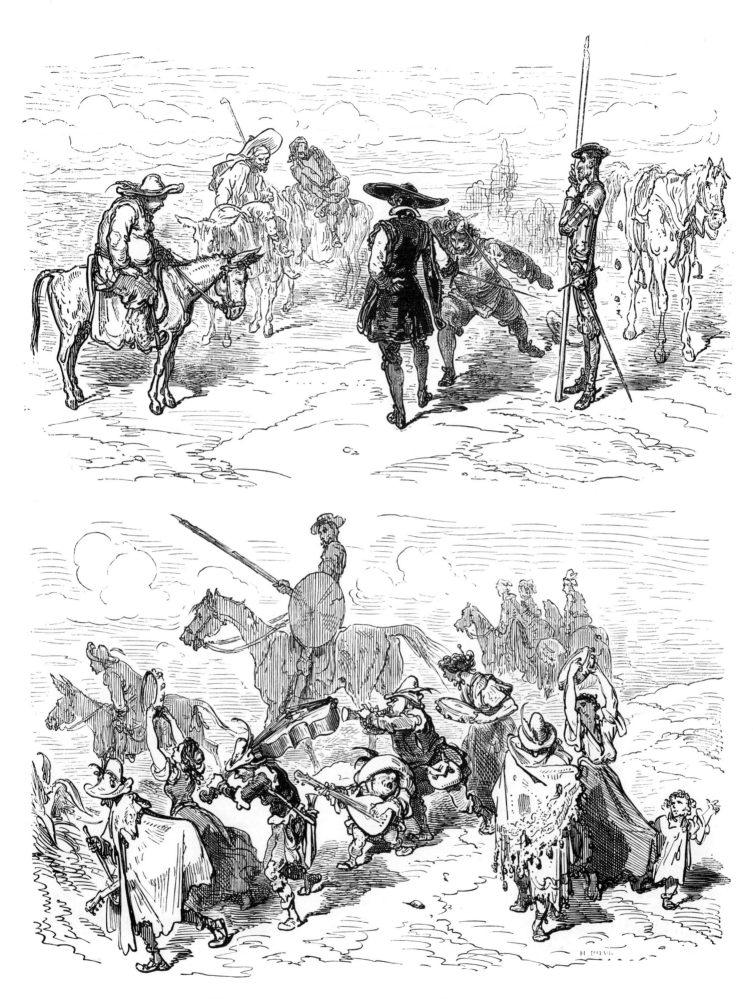

ABOVE: The fencing match of the two students (II, 19). BELOW: Musicians on their way to Camacho's wedding (II, 20).

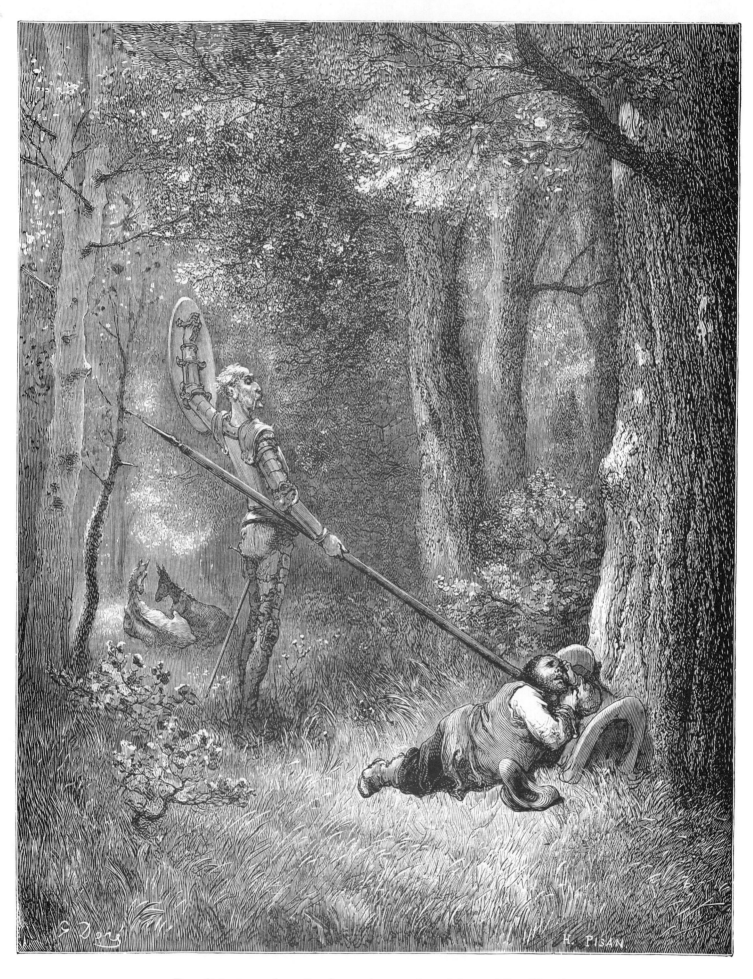

Don Quixote awakens Sancho on the morning of the wedding (II, 20).

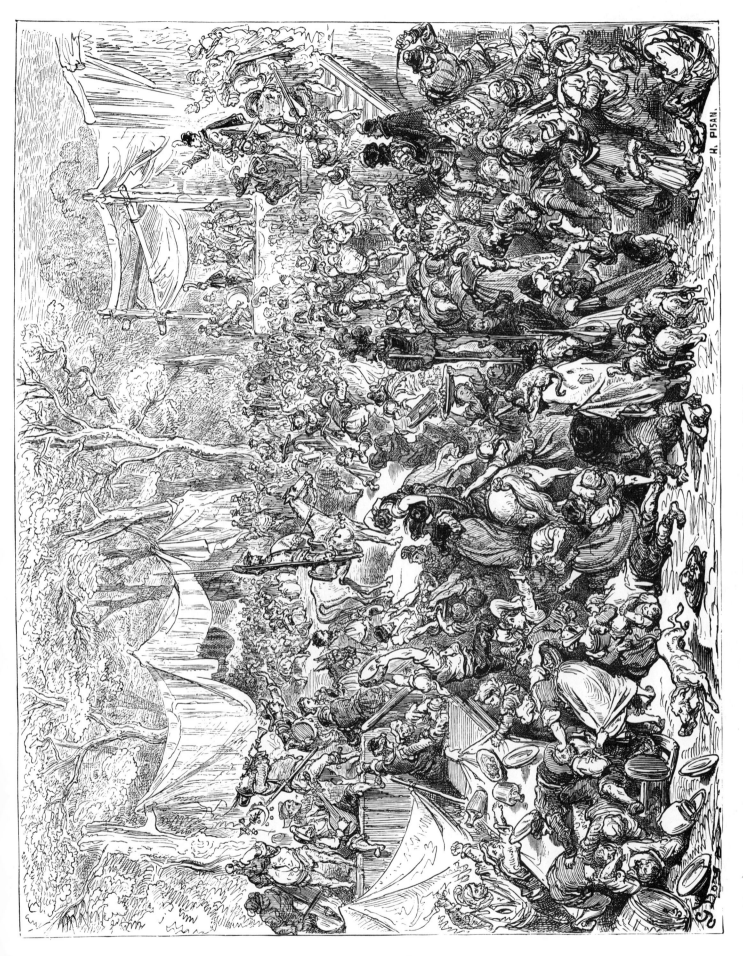

The wedding celebration (II, 20).

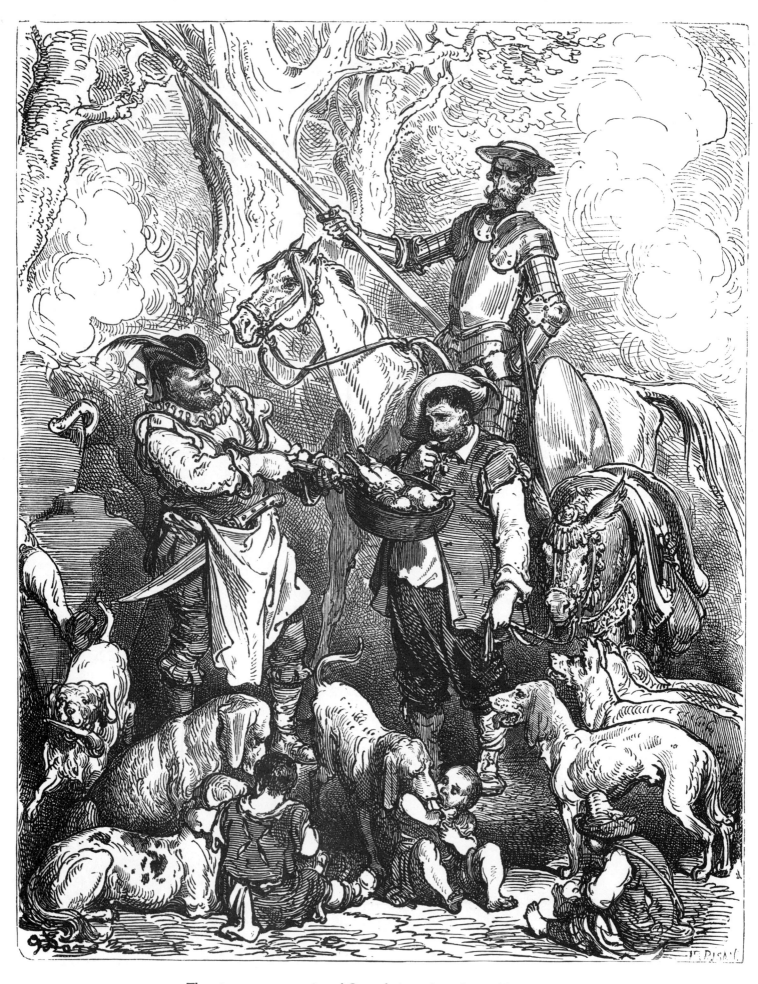

The enormous generosity of Camacho's cook at the wedding (II, 20).

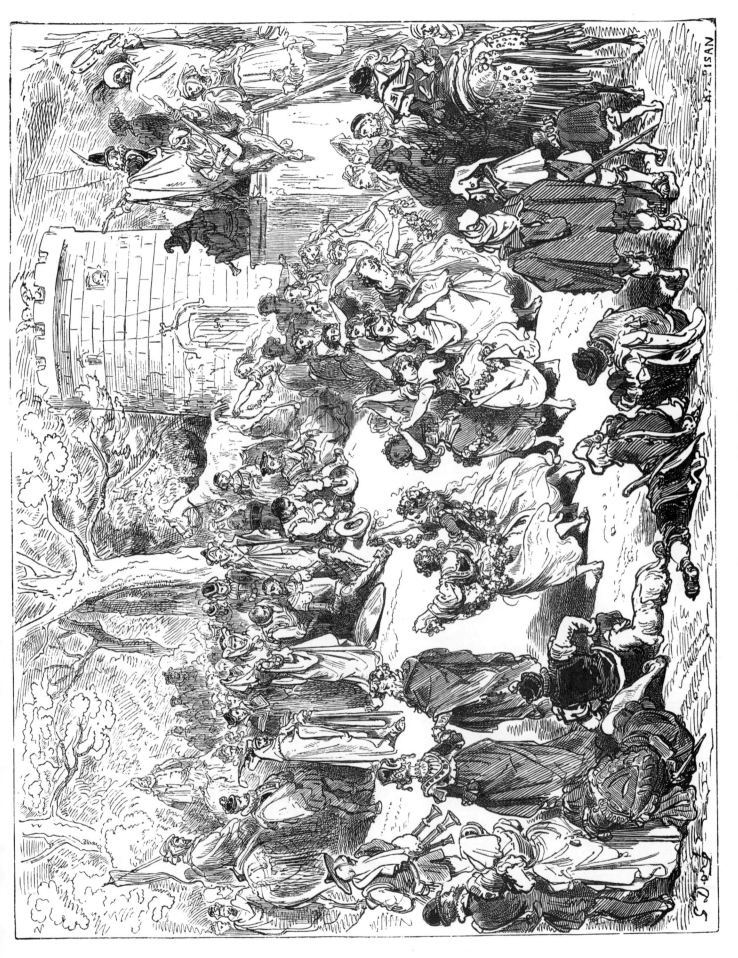

Dancers at the wedding (II, 20).

Quiteria, Camacho's bride, marries his apparently dying rival Basilio (II, 21).

Camacho orders the festivities to continue all the same (II, 21).

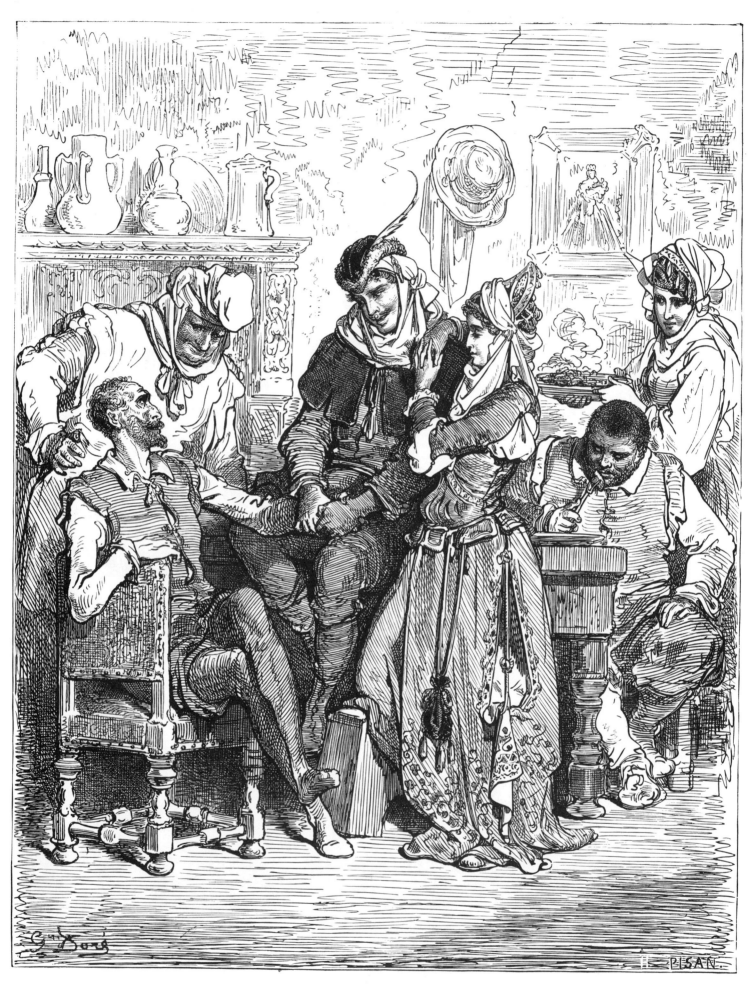

Sancho and the Don are entertained by the newlyweds (II, 22).

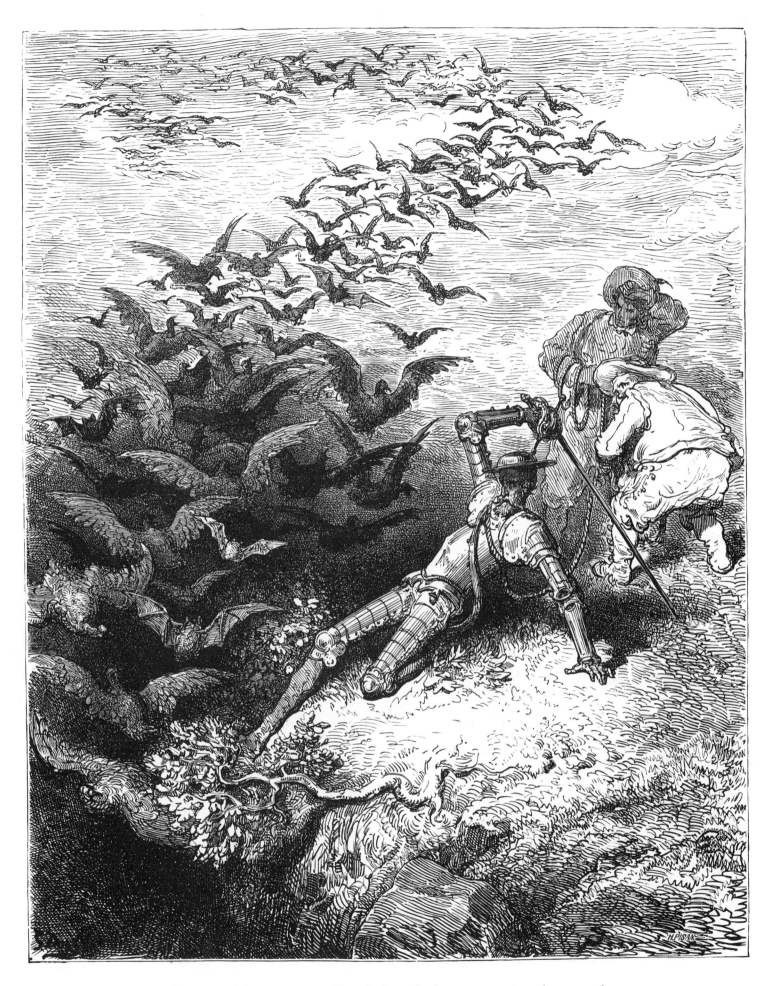

Ravens and bats swarm as Don Quixote hacks a passage into the cave of Montesinos (II, 22).

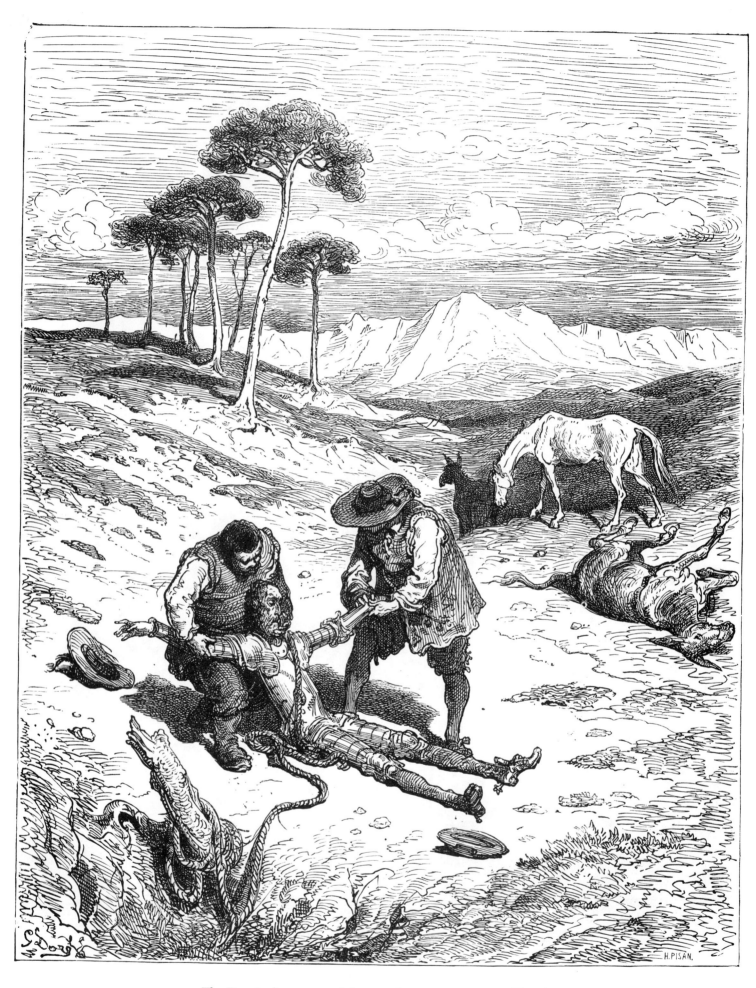

The Don is drawn out of the cave in a comatose state (II, 22).

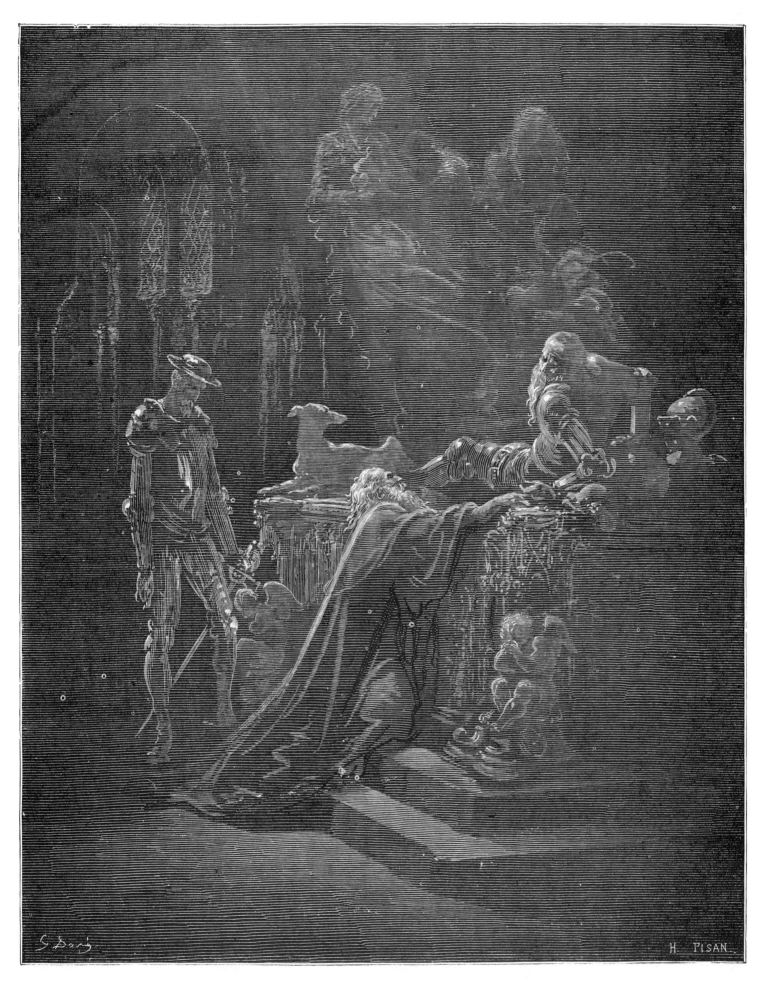

In the cave he saw the aged Montesinos converse with the dead warrior
Durandarte (II, 23).

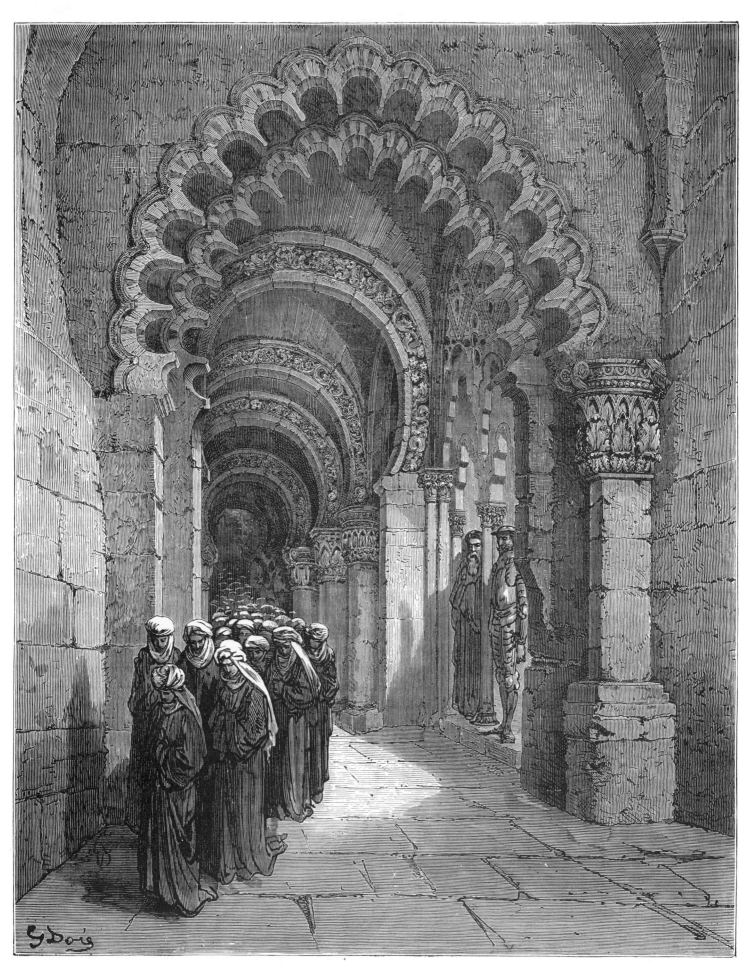

Montesinos showed him a procession of servants of Durandarte and Belerma
(II, 23).

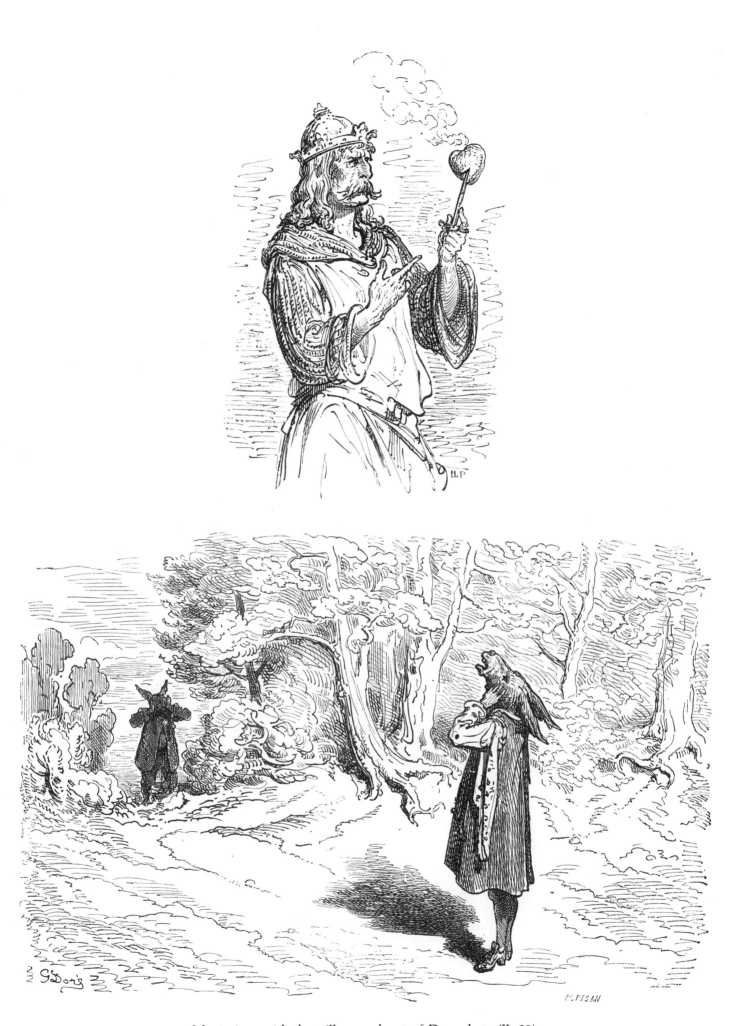

ABOVE: Montesinos with the still warm heart of Durandarte (II, 23). BELOW:
The aldermen braying after the lost donkey (II, 25).

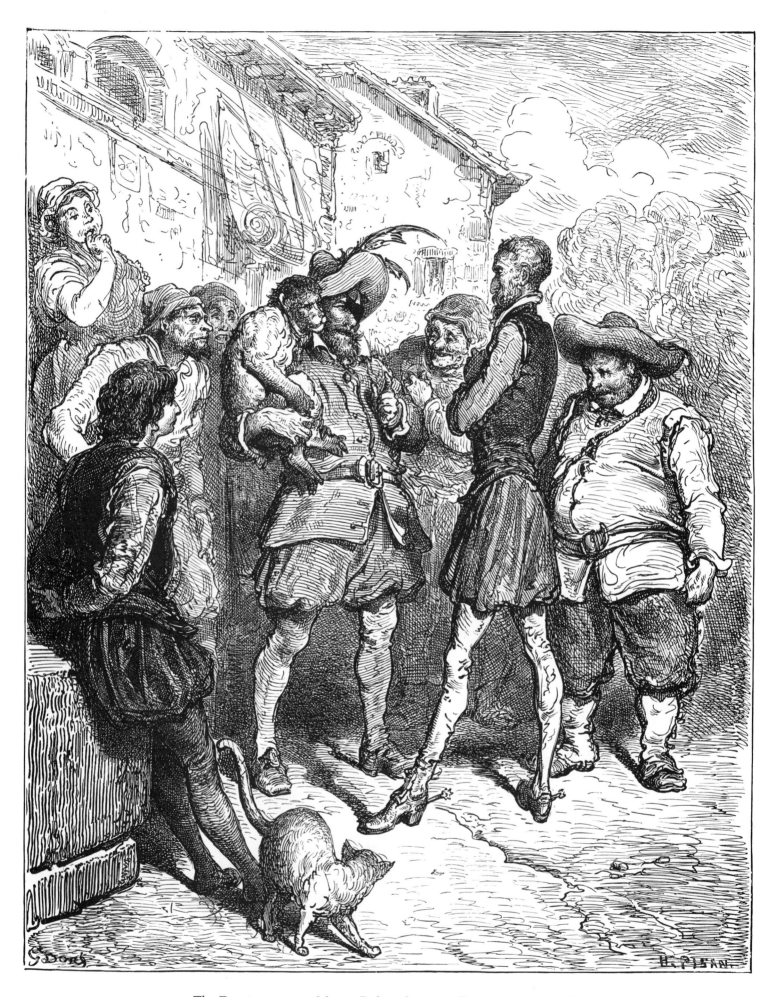

The Don interrogates Master Pedro's fortune-telling monkey (II, 25).

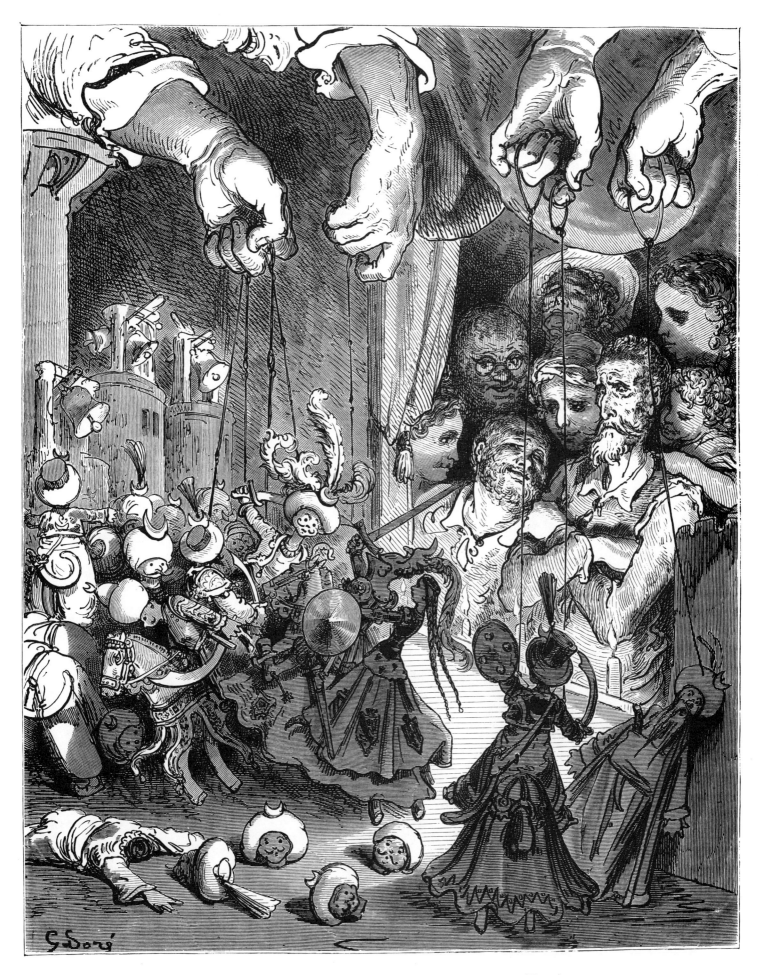

Don Quixote is fascinated by Master Pedro's marionettes (II, 26).

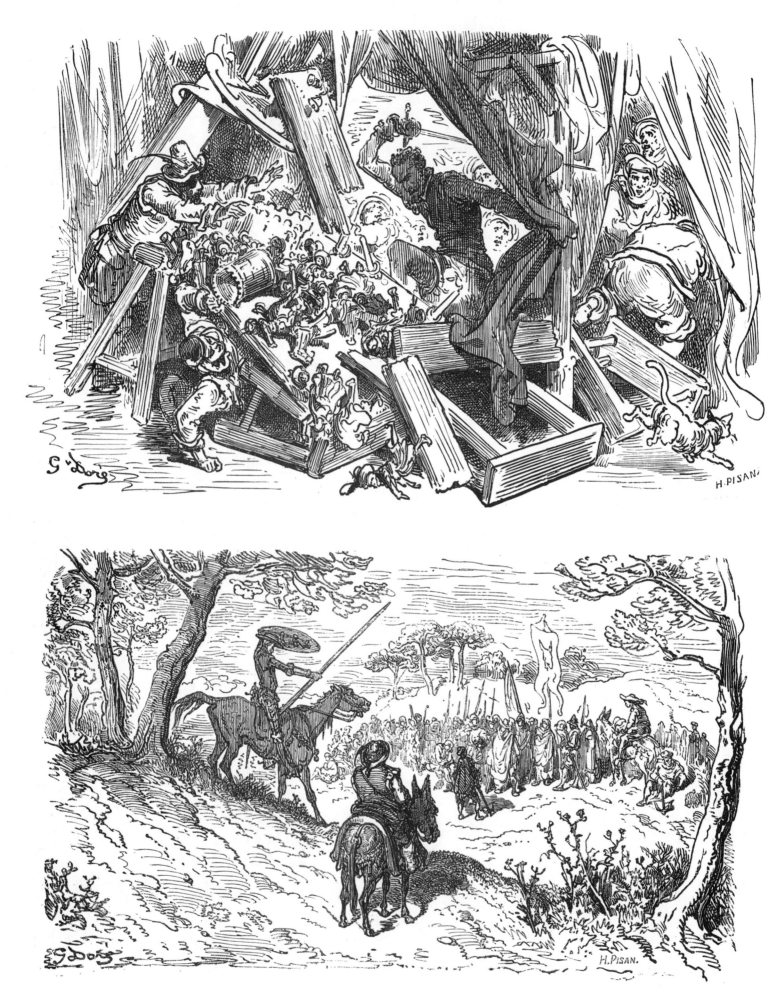

ABOVE: He attacks the villainous Moors of the marionette show (II, 26). BELOW:
The wanderers come upon an armed troop with a donkey banner (II, 27).

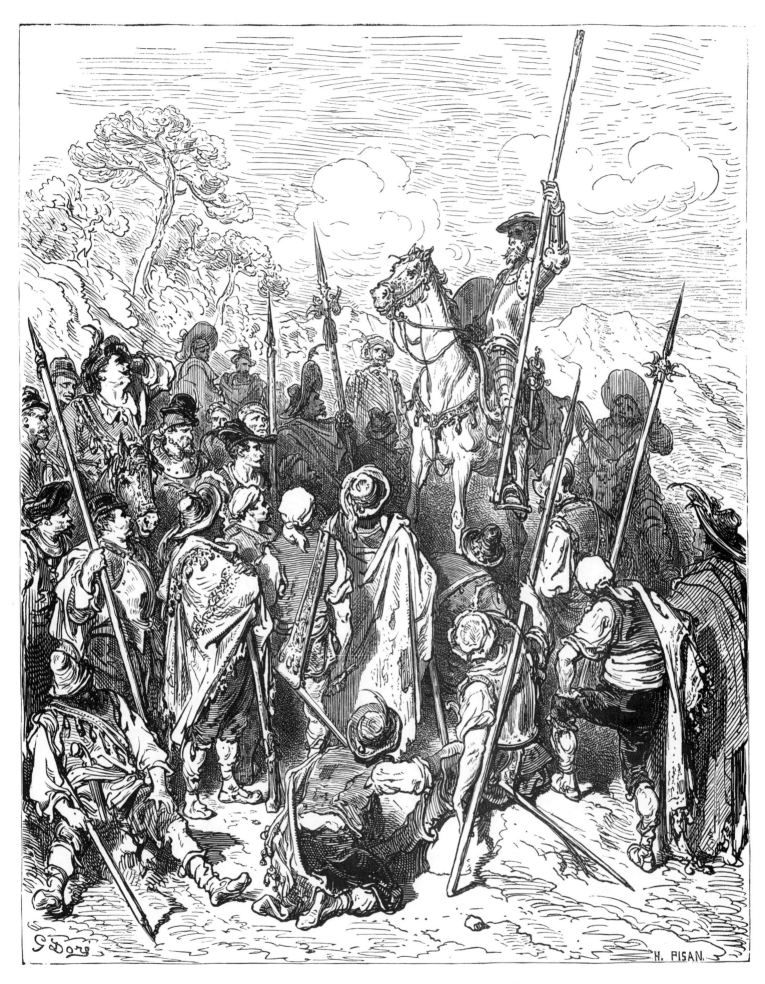

The Don introduces himself to the troop (II, 27).

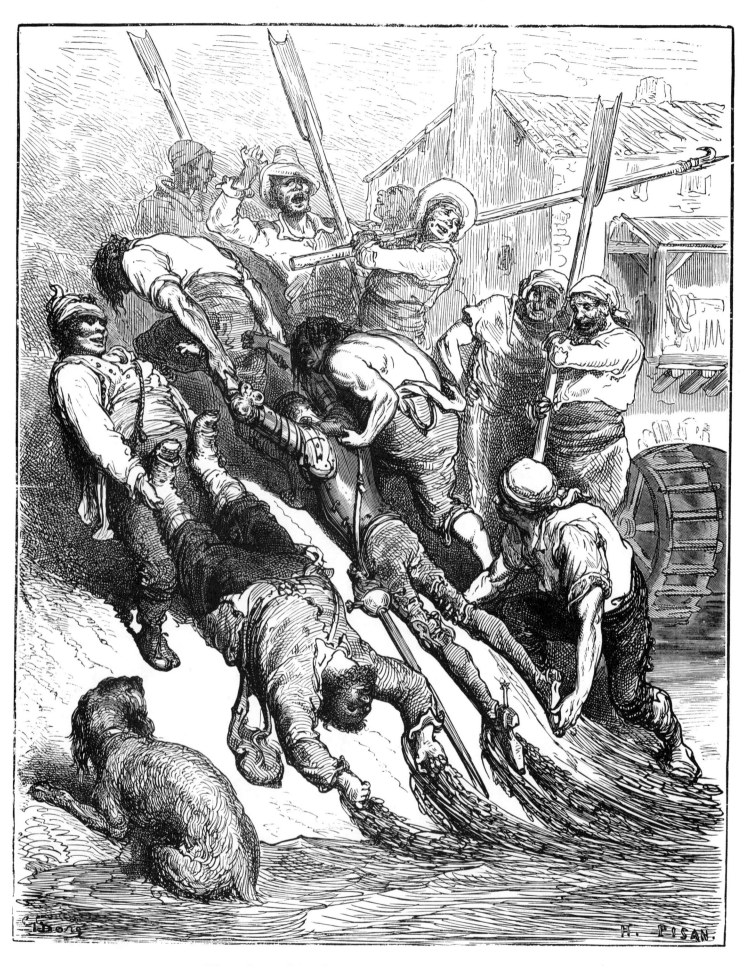

The millers pull knight and squire out of the river (II, 29).

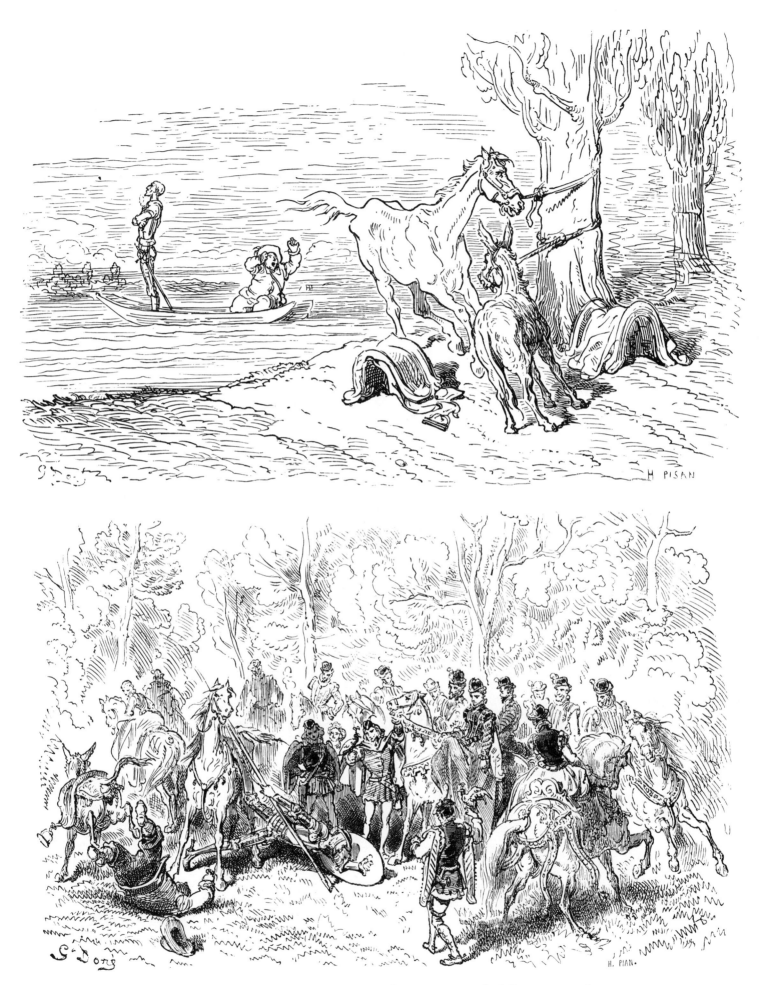

ABOVE: Sancho and the Don tie up their mounts and drift away on the enchanted boat (II, 29). BELOW: The pair fall while dismounting before the aristocratic huntress (II, 30).

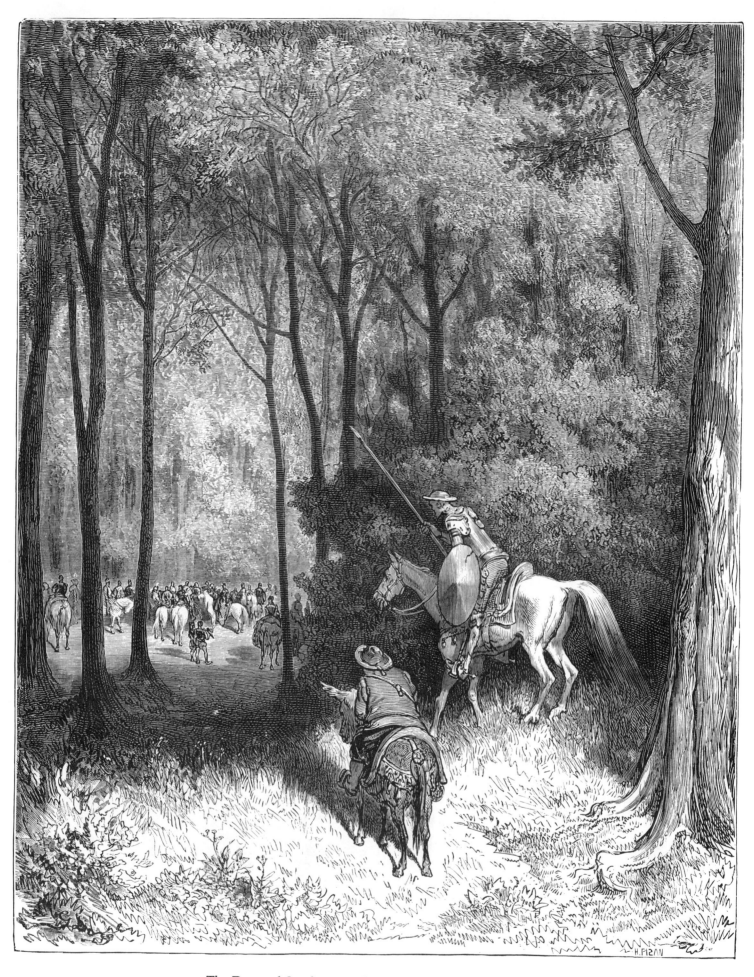

The Don and Sancho espy the noble fowling party (II, 30).

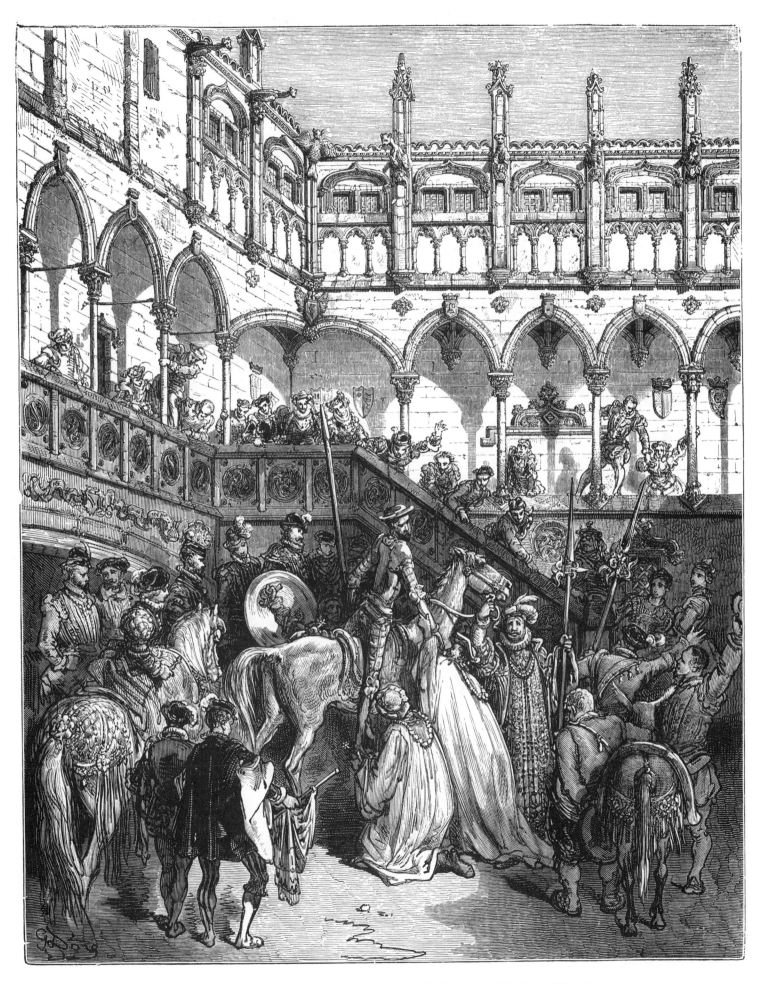

Don Quixote is welcomed at the palace of the Duke and Duchess (II, 31).

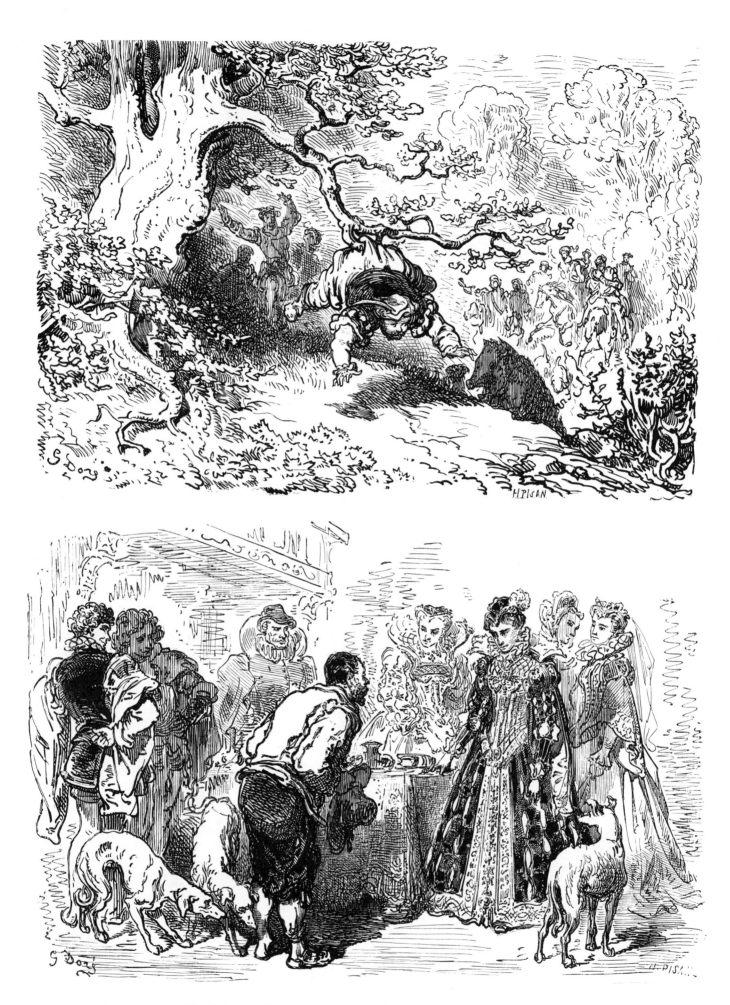

ABOVE: Headpiece to Chapter 31 of Part II (refers to the boar hunt in Chapter 34). BELOW: Sancho converses with the Duchess (II, 33).

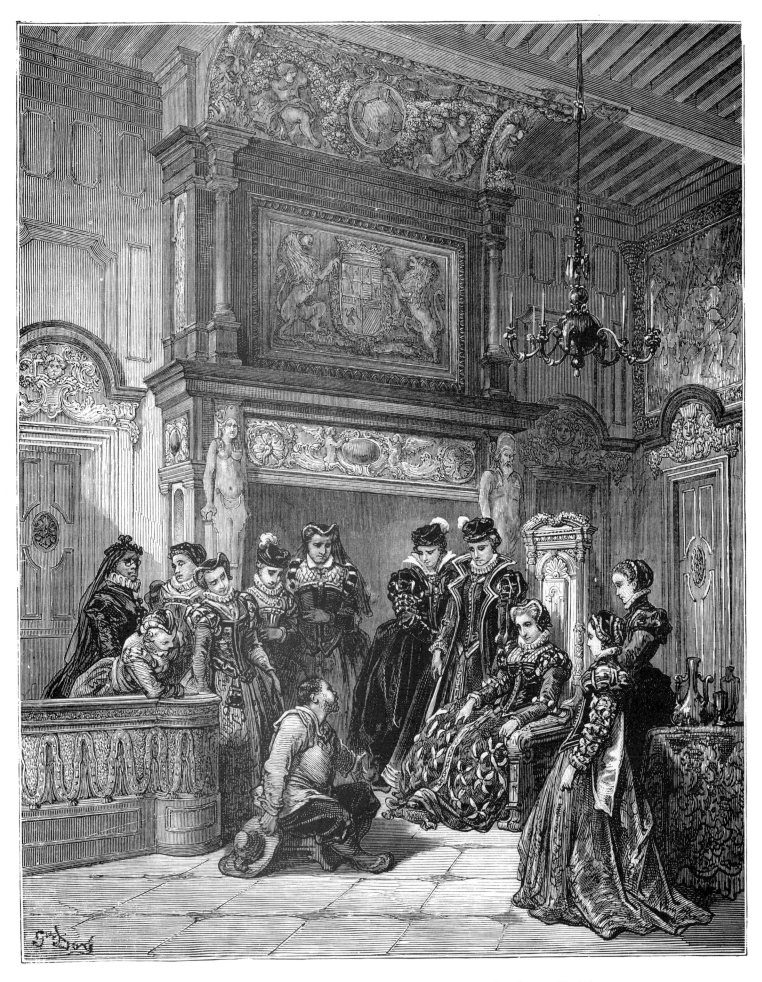

Sancho tells the Duchess about the recent enchantment of Dulcinea (II, 33).

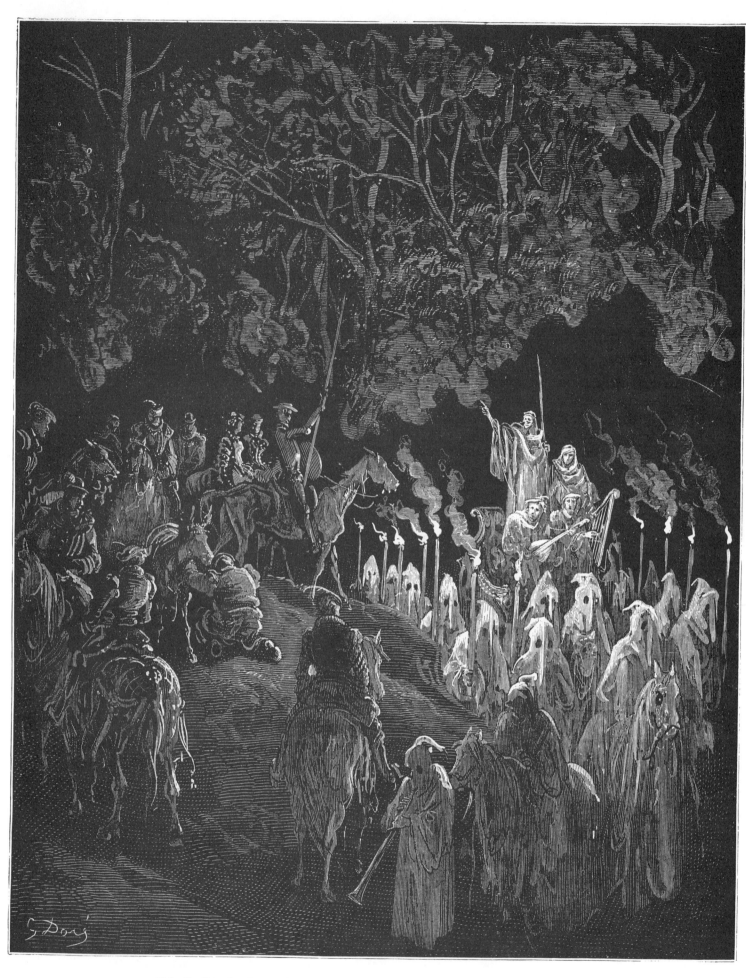

"Merlin," in the form of a skeleton, tells the Don he knows how to disenchant
Dulcinea (II, 35).

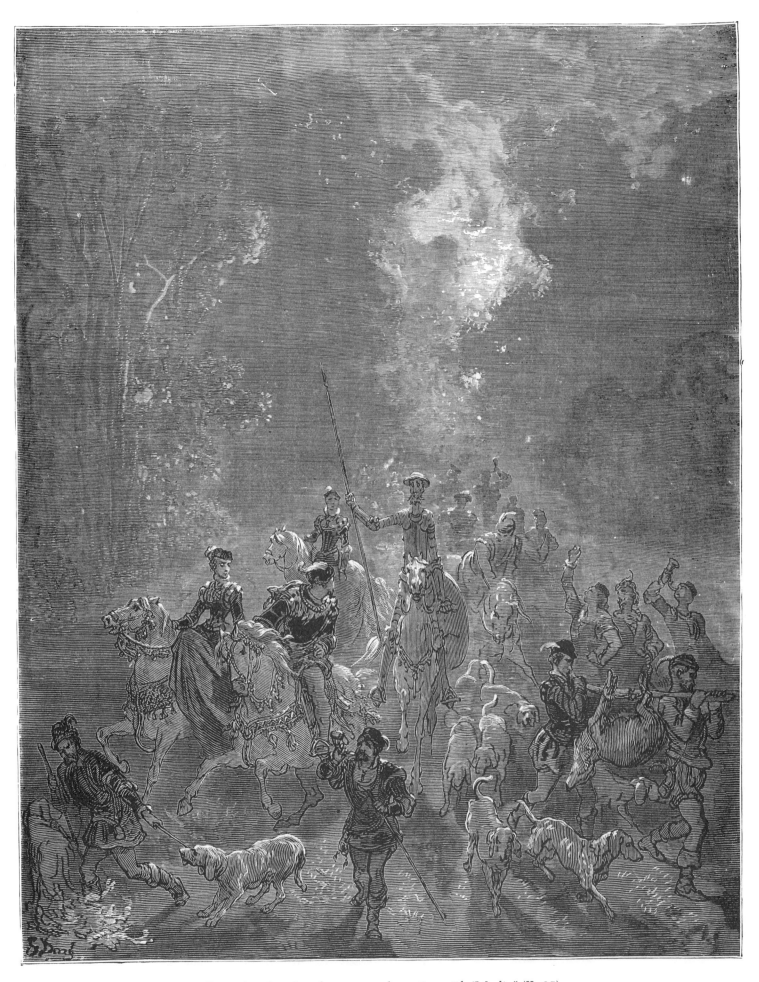

Dawn breaks after the nocturnal meeting with "Merlin" (II, 35).

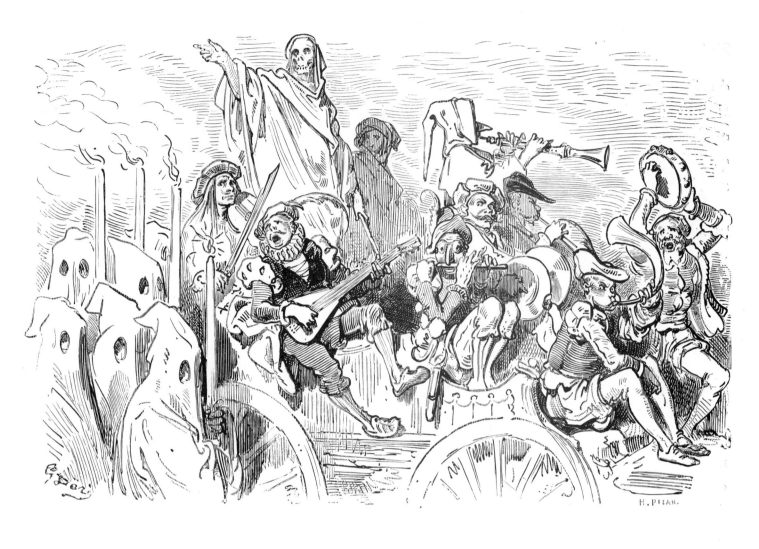

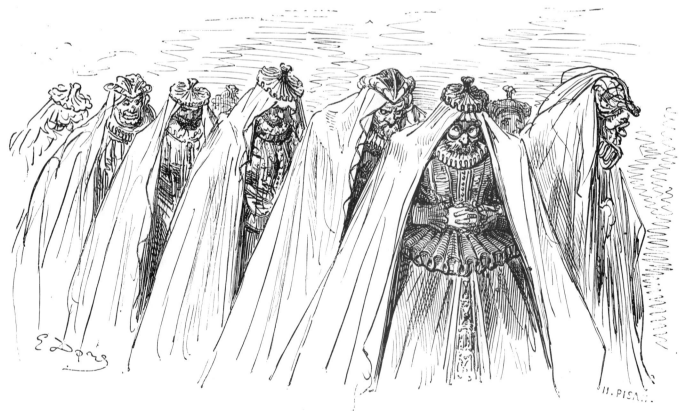

ABOVE: "Merlin's" car (II, 35). BELOW: The bearded duennas of the Countess Trifaldi (II, 39).

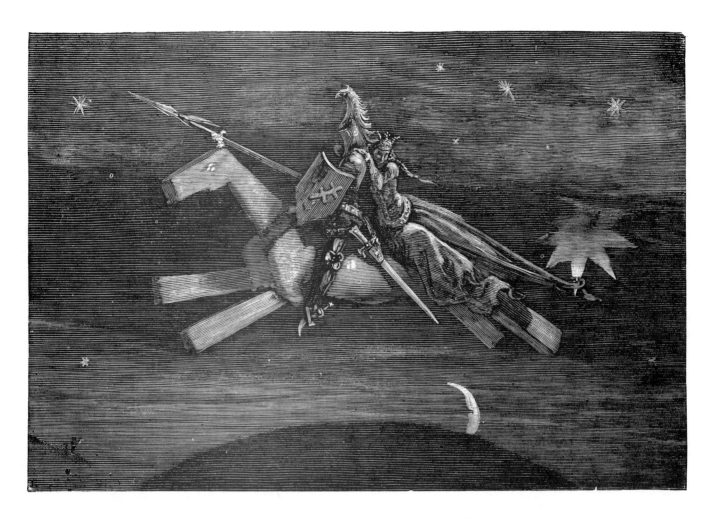

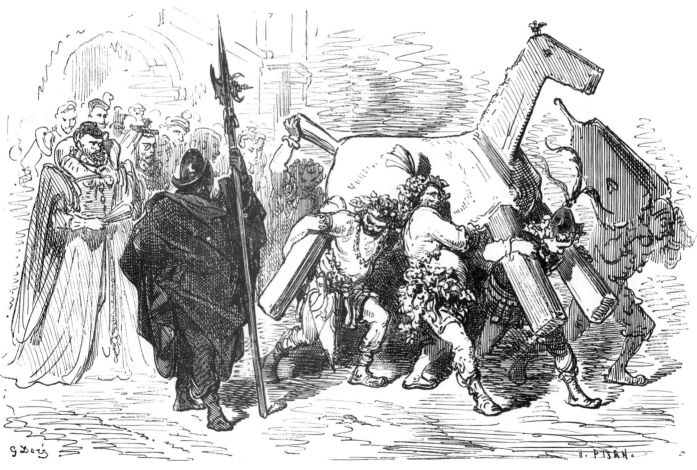

ABOVE: Clavileño, the wooden horse on which Peter of Provence flew away
with the beautiful Magalona (II, 40). BELOW: Four wild men draped in ivy carry
in the wooden horse (II, 41).

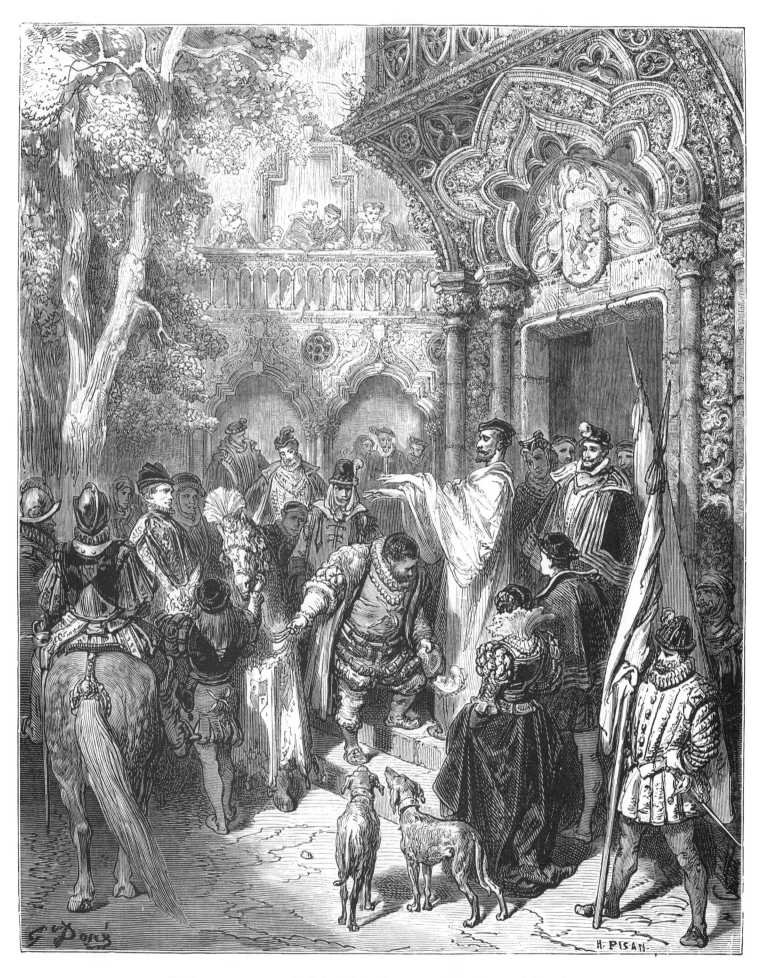

On the way to govern his "island," Sancho receives Don Quixote's benediction
(II, 44).

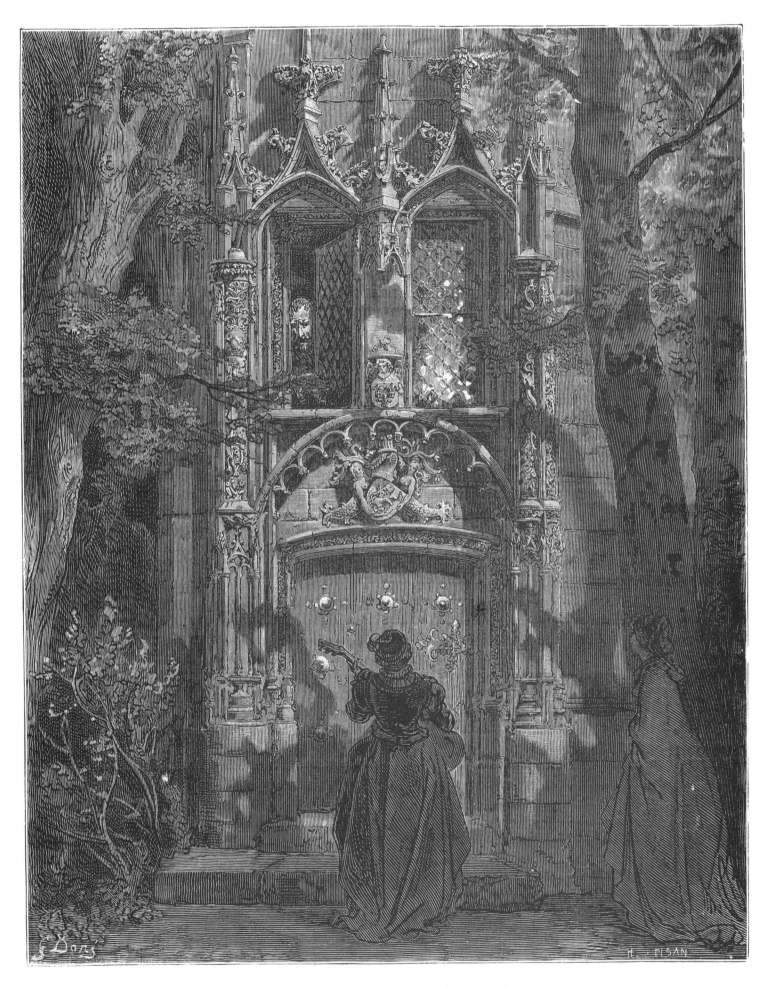

The Don is serenaded by Altisidora (II, 44).

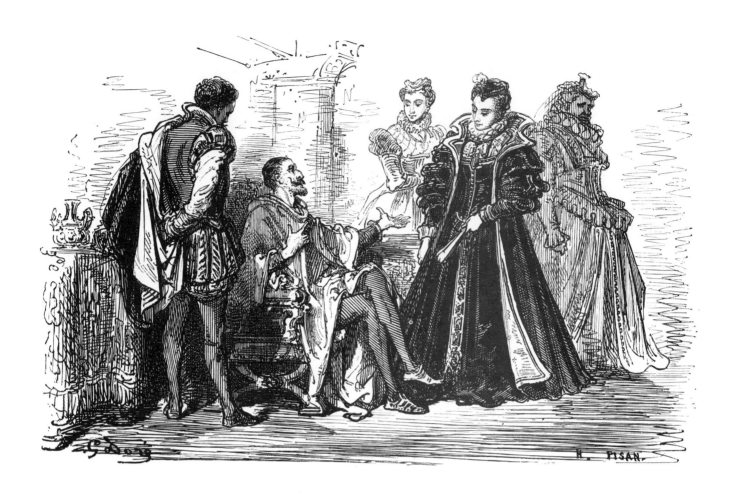

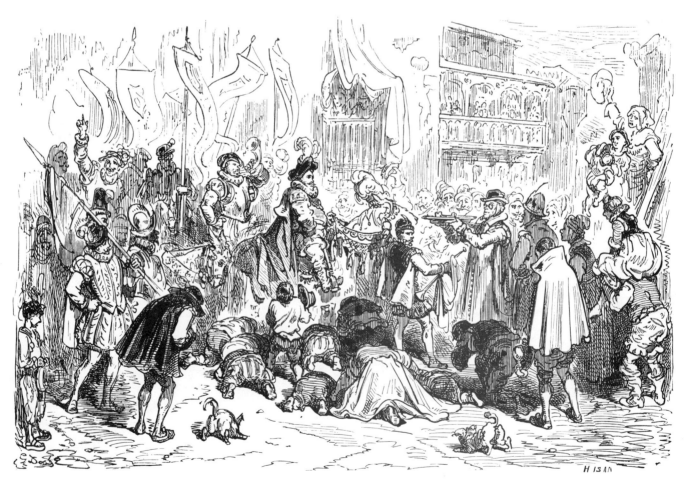

ABOVE: Don Quixote asks the Duchess not to give him personal servants during Sancho's absence (II, 44). BELOW: Sancho greeted by his subjects in Barataria (II, 45).

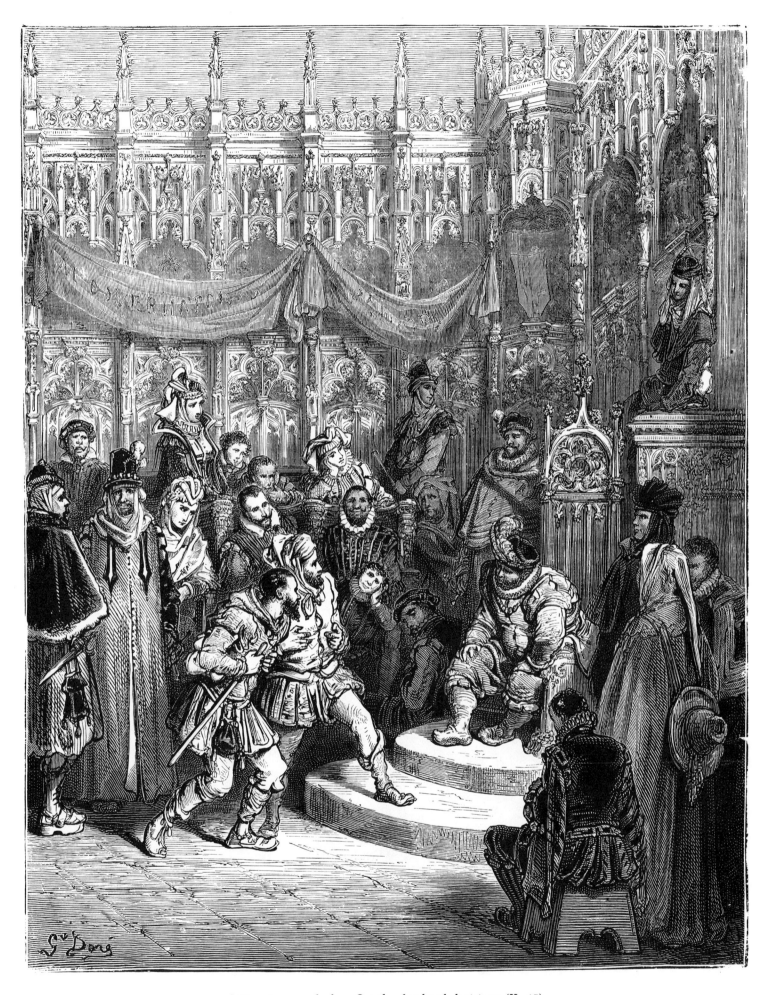

Litigants come before Sancho for legal decisions (II, 45).

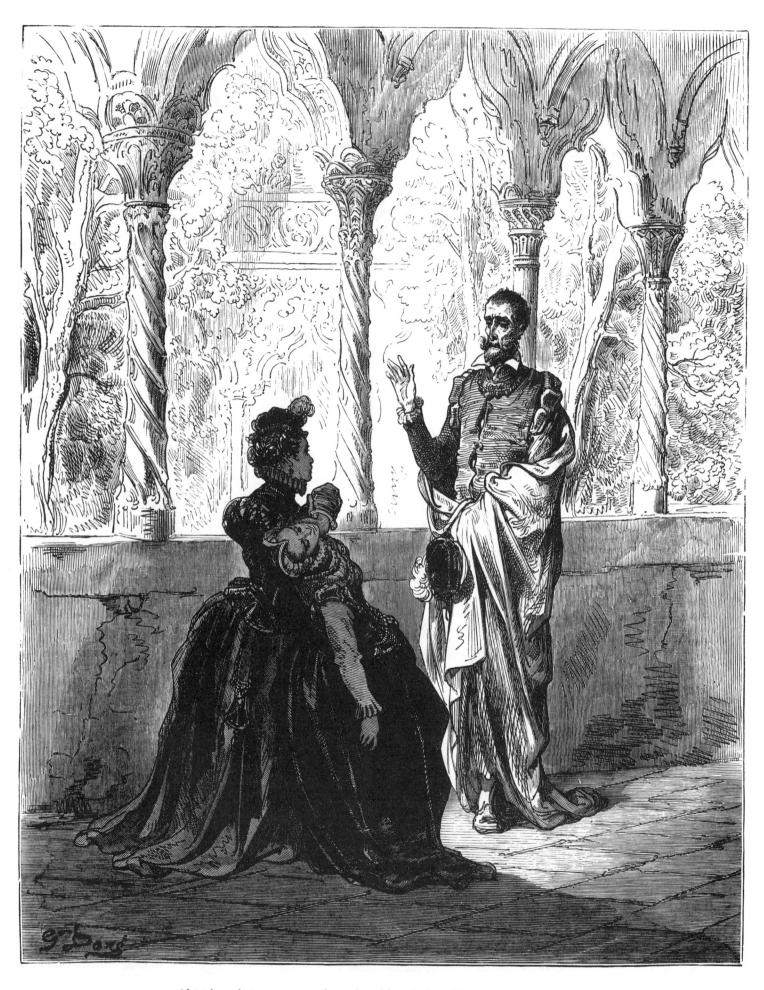

Altisidora faints away at the sight of her "beloved" Don Quixote (II, 46).

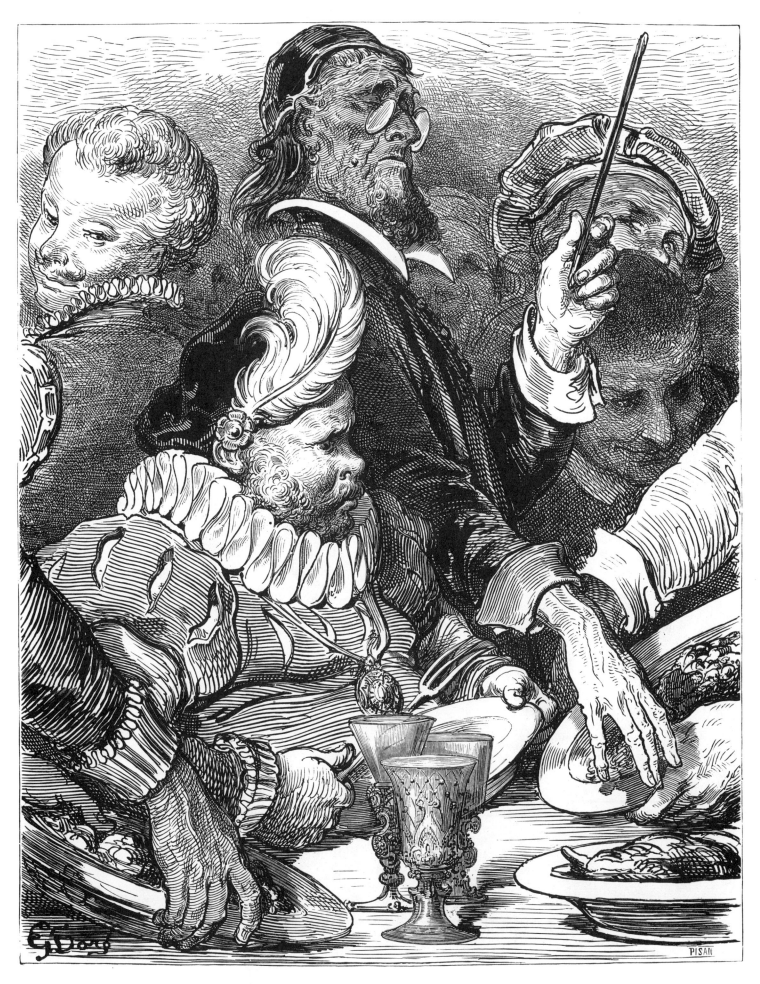

Governor Sancho's doctor refuses to let him eat to his heart's content (II, 47).

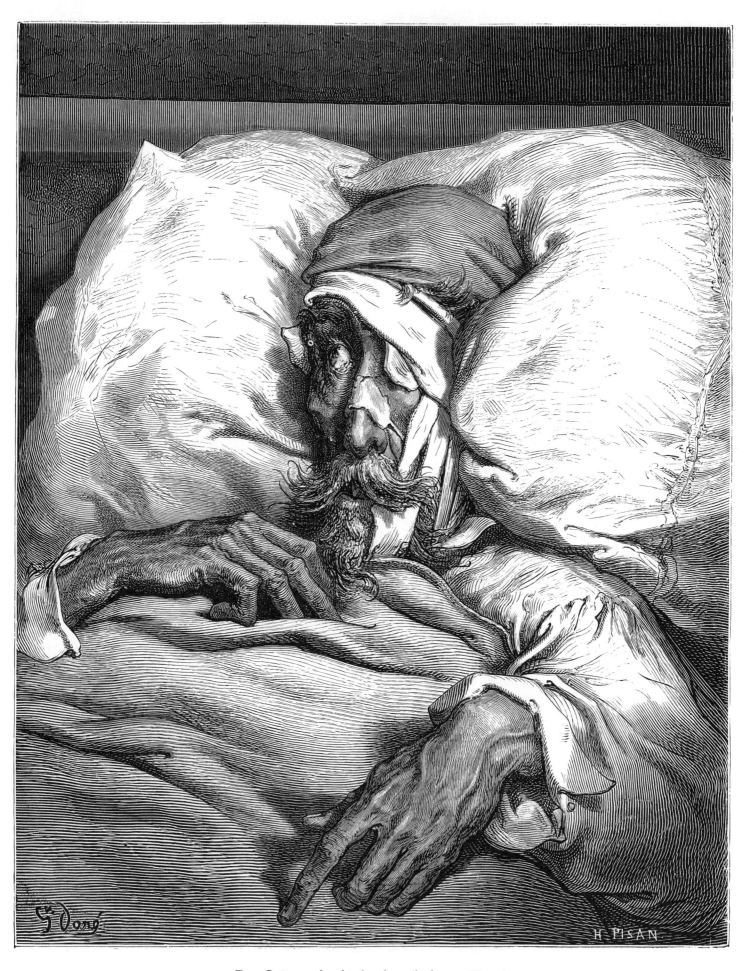

Don Quixote after his battle with the cat (II, 48).

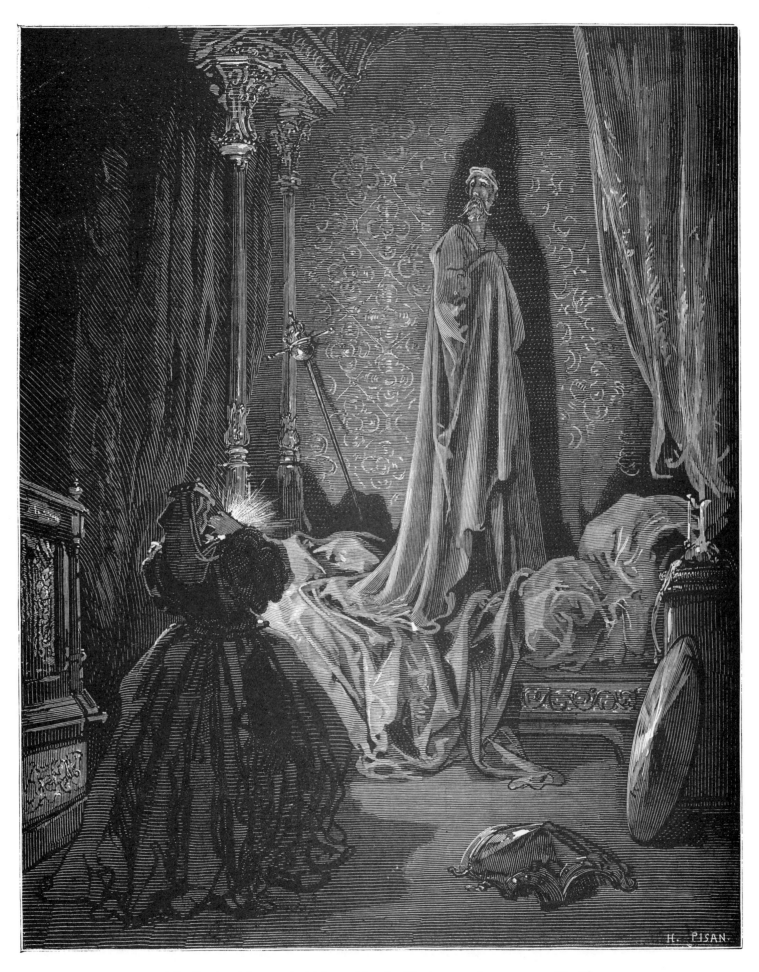

The Duchess' duenna is frightened by the Don's unusual appearance (II, 48).

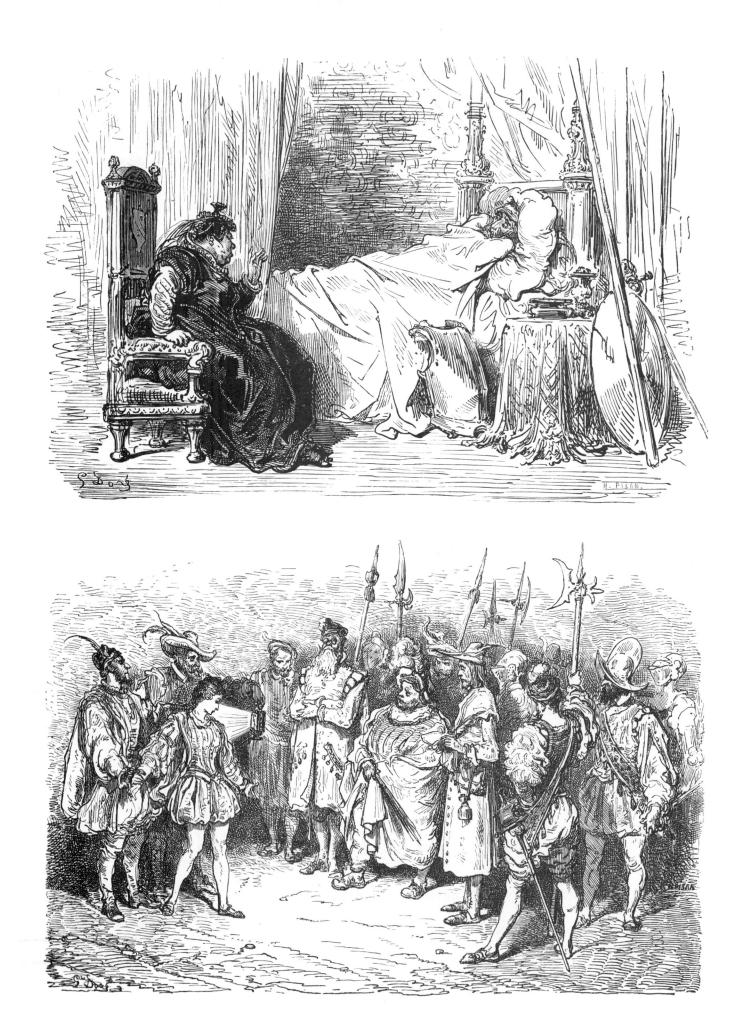

ABOVE: The duenna tells Don Quixote about her family (II, 48). BELOW: While making his rounds, Governor Sancho finds a girl in men's clothing (II, 49).

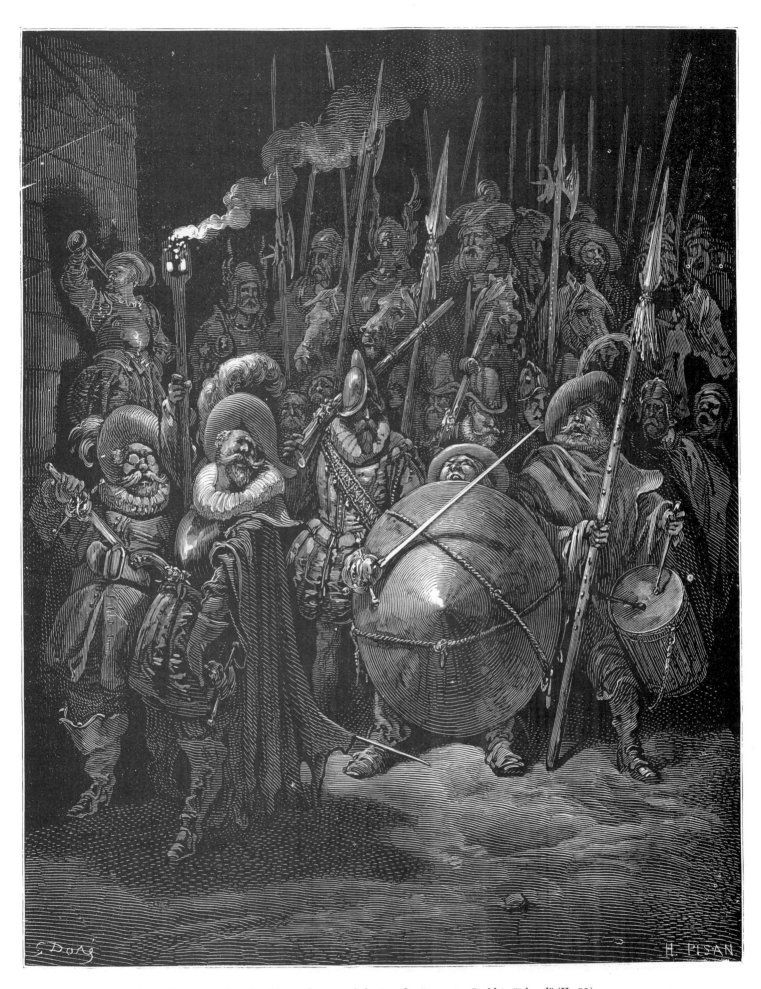

Governor Sancho bizarrely armed during the "invasion" of his "island" (II, 53).

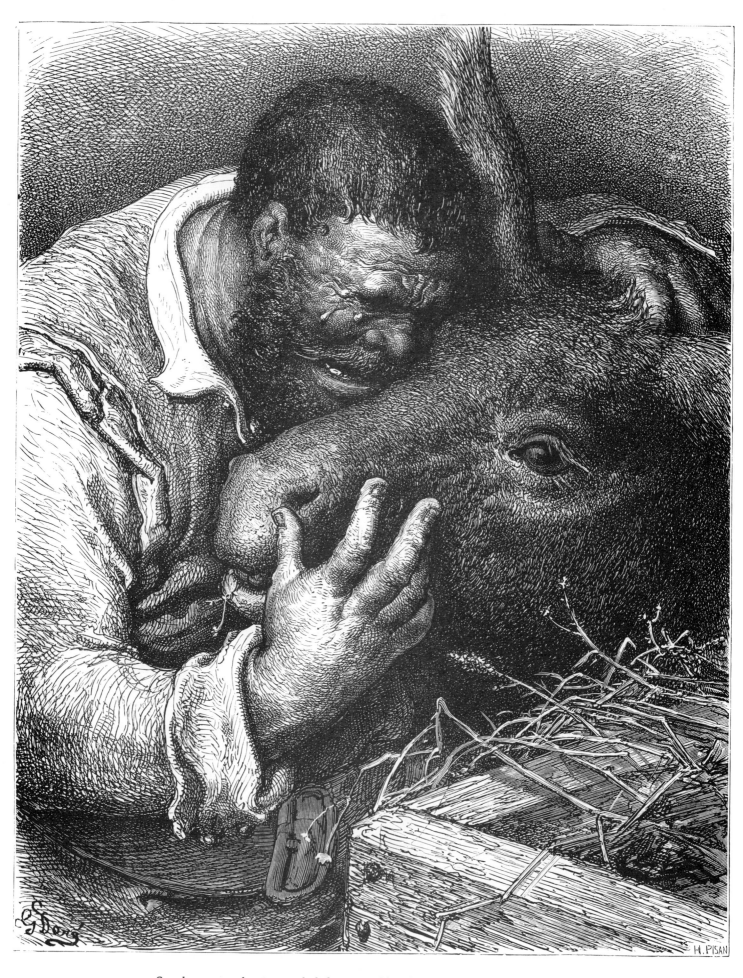

Sancho regrets having traded the care of his donkey for the role of governor
(II, 53).

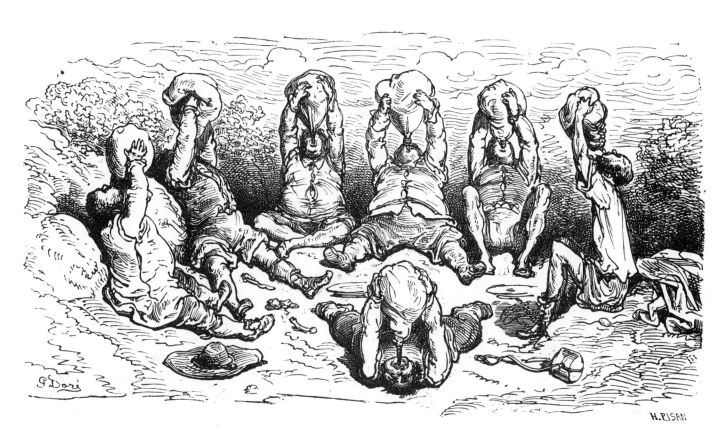

ABOVE: In the heat of "battle," Sancho is trampled (II, 53). BELOW: Sancho eating and drinking with Ricote and the pilgrims (II, 54).

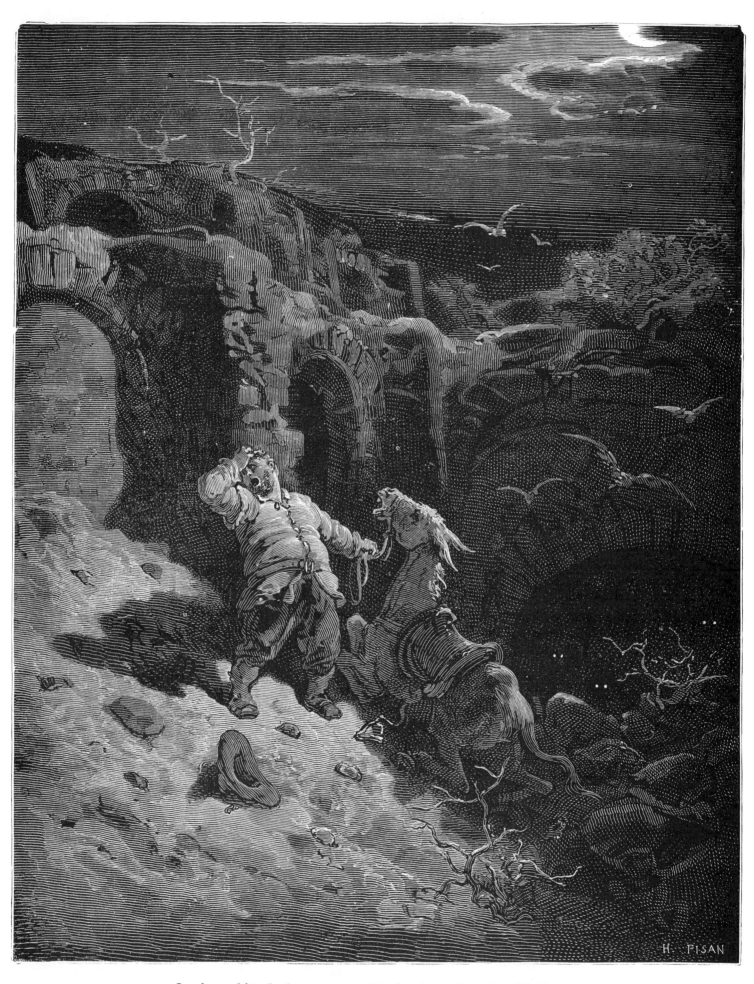

Sancho and his donkey are trapped in the place where they fell (II, 55).

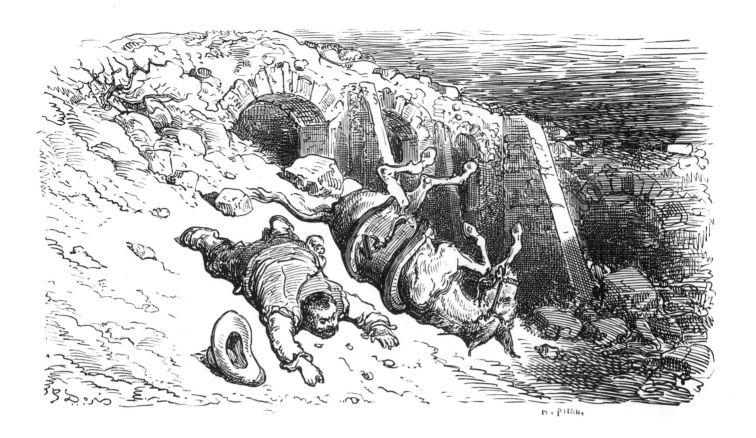

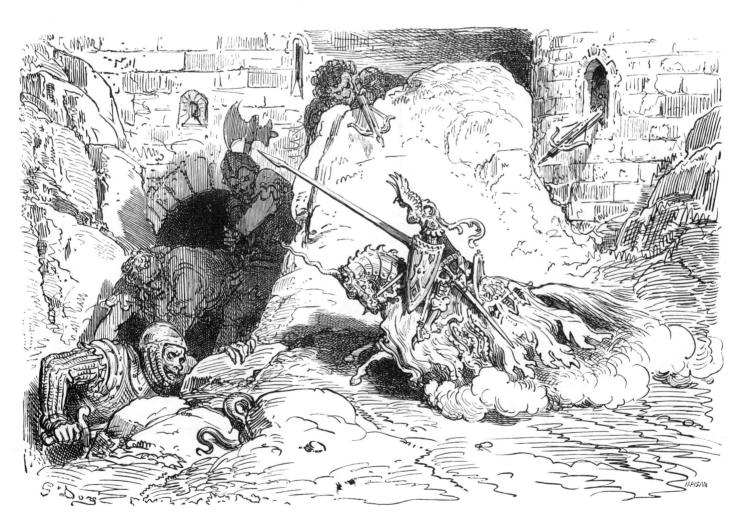

ABOVE: Sancho and his donkey take a fall amid the ruins of a building (II, 55).
BELOW: Don Quixote's combat with the lackey Tosilos suggests high deeds of
knight-errantry (II, 56).

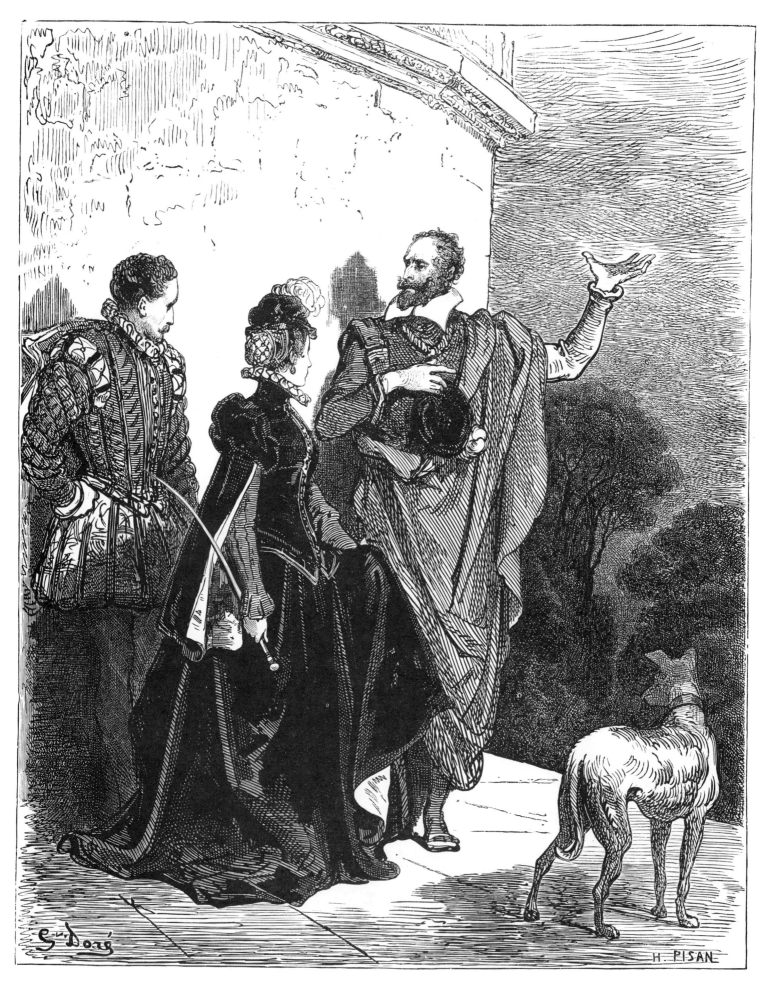

The Don asks permission to leave the home of the Duke and Duchess (II, 57).

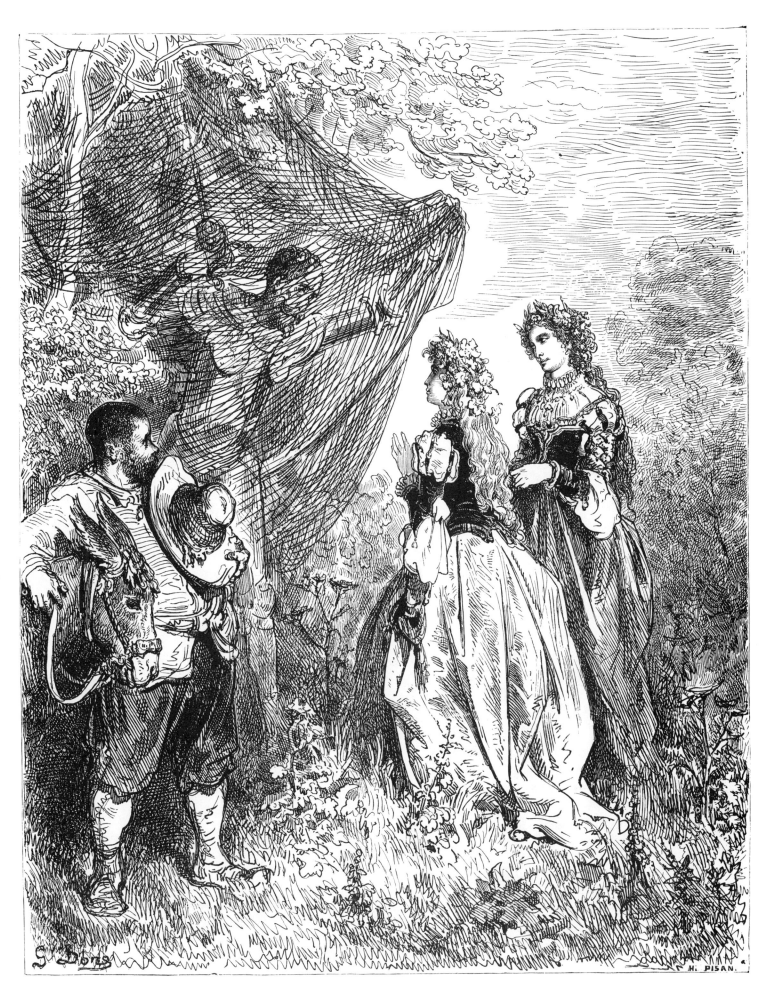

The two mock shepherdesses in whose net Don Quixote is caught invite him to
their village festivities (II, 58).

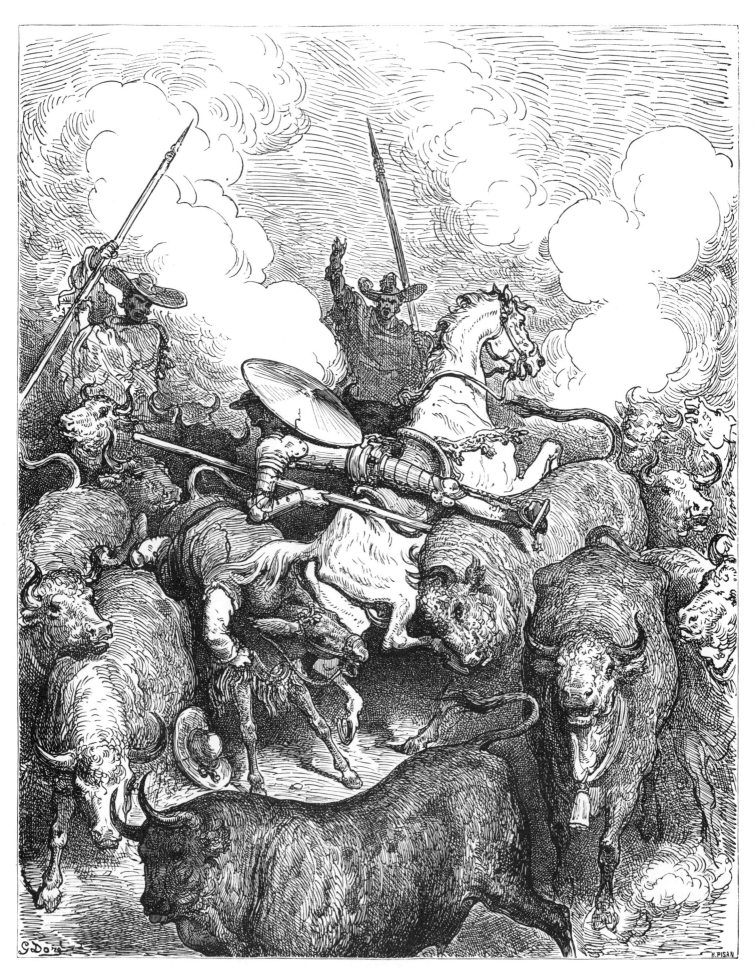

Sancho and Don Quixote buffeted by the herd of bulls (II, 58).

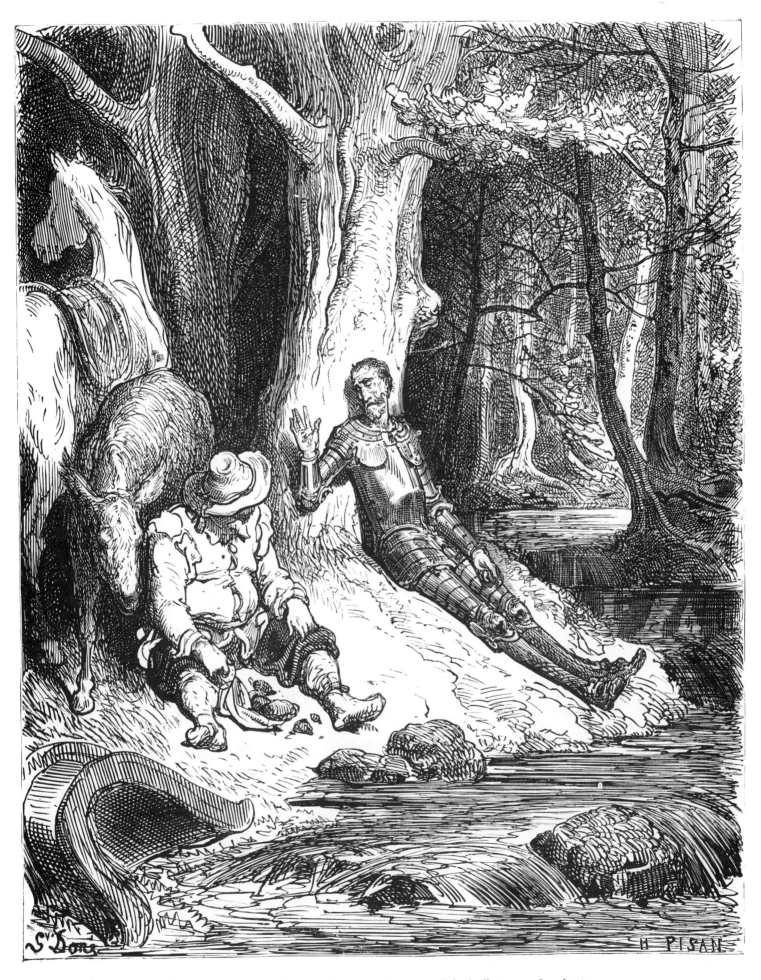

Don Quixote is too depressed by the adventure of the bulls to join Sancho in a
meal (II, 59).

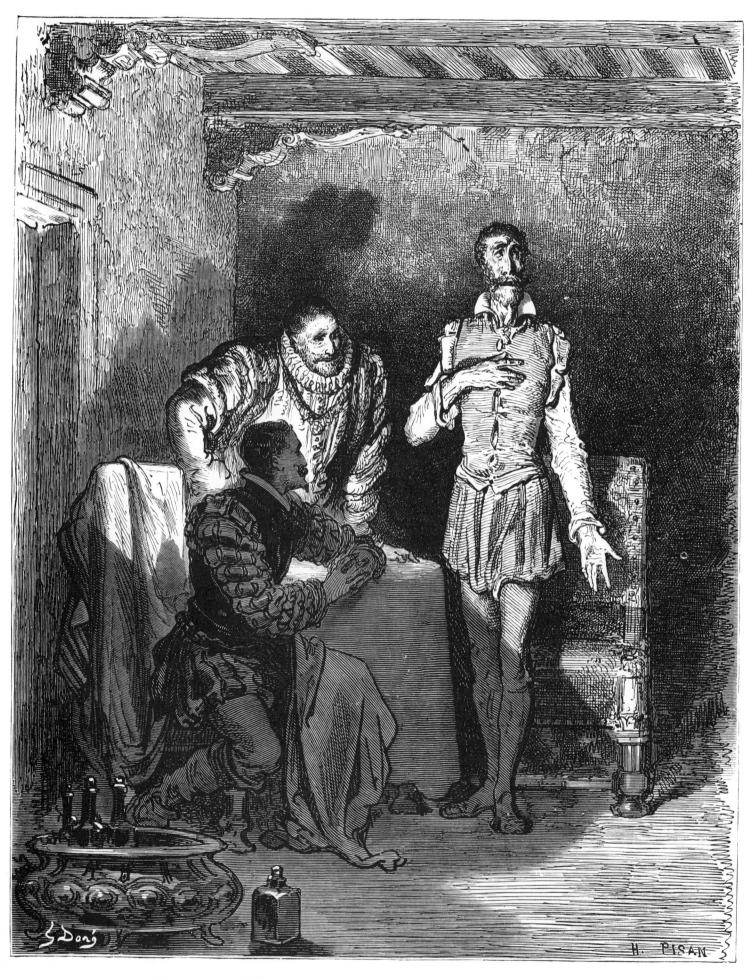

Don Quixote tells his fellow guests at the inn about the spell cast on Dulcinea
(II, 59).

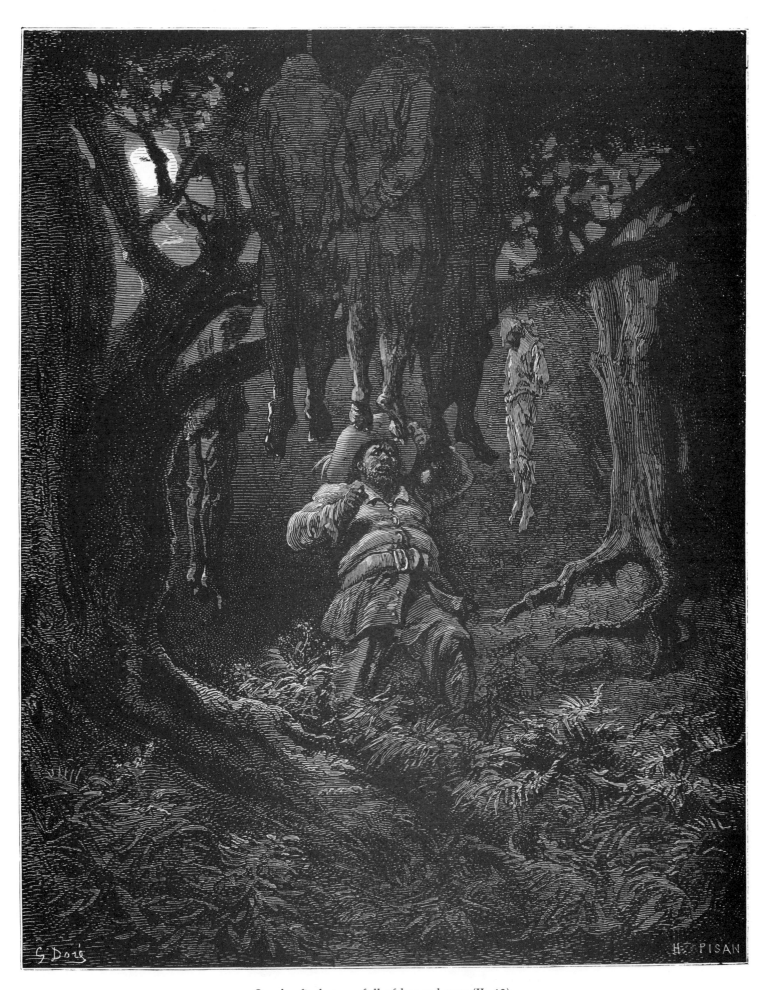

Sancho finds trees full of hanged men (II, 60).

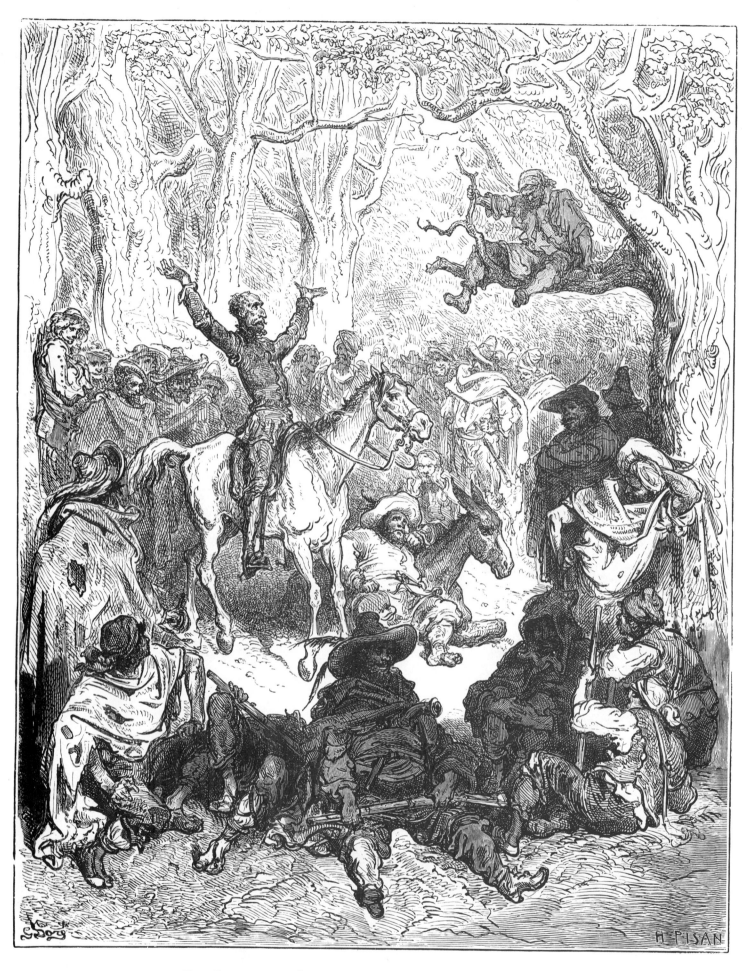

Don Quixote urges the bandits to give up their way of life (II, 60).

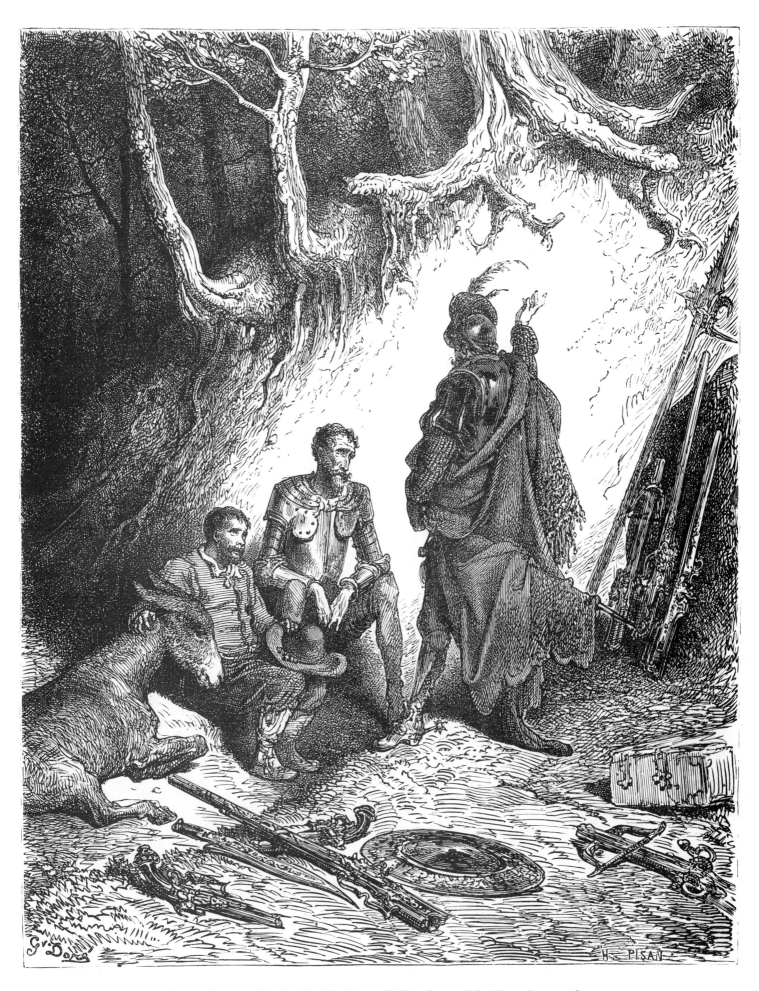

Roque Guinart, the bandit chieftain, tells Sancho and the Don about outlaw
existence (II, 60).

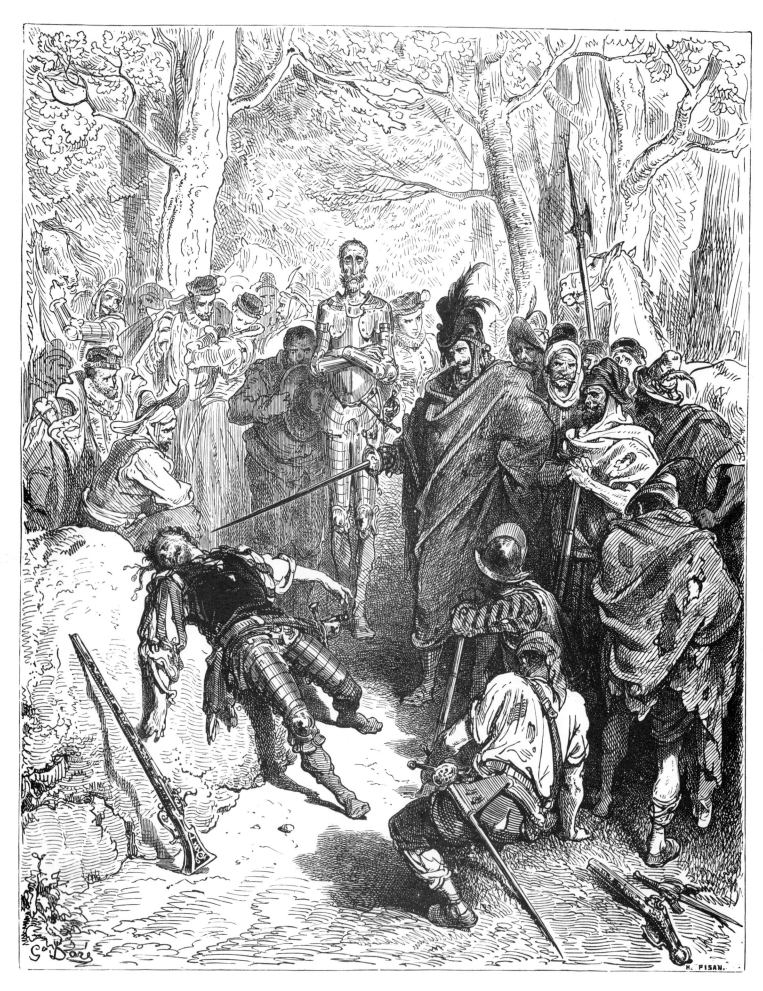

Roque kills an insolent member of his band (II, 60).

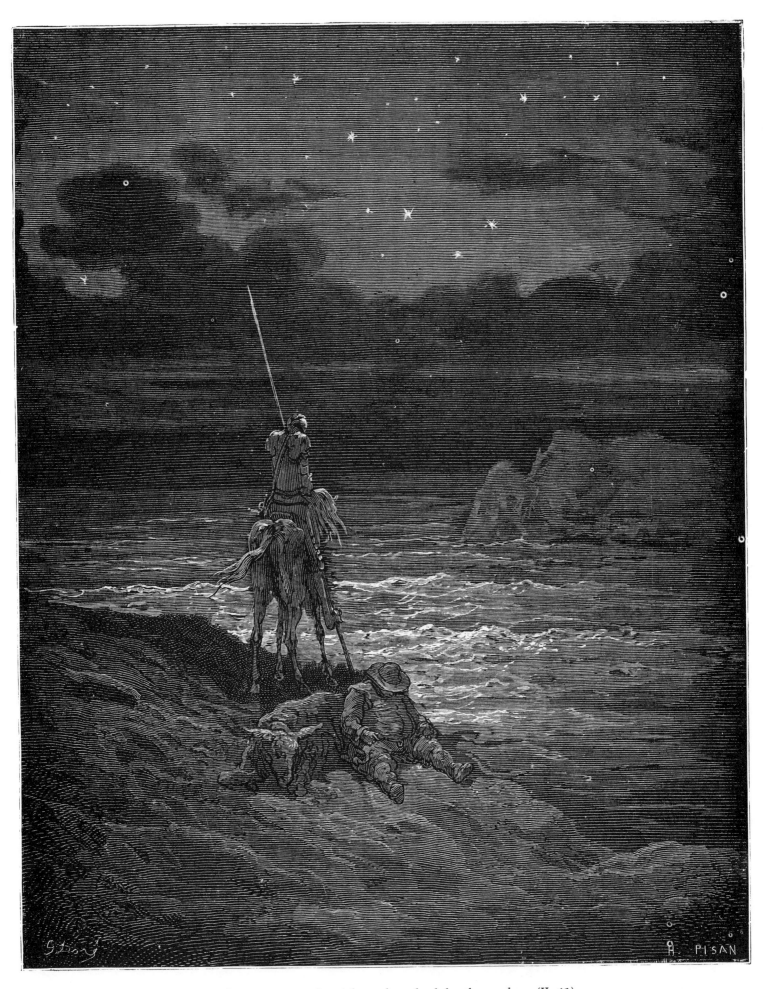

Don Quixote passes the night on horseback by the seashore (II, 61).

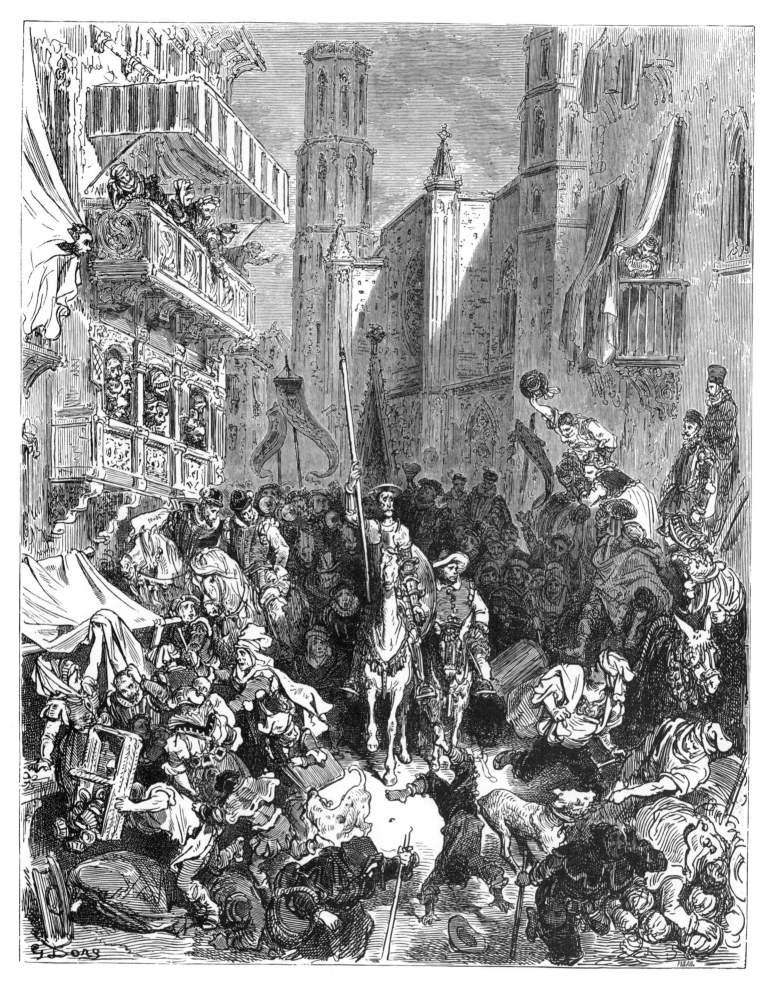

The Don enters Barcelona (II, 61).

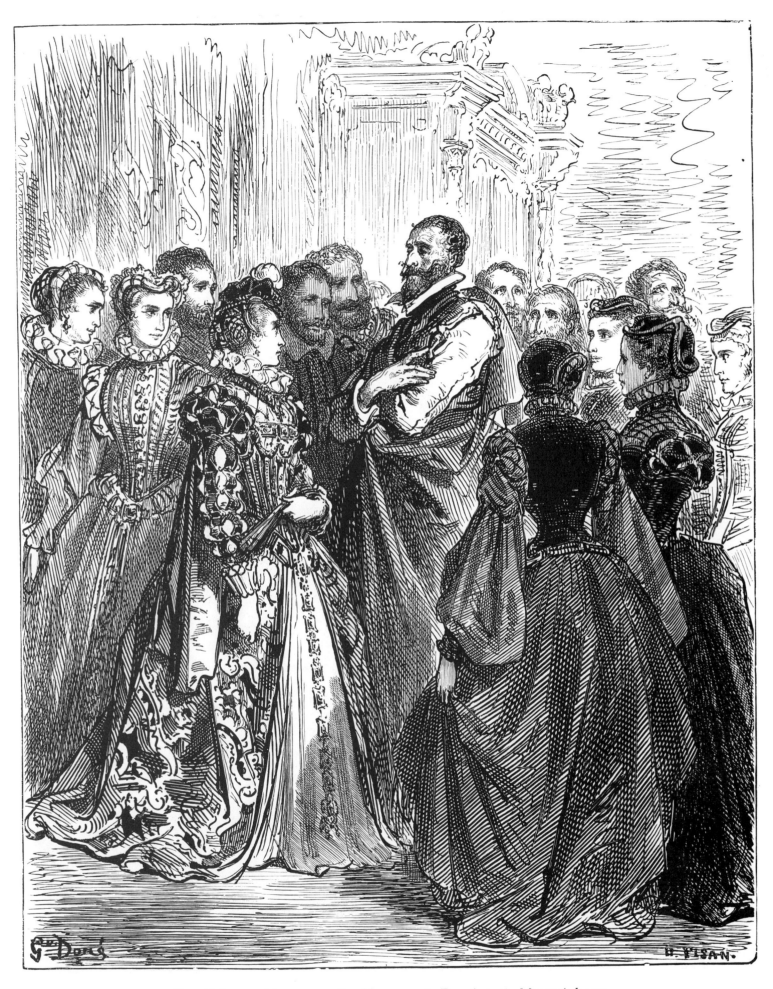

Don Quixote with a group of noblewomen in Don Antonio Moreno's home
(II, 62).

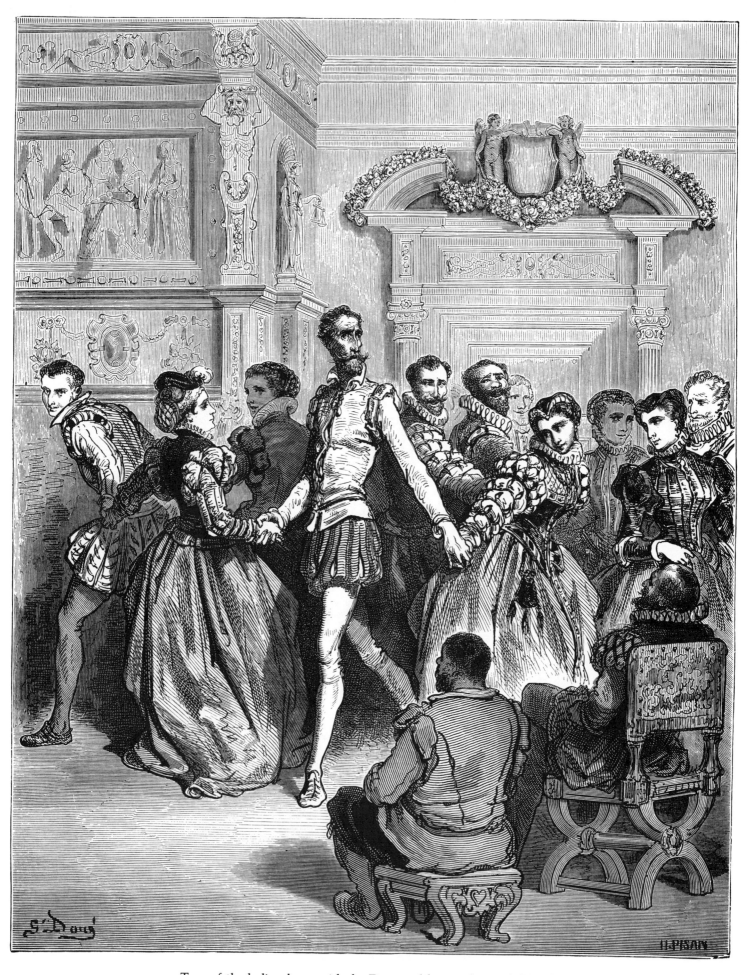

Two of the ladies dance with the Don until he is exhausted (II, 62).

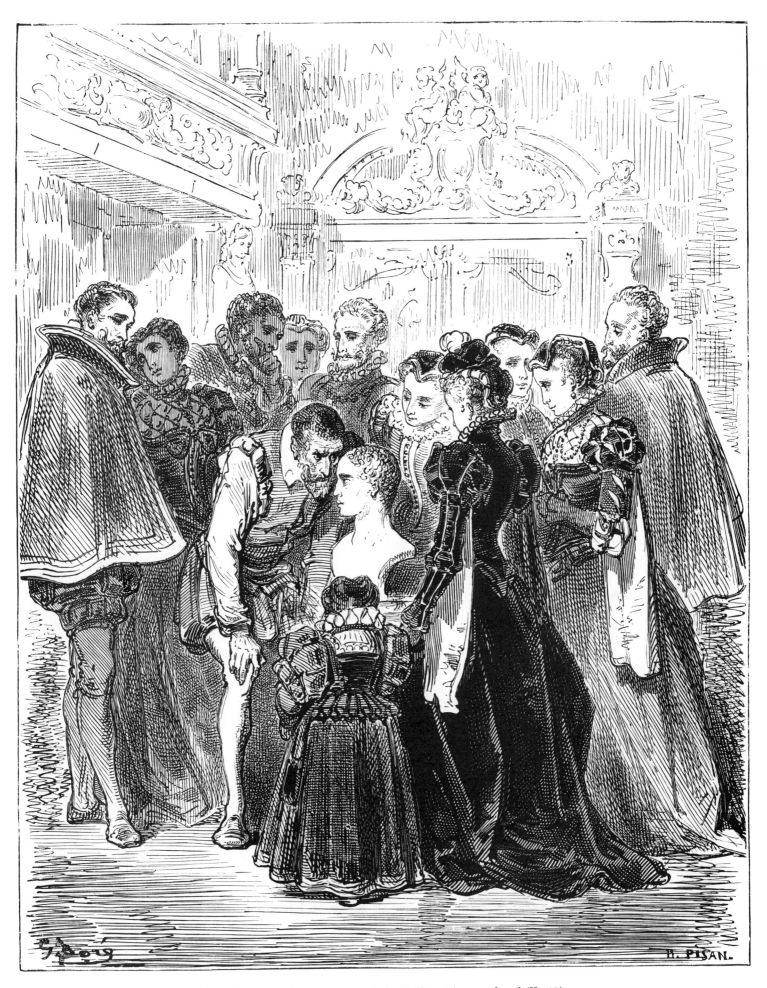

Don Quixote asks questions of the "talking" bronze head (II, 62).

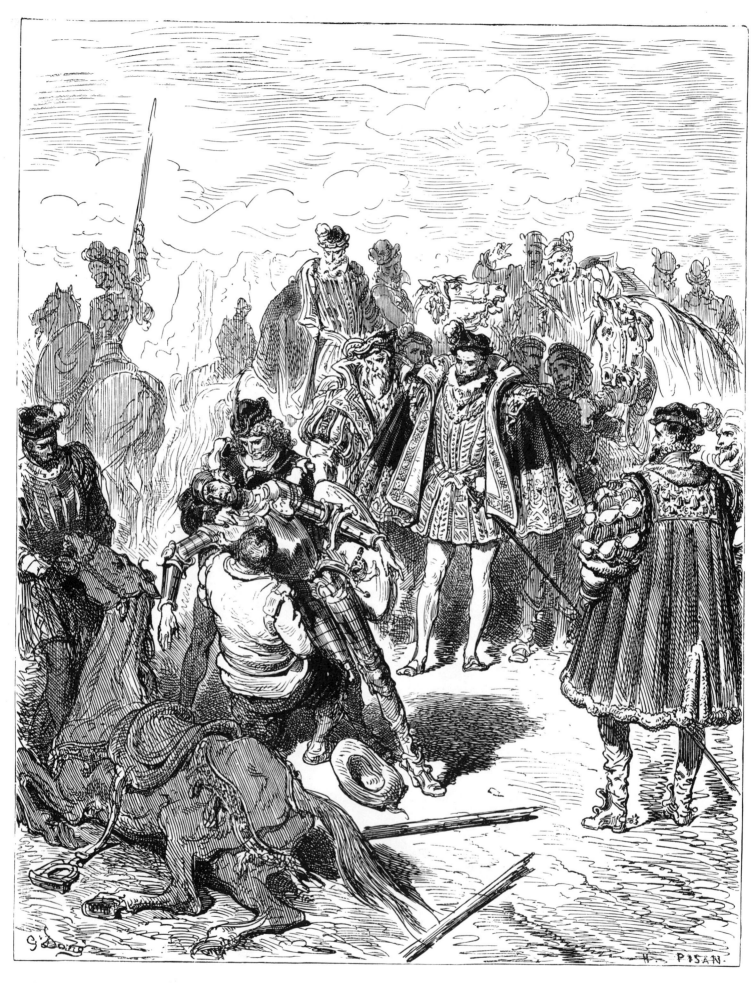

The Don in sorry shape after his defeat by the Knight of the White Moon
(II, 64).

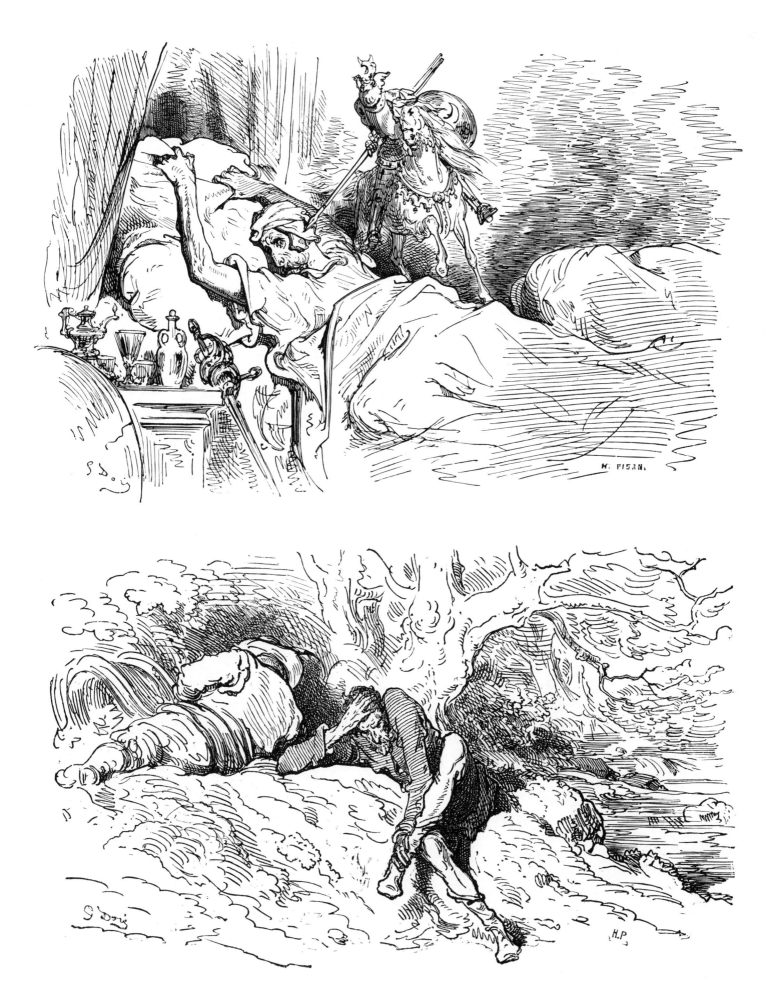

ABOVE: Don Quixote bedridden and plagued by the memory of his last encounter (II, 65). BELOW: The sadness of Don Quixote on his way home (II, 66).

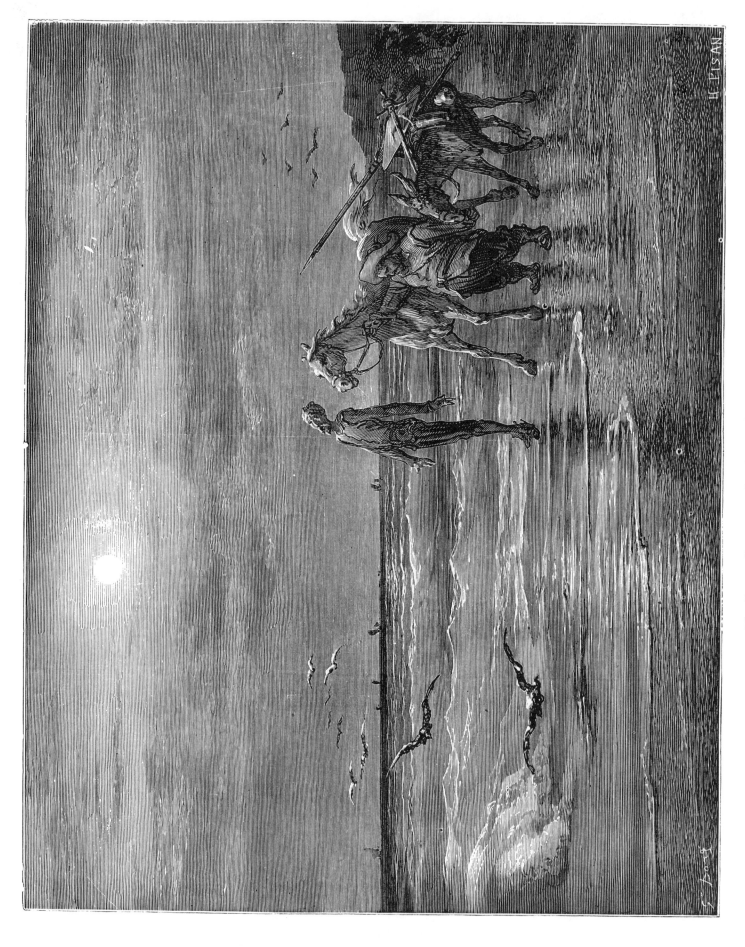

The Don sadly revisits the place of his defeat (II, 66).

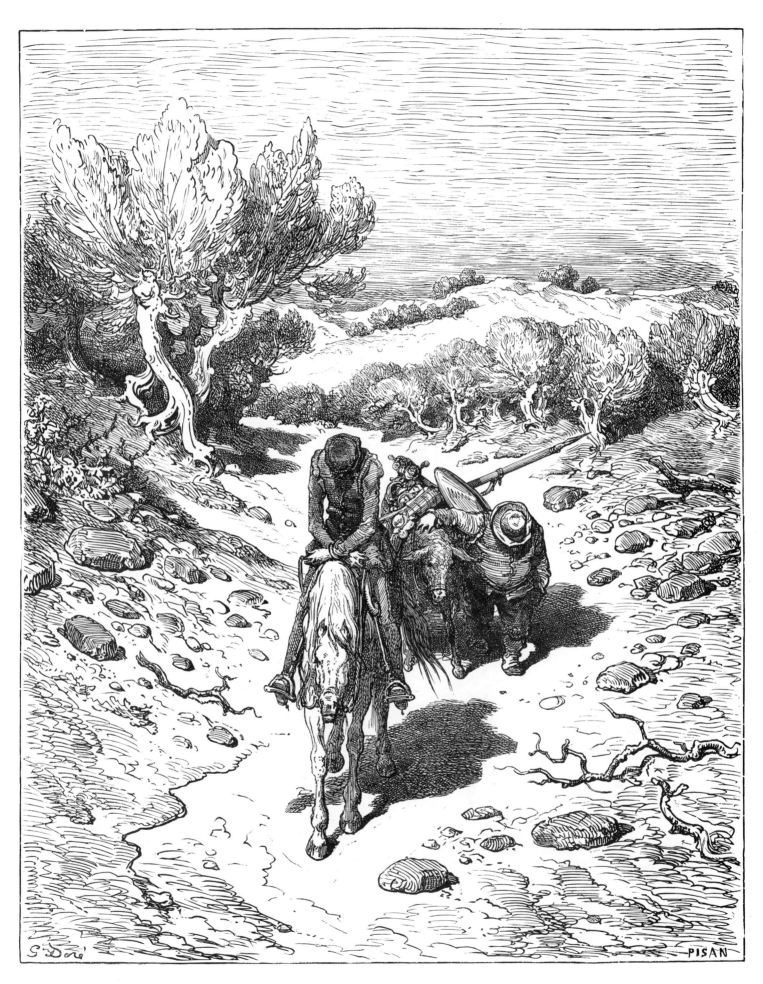

The two adventurers turn homeward dejectedly (II, 66).

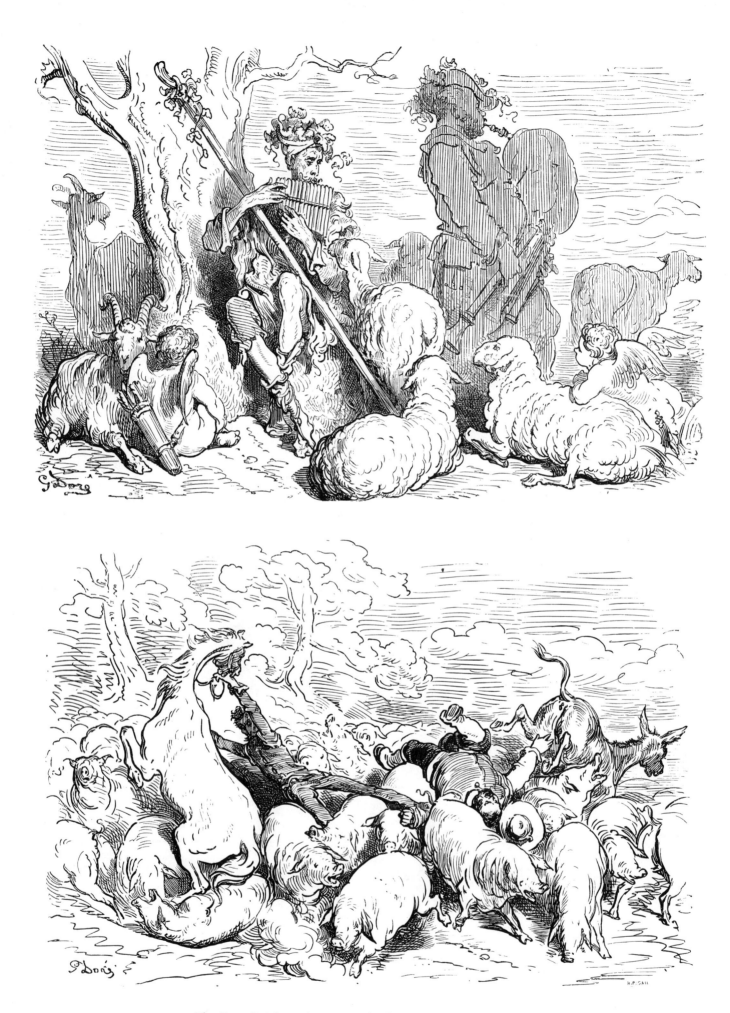

ABOVE: The Don decides to become a shepherd during the year in which he is forbidden to bear arms (II, 67). BELOW: Sancho and the Don overwhelmed by the pigs (II, 68).

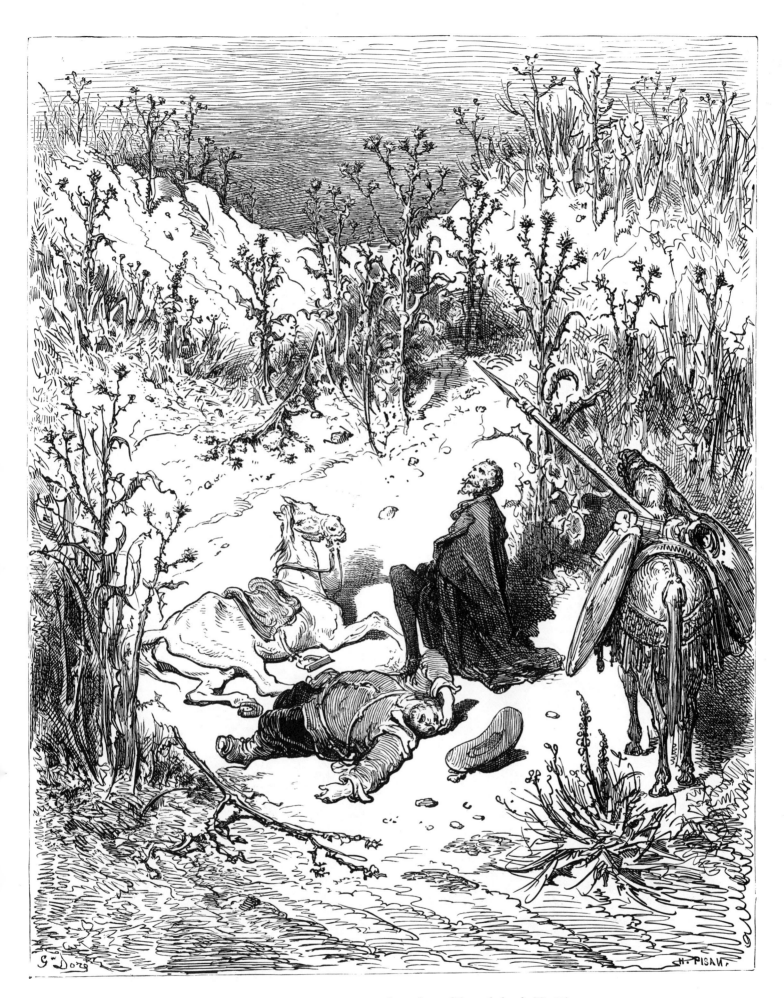

Don Quixote recites a poem about love, life and death (II, 68).

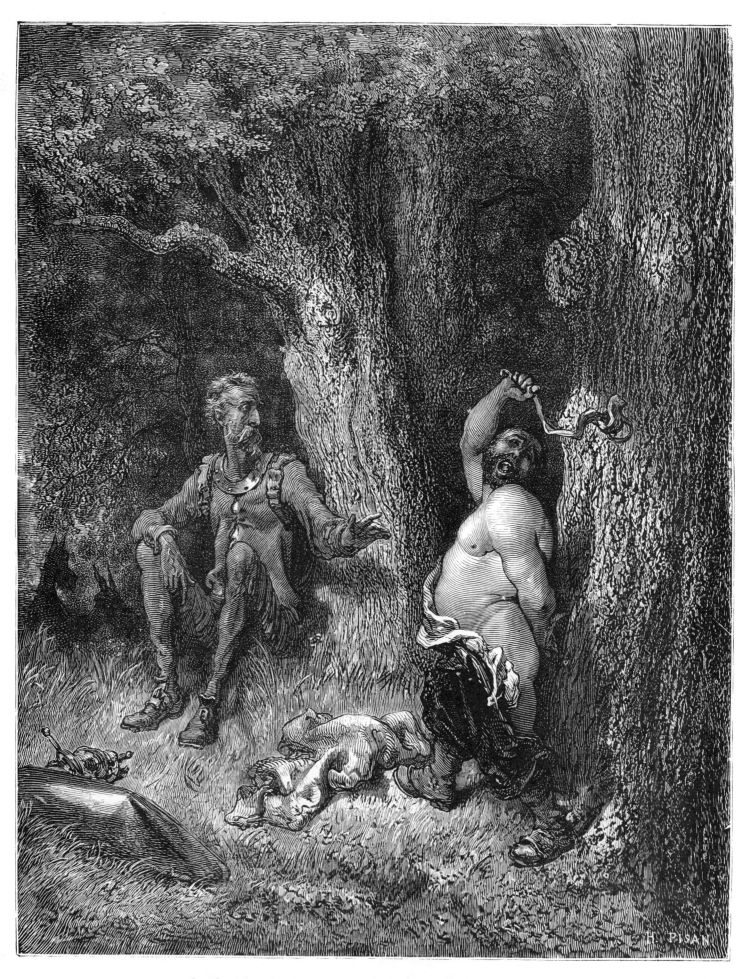

Sancho whips himself to break the spell cast on Dulcinea (II, 71).

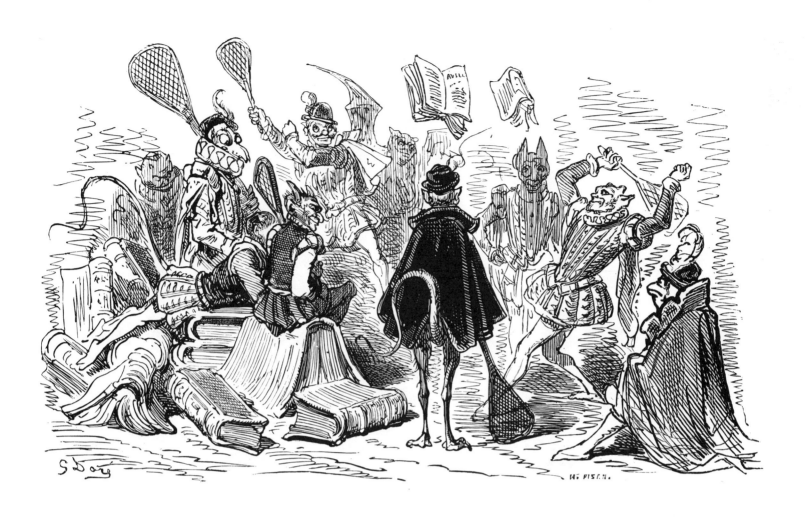

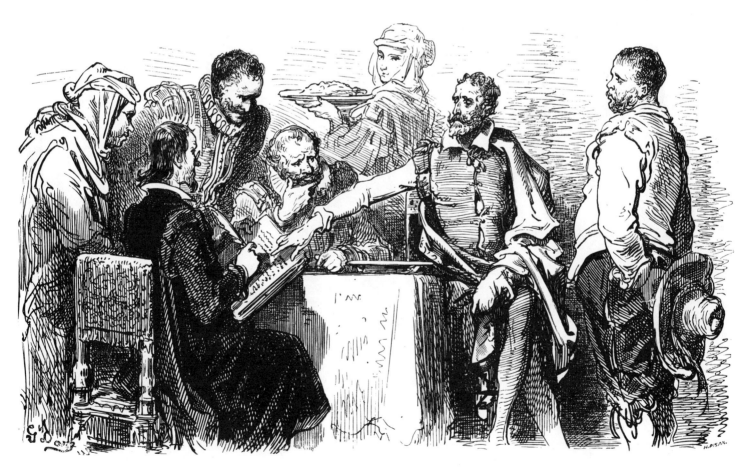

ABOVE: In Altisidora's narrative, devils play court tennis using books as balls (II, 70). BELOW: Don Quixote makes a formal declaration that he was not the hero of the false *Second Part of Don Quixote* by Avellaneda of Tordesillas (II, 72).

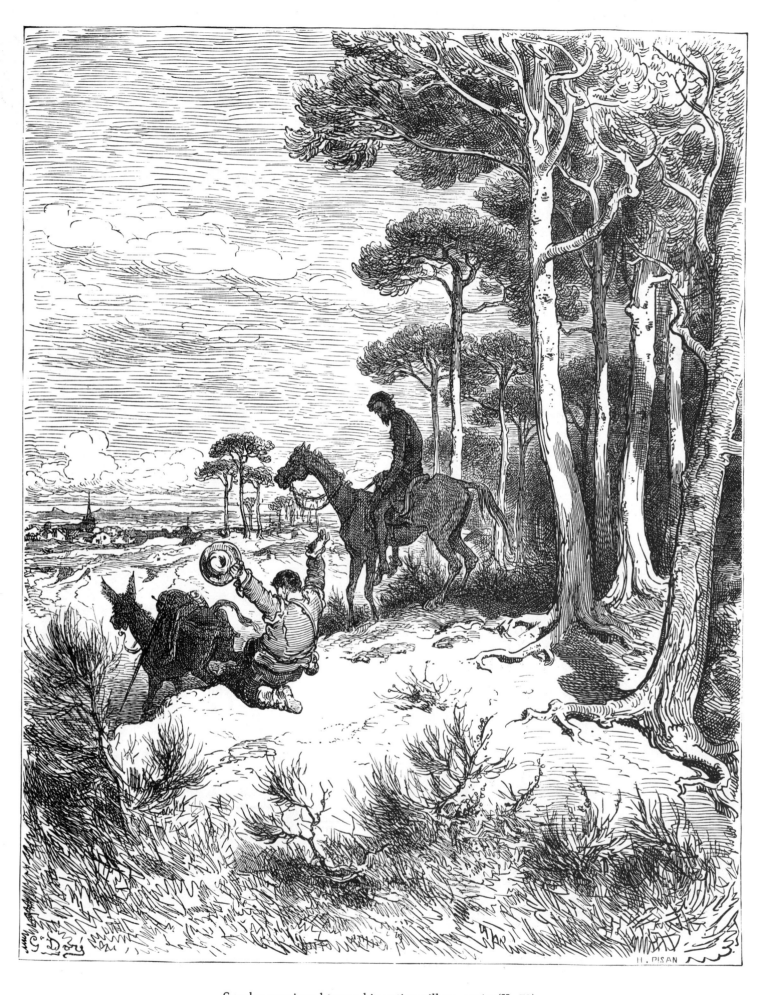

Sancho overjoyed to see his native village again (II, 72).

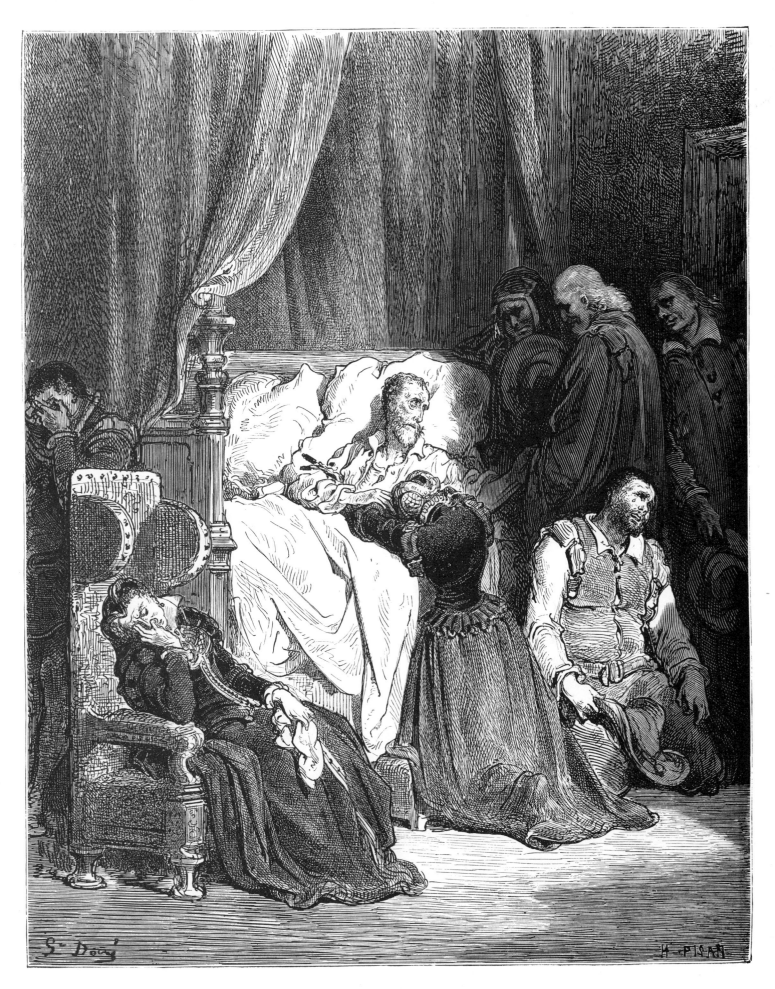

Death of Don Quixote (II, 74).